IMAGES
of America

GRAND RIVER AVENUE
FROM DETROIT TO LAKE MICHIGAN

IMAGES
of America

GRAND RIVER AVENUE
FROM DETROIT TO LAKE MICHIGAN

Jon Milan and Gail Offen

ARCADIA
PUBLISHING

Published by Arcadia Publishing
Charleston, South Carolina

Library of Congress Control Number: 2013956049

For all general information, please contact Arcadia Publishing:
Telephone 843-853-2070
Fax 843-853-0044
E-mail sales@arcadiapublishing.com
For customer service and orders:
Toll-Free 1-888-313-2665

Visit us on the Internet at www.arcadiapublishing.com

CONTENTS

ACKNOWLEDGMENTS

This book was made possible through the efforts, support, generosity, patience, and sense of humor of many.

We would like to thank the following people for these qualities and more: Scott Bartoszek, Leighanna Beach, Willard "Bill" Burkhardt, Milt Charboneau, Anya L. Cobler, Durwood Coffey, Joe Crachiola, Dawn Eurich, the Farmington Hills Historical Society, Joyce Fisher, Jean M. Fox (posthumously), the Frauenthal Center for the Performing Arts, Brian M. Golden, Laura Grimshaw, Trudy Hester (posthumously), Mike Karoub, Larry Lawrence, Cary Loren, Angela Maniaci, Romie Minor, R. Michael "Mike" Montgomery (posthumously), David Mrosek, Jerry Offen, Kristin M. Olson, A.J. Purdum, Charles A. Rasch (posthumously), Tina Rebottaro, Samyra Reid, Mark Root, Dr. Randle Samuels, Rudy Simons, Amy Seng, Steve Smith, Craig Tascius, Mindy Temple, Ruth Tepin, Dirk Thompson III, Robert Vedro, Jerome Weingarden, Joan Young, and Duane Zemper.

Very special thanks go to those listed below.

David V. Tinder: This project could not have been possible without the assistance of Dave Tinder. Dave's expertise, kindness, and generosity in extending to us complete access and unlimited use of the majority of the photographs contained herein has made this project a reality.

Willard "Bill" Burkhardt: Bill Burkhardt has been an inexhaustible source of information on this project. He has accompanied us on fact-finding trips, talked to friends and relatives, and provided us with a collection of articles, maps, and information that have proven to be invaluable to the project.

Brian M. Golden: We discovered Brian M. Golden through his 1999 book *Farmington Junction: A Trolley History*. His assistance on the history of interurban railways in southeastern Michigan proved invaluable. The author of several books on Michigan history, Brian is president of the Farmington Historical Society and the Friends of the Governor Warner Mansion.

Duane Zemper and Milt Charboneau: As one of the best-known photographers in Howell, Michigan, operating a shop along Grand River from 1946 until early this century, archivist Duane Zemper is a historical figure in his own right. He, along with teammate Milt Charboneau, contributed to this book in many ways, providing more than enough material and stories to fill a book.

Rob Vedro and Bluefrog Books: With an extensive background in photography and computer graphic support, Rob Vedro provided the high-quality scans necessary for reproducing the various photographs and graphic materials used in this publication. He and his family are proud owners of Bluefrog Books, at 615 East Grand River Avenue in Howell. Support independent bookstores!

Unless otherwise noted, all photographs included in this book are courtesy of the David V. Tinder Collection of Michigan Photography in the William L. Clements Library at the University of Michigan in Ann Arbor, which is an amazing collection.

INTRODUCTION

I frequently stare at a magnet on my refrigerator. It is a quote from Hans Christian Andersen's *The Fairy Tale of My Life: An Autobiography*: "To travel is to live."

My father gave me that magnet, and, to twist it a bit, he lived to travel. Many of my favorite memories with my parents have a famous backdrop—the Gateway Arch, the Grand Canyon, the Unisphere, Wall Drugs, Mount Rushmore, Disneyland, the Soo Locks—with my brother, my mother, and me posed stiffly or waving at my father and rendered in saturated Ektachrome slides and Super 8 film.

My father was born in Poland and came to this country in 1951. America's highways were busy again after the war, and he was amazed that almost everyone seemed to have a car. Before too long, he had one, too, and began his lifelong love of driving—anywhere. He would be happy to drive to California, and he was also happy to drive me around the corner. We had a ritual called "F'ride"—a five-year-old's way of saying "take me for a ride."

Summers were when we saw most of America. We could take the time to see things at the proper pace. My brother and I would each sit on our side of an imaginary but uncrossable line in the backseat of a seafoam blue 1969 Catalina. My dad would smoke his pipe and whistle. My mom put on her head scarf when the convertible top came down. I remember complaining sometimes about having to see "another dumb monument" or "some stupid museum." But I look back now and I am so thrilled and grateful to have been dragged to 46 of the 48 contiguous United States. (Someday, I will get to Idaho and Montana, Dad. I promise.)

This book is dedicated to all the dads and moms who are smart enough to sense their children will be grateful someday—but mostly to my dad, who overcame many physical barriers and traveled the world. He passed along the love of seeing the unusual along with the usual, the irresistible lure of a "souvenir" sign, curiosity about how things are made, back roads, boxes of fudge, a clean windshield, tourist traps, fishing piers, mom-and-pop motels, town squares, and funky signs. Oh, and, although he loved maps (and could actually refold them), he did not mind asking for directions. "That's how you meet the locals," he would say.

Writing this book gave us a chance to take a closer look at one such road: Grand River Avenue, or—perhaps a bit less flamboyantly—US 16. It is one of the more historically significant pathways running through our own home state of Michigan. Taking to the road with the intention of exploring it in its entirety (nearly 200 miles) and attempting to better understand its overall significance has rivaled many of the long-distance treks of my youth. At times, it has even re-conjured memories of those long-past adventures, riding in the backseat, being safely transported across the country by mom and dad.

As to the "Grand" part of Grand River, when your name comes with bragging rights ("Okay, what makes Grand River so darn grand?"), you better have lots of stories to tell. And, while many of the books in this series are about places and things, we thought it would be interesting to write about a road that is also a trail, a highway, and the state's longest river. Basically, it is the "utility infielder" of how to get somewhere across Michigan. You can even go on its car ferry extension to Milwaukee.

Running between the heart of Detroit and the edge of Lake Michigan, Grand River is a great choice for seeing urban, suburban, and rural Michigan. For four decades, it served as the primary connection between the state's largest cities. But it all started as a migratory route for its earliest inhabitants—the Sauk, Huron, and Potawatomi tribes.

Along with many other firsts, the first roadside picnic tables in Michigan were set along Grand River in 1929, near Saranac. These were the brainchild of Ionia County engineer Allan M. Williams, who also developed the Mitten State's first official road map. The Grand River was also the source for the first electrically powered lighting system in America, in Grand Rapids in 1880.

So drive, bike, walk the road, or even canoe all 225 miles of the river, as a Great Lakes Expedition team did in 2010, from Jackson County to Grand Haven. We have learned along the way that "la rivière Grande" is pretty darn grand.

There are still many places and things to discover on nearby highways and two-lane, blacktop roads closer to home—some perhaps even running right past your backyard.

And so, the magnet. Good advice, Hans.

I plan to keep on the move, Dad. I just wish you were at the wheel.

—Gail Offen, 2014

One

THE RIVER, THE TRAIL, AND US HIGHWAY 16

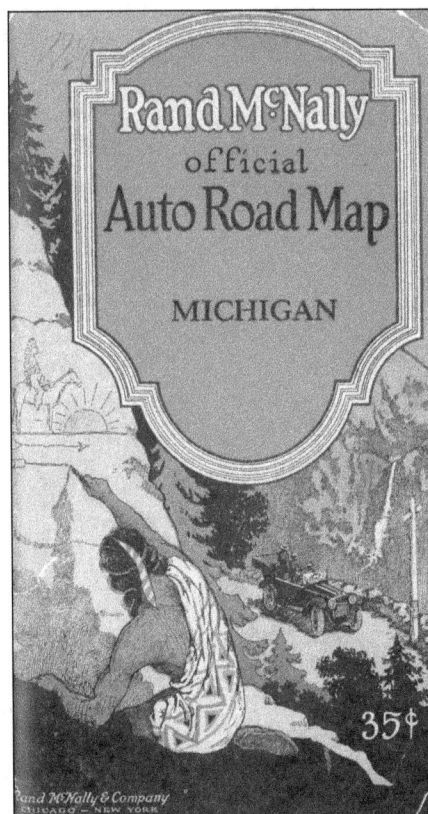

THREE OF A KIND. In Michigan, there are three significant entities going by the name of Grand River—a river, an ancient trail, and US Highway 16. As indicated by the cover of this 1926 Rand McNally Official Auto Road Map of Michigan, the histories of these three entities are inextricably linked, weaving together a narrative that combines natural waterways, Native American trails, and the many social and geographic changes brought about by the auto industry.

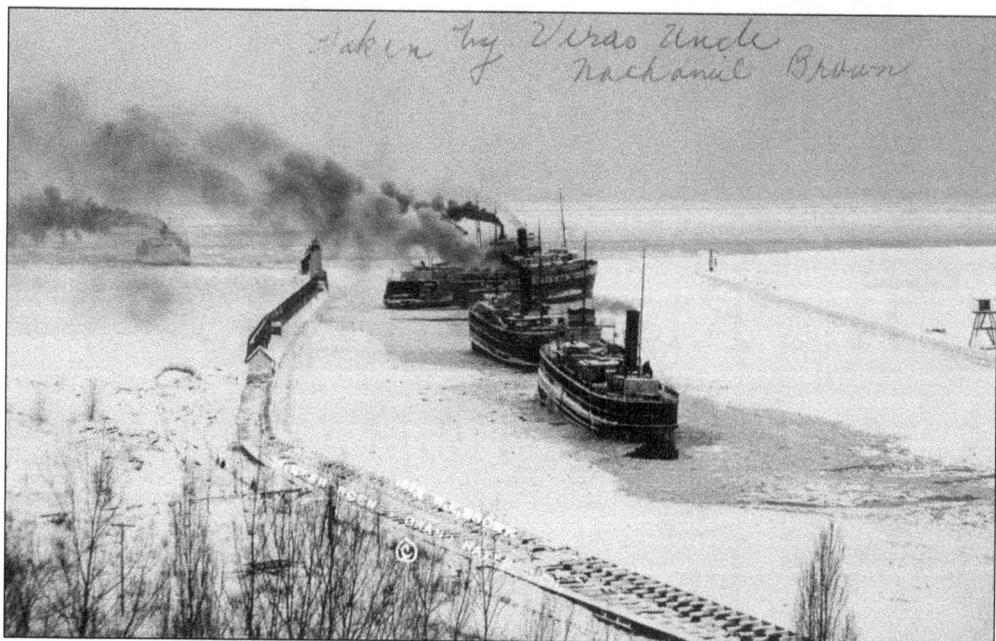

Taken by Veras Uncle Nathaniel Brown

THE RIVER. Stretching more than 250 miles, the Grand River is Michigan's longest, rising near Somerset, in Hillsdale County, just south of Jackson, and meandering up through Lansing and westward through Grand Rapids until it reaches Lake Michigan at Grand Haven. Over time, Native Americans, western explorers, and early settlers all used it for transportation and commerce. In the 1912 winter scene above, ships ply the last stretches of the Grand River before reaching the open waters of Lake Michigan. In time, the river and the highway that bears its name (US 16) would end up crossing paths in several places as they make their separate ways across the state. In the photograph below, the M16 (US 16) Bridge is shown spanning the river at Portland.

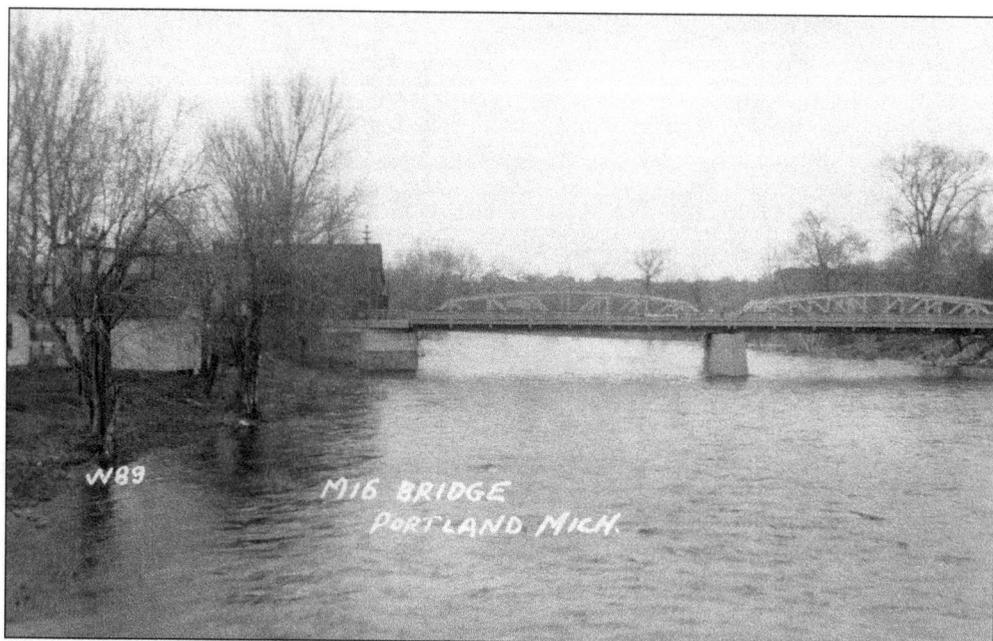

W89
M16 BRIDGE
PORTLAND MICH.

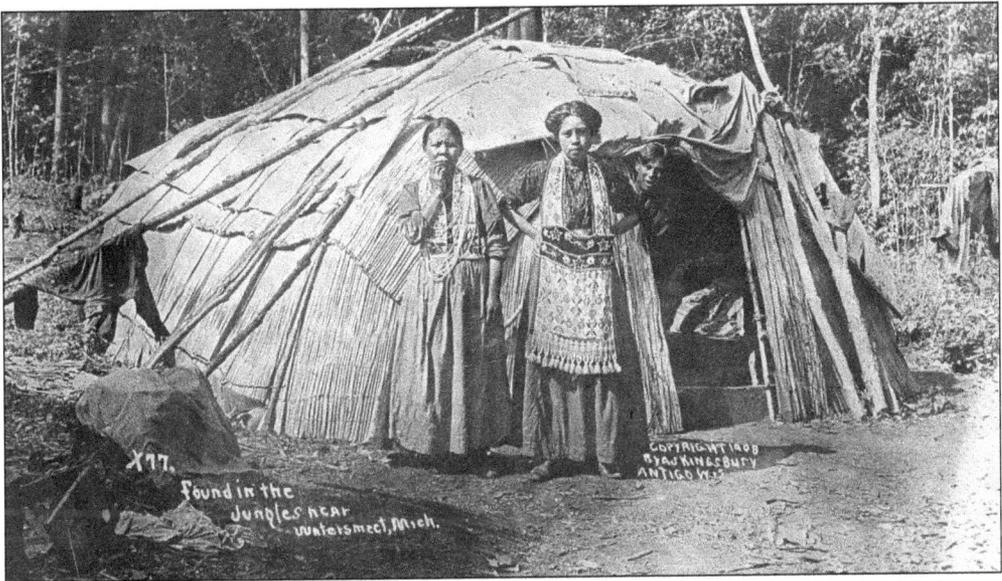

THE TRAIL. The Grand River Trail is one of many Native American pathways found in Michigan, all of which predate western histories of the Americas. These are trails worn by the footfalls of thousands of years. Many stretches were formed by glaciers and forged by migrating peoples as far back as the Ice Age. Most of Michigan's indigenous tribes are considered part of the Algonquian peoples. Among others, these include Ottawa, Sauk, Fox, Potawatomi, Chippewa, and Kickapoo. The trails they blazed once connected them with places for hunting, fishing, and selected campsites for setting up living quarters. At one time, they would have pitched their birchbark waginogans, or wigwams (above), in a clearing along the trail or along the banks of the Grand River, but, by the turn of the 20th century, most of this land had been ceded to the American government. A Native American family in Michigan (below) probably supplemented their income by selling this family portrait to tourists as a souvenir.

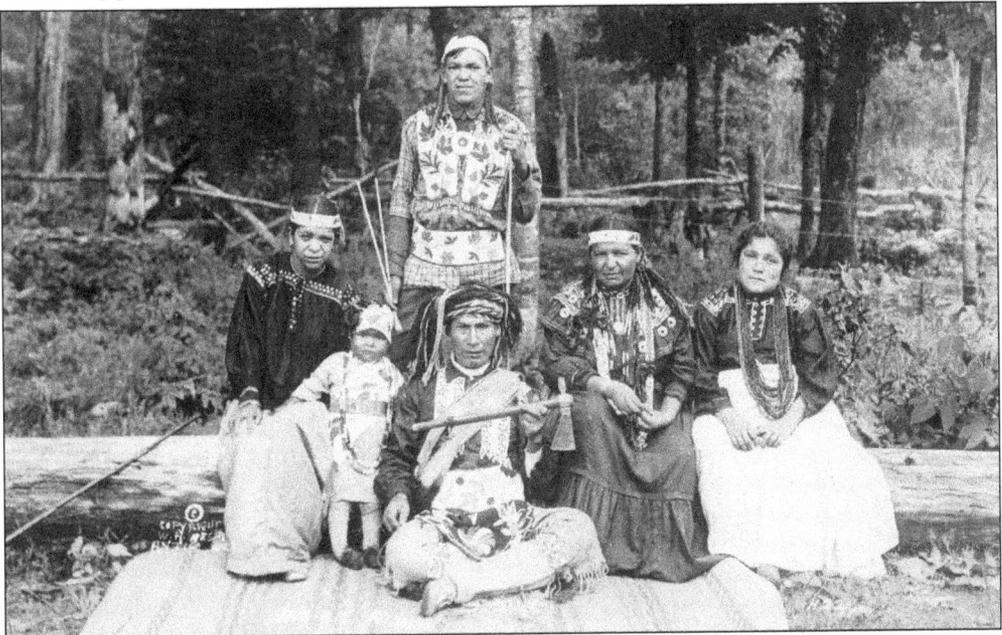

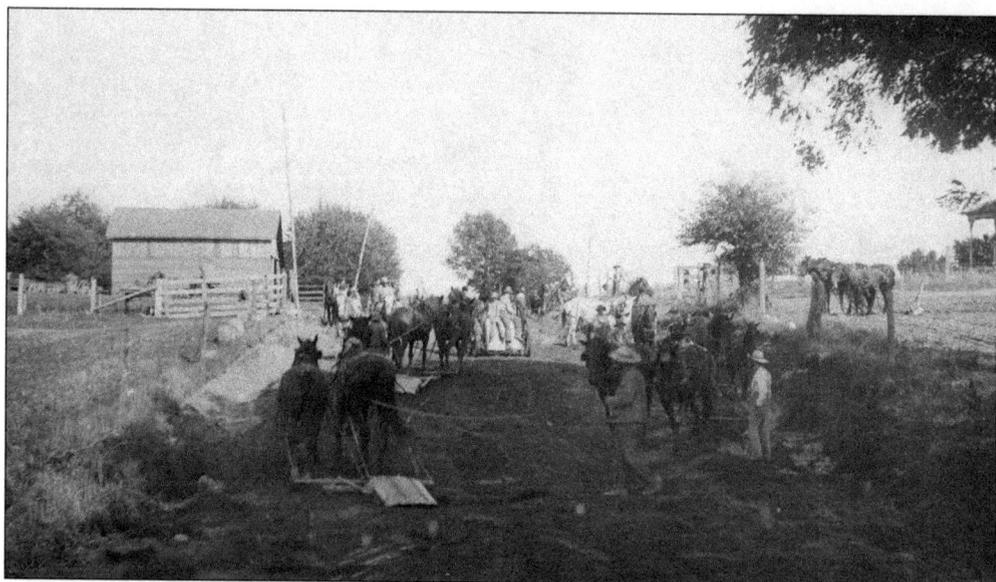

TRAILS TO HIGHWAYS. In addition to the Grand River Trail, some of the more historically significant trails of this kind are the Old Sauk Trail (modern US 12, or Michigan Avenue), the Shiawassee Trail, and the Orchard Lake Trail. All of these trails are the foundations of routes that eventually became major modern roadways. While a modified version of the Grand River Trail eventually became a major stagecoach route in the 19th century, the highway known as US 16 was not created until the automobile age. In the photograph above, work crews near Portland use horse-drawn equipment to dig, widen, and grade the pathway that would soon become US 16. While the newly evolving highway and the old trail often shared the same path or ran parallel as they headed toward Muskegon, the Grand River eventually meanders off in its own direction en route to Lake Michigan, passing through Spring Lake and under the once incredibly priced $250,000 bridge, seen below, at Grand Haven.

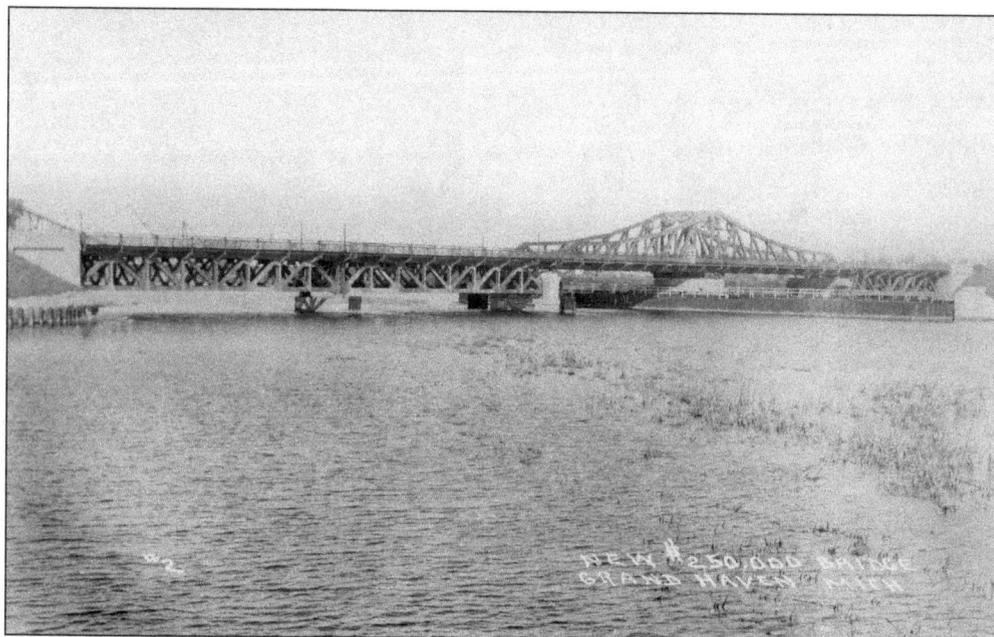

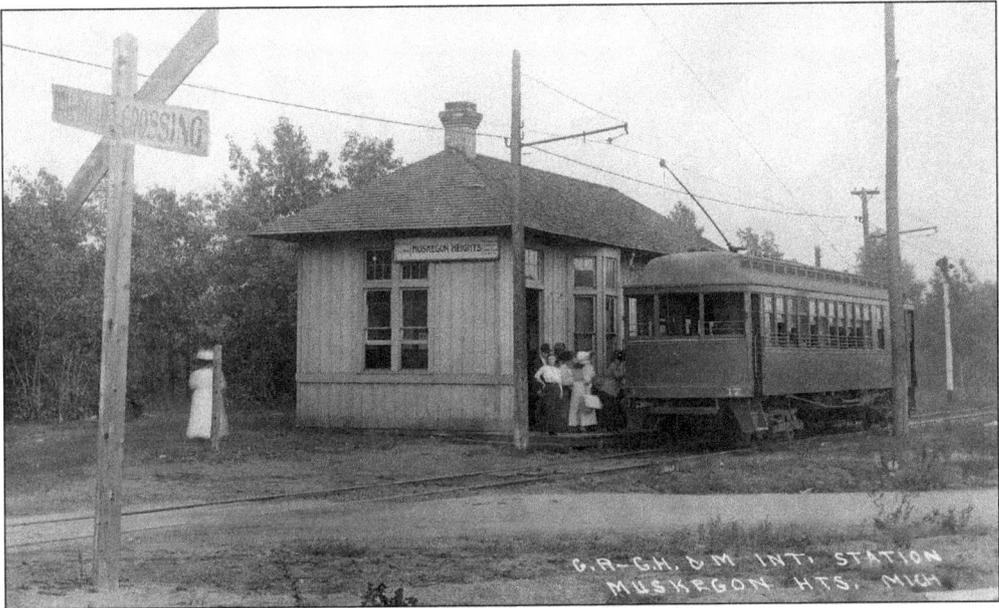

ELECTRIC AVENUE AND GASOLINE ALLEY. Since the Grand River Highway begins its western trek in Detroit and winds up in the busy industrial city of Muskegon, it seems only natural that the highway would develop quickly and readily adapt to the latest emerging modes of transportation. On both sides of the state, the interurban railroads, initially horse-drawn and eventually electrically powered, became a standard mode of high-speed transportation in and around the big cities. Shown above, the Grand River, Grand Haven & Muskegon (GRGH&M) interurban stops at the Muskegon Heights station. Below, a car whizzes by in a blur along Grand River near Woodward as an early traffic cop daringly stands in the middle of the road, hand-turning a lighted traffic signal pole.

US 16 AND THE INFERNAL MACHINE. Within the city of Detroit, US 16, or Grand River Avenue, as it was locally known, soon became one of the major arteries leading in and out of the city, carrying upon its shoulders each of the latest developments of private and public transportation. With the advent of the automobile, it was no different—especially in the "Motor City," where even the outlying stretches of Grand River (above) were completely paved by 1929. Along with being first in line to receive improved road surfaces, Grand River also presented a perfect test environment for emerging innovations in traffic management and safety. The bizarre whitewashed, concrete traffic light tower below was photographed in 1928. It stood in the middle of Grand River at American Avenue, an intersection no longer extant due to the construction of the Jeffries Freeway (Interstate 96).

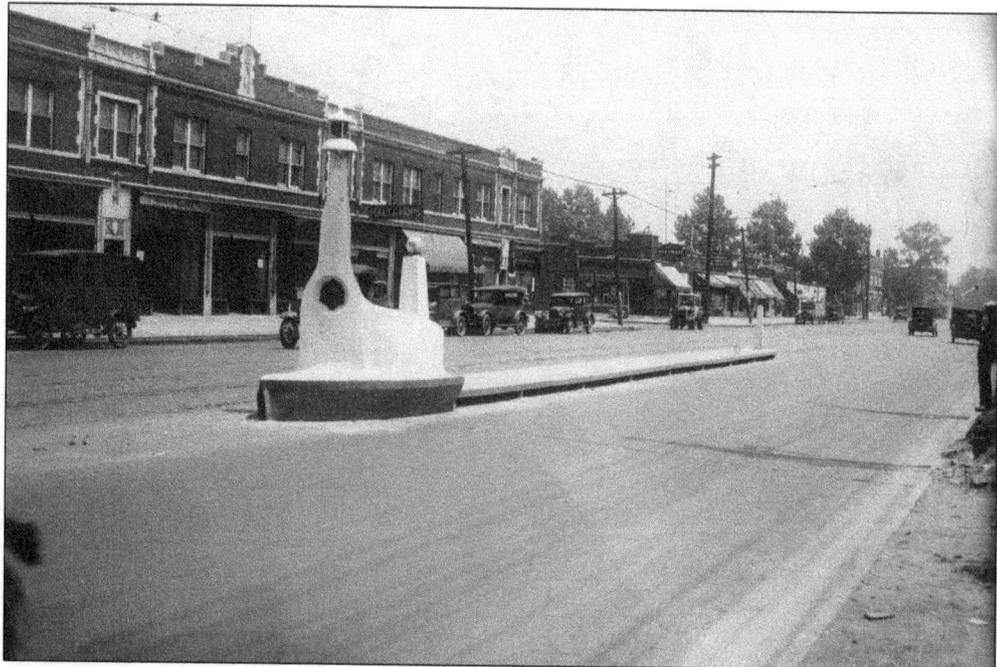

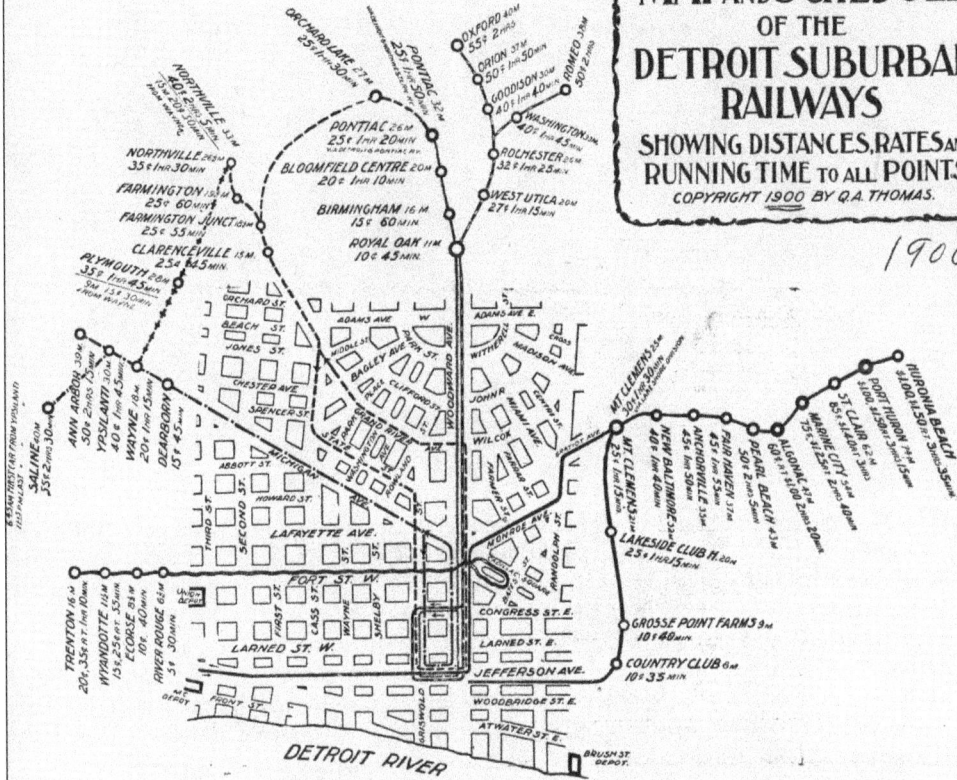

SUBURBAN CONNECTIONS. Grand River figured prominently in Detroit's elaborate rail network of 1900. At the time, major lines ran along Jefferson and Fort Streets, Michigan, Woodward, and Grand River Avenues, and up Monroe Street to Gratiot Avenue. Each line connected major outlying population centers, including Grosse Pointe, Port Huron, Wyandotte, Pontiac, Romeo, Ypsilanti, and Ann Arbor. The line progressing up Grand River would eventually connect to lines that ran to Farmington and Northville to the west and Orchard Lake to the north. (Courtesy of Brian M. Golden.)

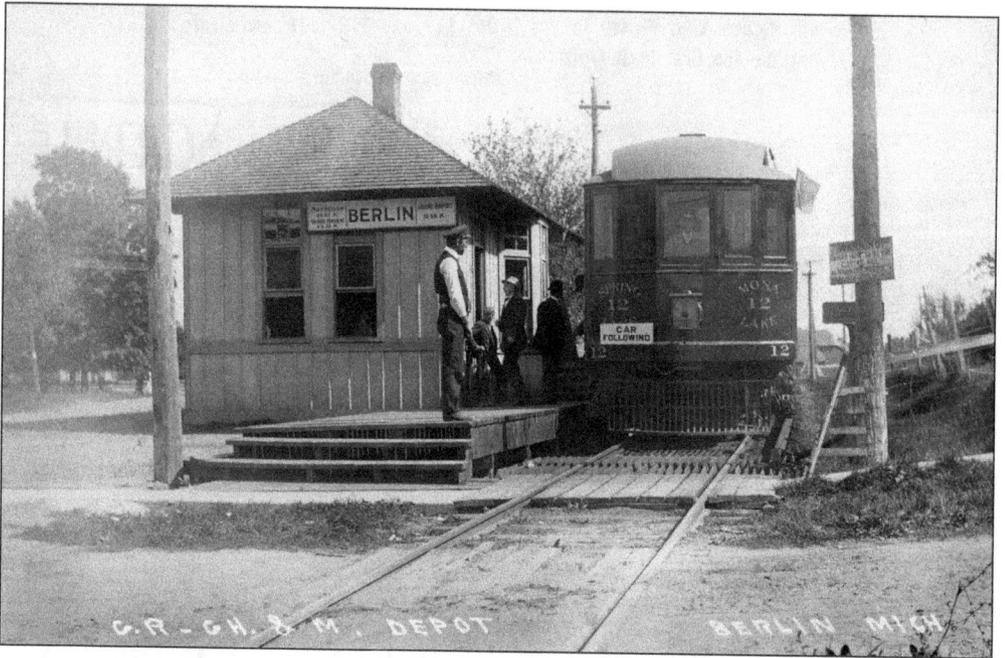

C.R.-G.H.&M. DEPOT BERLIN MICH.

GRGH&M. On the western side of the state, a similar network of rail lines connected the major business and industrial centers from Grand Rapids to Lake Michigan. The GRGH&M railway closely followed the path of old Grand River Avenue (US 16), running from Grand Rapids into Nunica and then varying slightly from the roadway by first running into Fruitport before heading south to Spring Lake and Grand Haven. The northbound line running from Fruitport went along a path that eventually became US 16 after 1940. This route ran directly into Muskegon Heights and Muskegon. In the 1911 photograph above, a GRGH&M train stops briefly at the Berlin (later Marne) depot. Taking great artistic license with geography and the scale of miles involved, the GRGH&M-issued map below illustrates the route and the stops it once serviced.

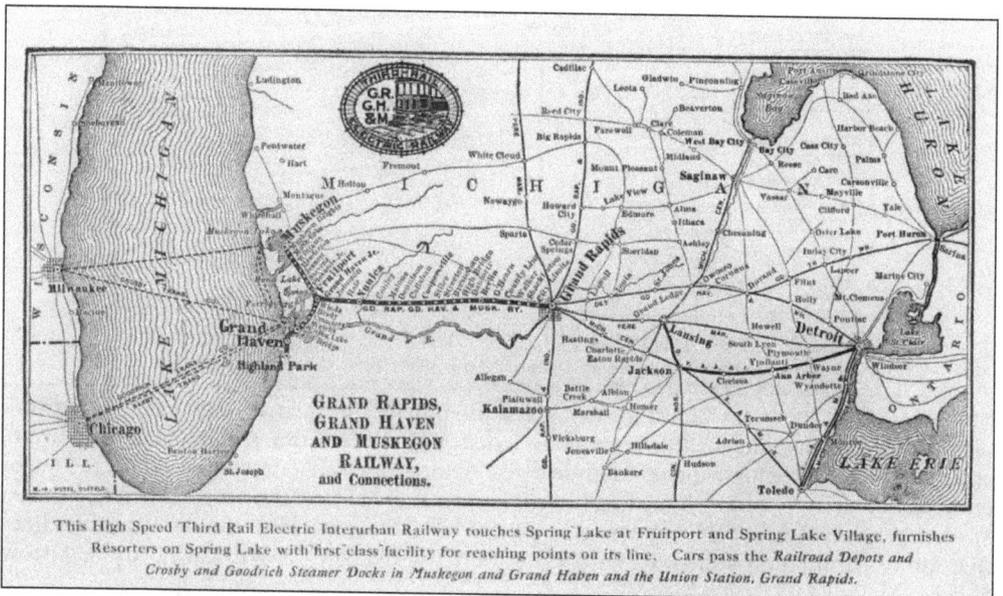

This High Speed Third Rail Electric Interurban Railway touches Spring Lake at Fruitport and Spring Lake Village, furnishes Resorters on Spring Lake with first class facility for reaching points on its line. Cars pass the Railroad Depots and Crosby and Goodrich Steamer Docks in Muskegon and Grand Haven and the Union Station, Grand Rapids.

Two

WAYNE COUNTY

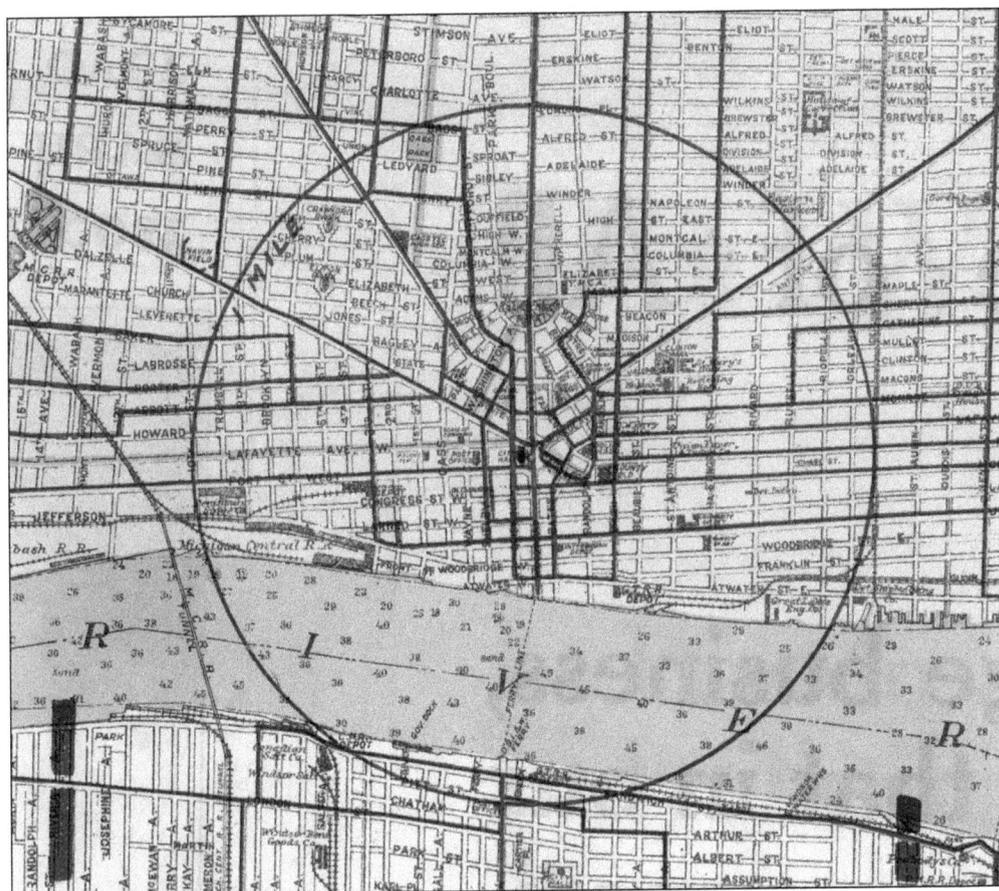

CROSSING WOODWARD AVENUE. Detroit was destroyed by fire in 1805. During the rebuilding process, Judge Augustus Woodward borrowed heavily from the layout for Washington, DC, ultimately creating a pattern where Detroit's major streets converge like wagon wheel spokes near the city's center. Seen here, Grand River Avenue is one such "spoke," beginning on the east side, at Madison Street (center right), crossing Woodward Avenue in a half circle, and completing its westbound trajectory at the top left.

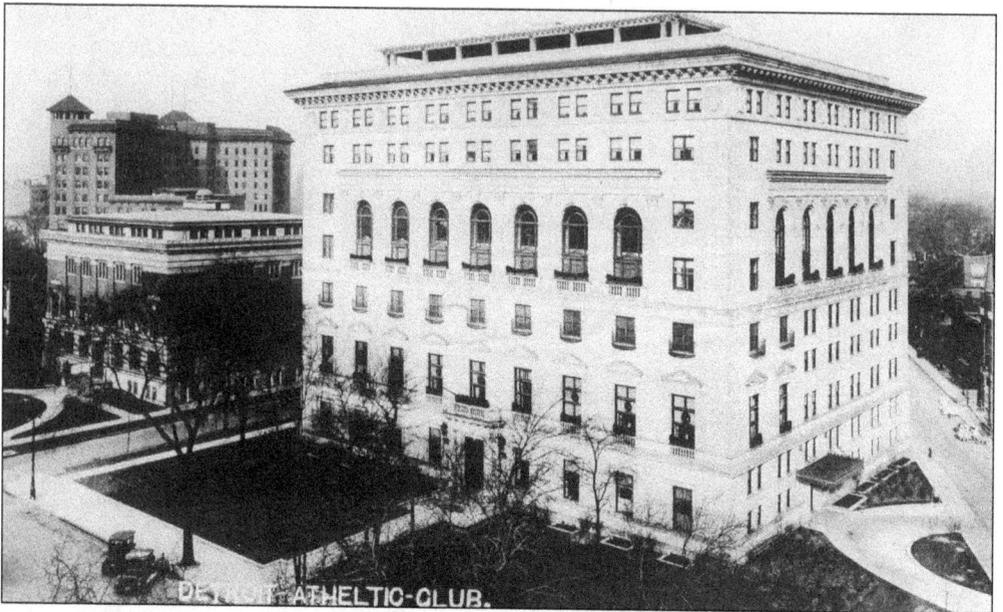

DOORWAY OF THE DAC. The eastern terminus of Grand River Avenue is found at the front door of the Detroit Athletic Club (DAC), one of the city's oldest and most exclusive social clubs, established in 1887. Designed in the Renaissance Revival style by Albert Kahn, the stately 1915 clubhouse stands along Madison Avenue and faces Grand River's intitial footfalls.

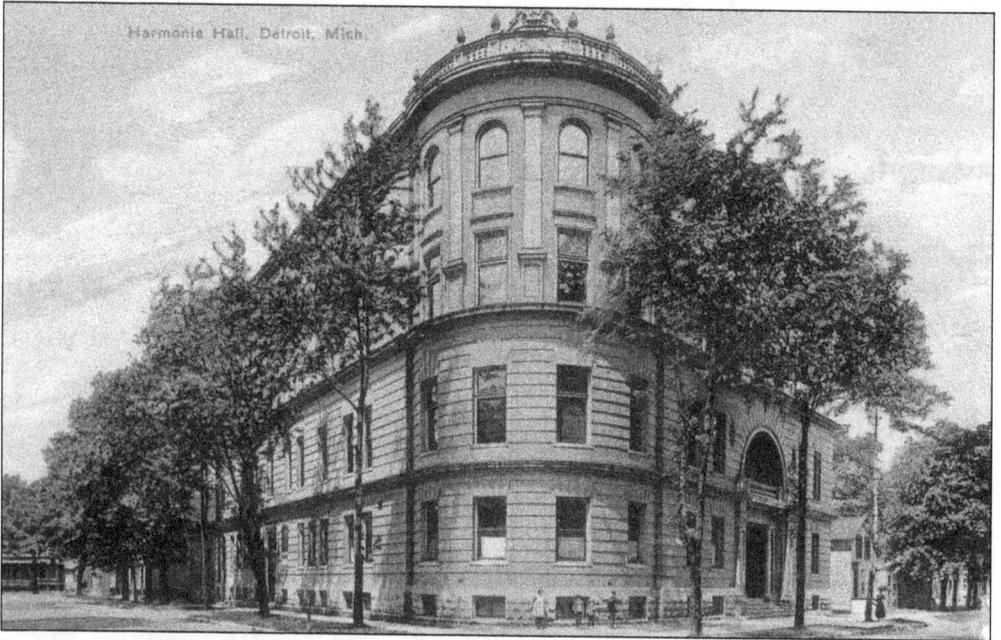

IN HARMONIE. The Harmonie Club was built in 1895 by Detroit's Harmonie Musical Society. In 2009, the Arts League of Michigan gave the building new life as the Virgil H. Carr Center for the Arts. With galleries and classrooms throughout, the center enables people of all ages to study the arts. According to Oliver Ragsdale Jr., the center's president, "it's America's only African American arts center where all the disciplines are practiced under one roof." (Courtesy of the author's collection.)

18

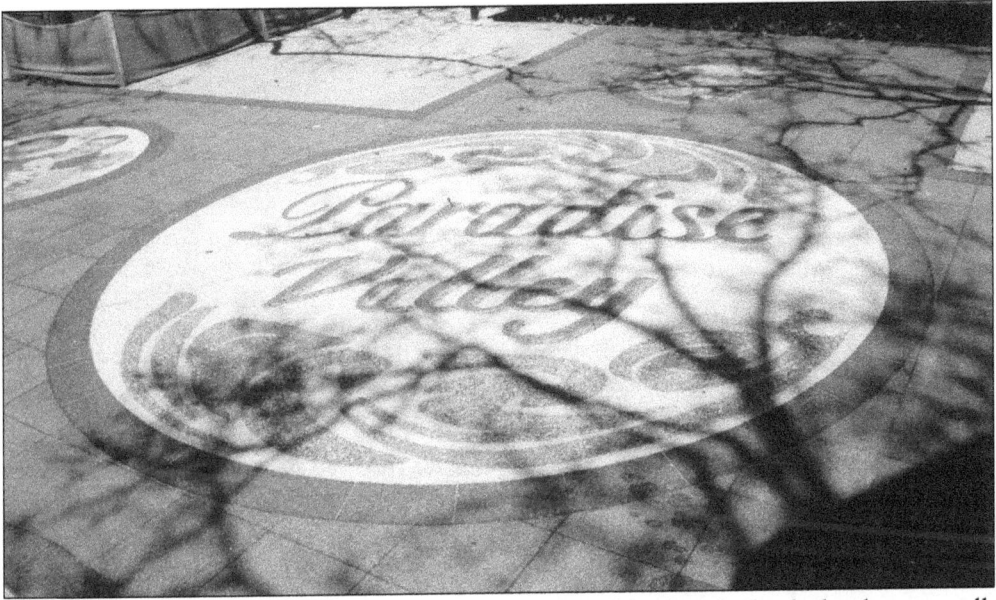

PARADISE. Just as the Harmonie Club was reborn, the small park in front of it has been as well. In 2009, Harmonie Park was officially renamed Paradise Valley/Beatrice M. Buck Park, honoring Detroit's now legendary African American entertainment district, where many of Detroit's greatest performers began and international giants such as Duke Ellington and Cab Calloway regularly came to perform. The park also honors local playwright Beatrice Buck.

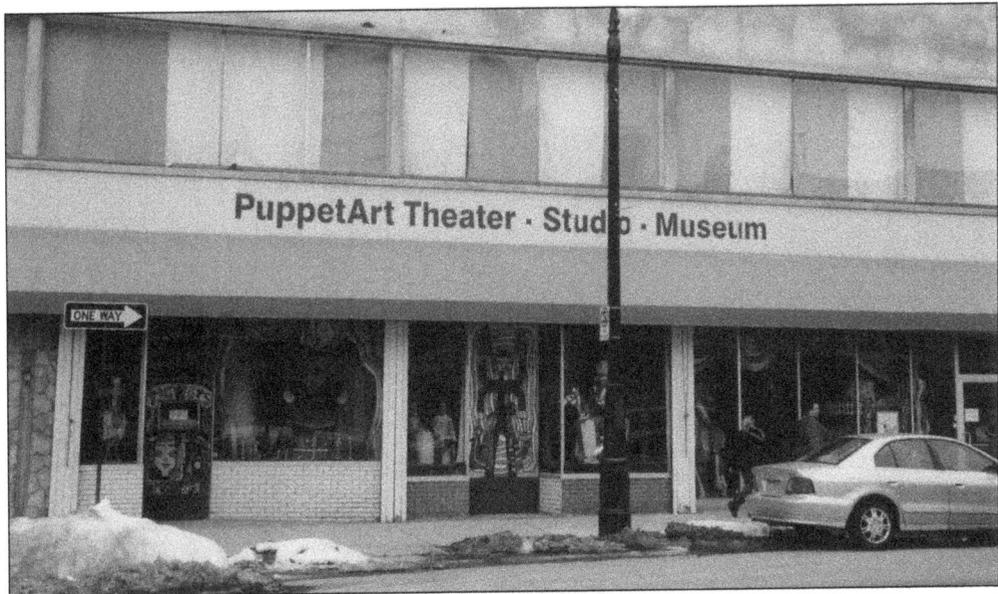

PULLING A FEW STRINGS. Located along Grand River Avenue between Farmer Street and Woodward Avenue is PuppetART, the Detroit puppet theater. Founded in 1998, the nonprofit organization is a collective of artists and puppeteers originally trained in Russia. The PuppetART performance company offers a repertoire of popular productions year-round, and every visit includes a performance in its 70-seat auditorium, a museum tour, and a workshop in the puppet studio. (Courtesy of the author's collection.)

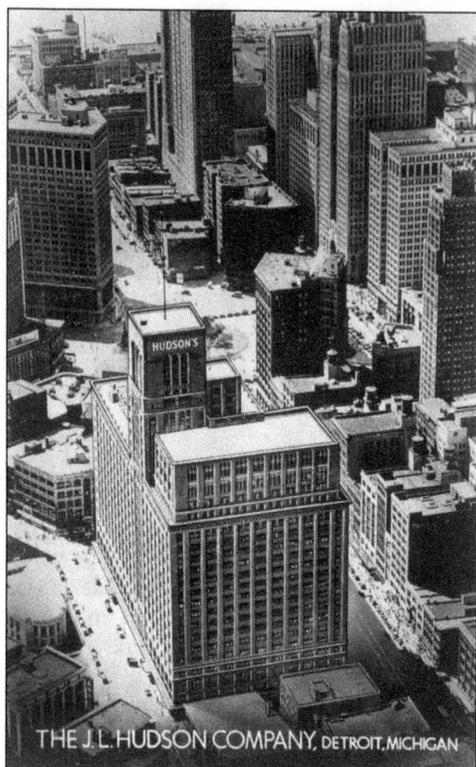

THE J.L. HUDSON COMPANY, DETROIT, MICHIGAN

WOODWARD AND GRAND AVENUES. Just beyond the puppet show, Grand River crosses Woodward Avenue—one of Detroit's busiest and most familiar intersections. This stretch of Woodward is the Lower Woodward Avenue Historic District. Often referred to as Merchants' Row, it was added to the National Register of Historic Places in 1999. Though no longer extant, the J.L. Hudson Company (left) stood along the southeast corner. More than 14 stories high, it was the tallest department store in the world, and it sponsored an annual, nationally recognized Thanksgiving Day parade. The company began in Detroit in 1881 and occupied the block bordering Grand River from 1911 until the building was closed in 1983. It was demolished by implosion in 1998. For many years, the J.L. Hudson Company was also known for displaying the world's largest American flag (below), measuring 90 feet by 230 feet and weighing 900 pounds.

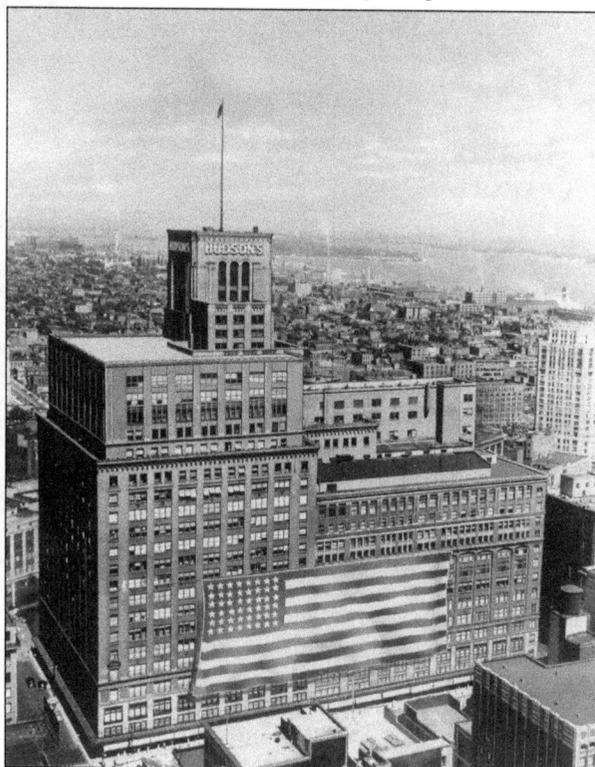

MERCHANTS' ROW. The T.B. Rayl Building (above, right) was completed in 1915. It was the second structure on this site to house the T.B. Rayl Hardware Company and was designed by Wirt Rowland, who later designed Detroit's Guardian Building. Just across the intersection is the Elliott Building, built in 1894. Sebastian S. Kresge opened his first Kresge 5 & 10 Cent Store here in 1899. Today, the historic structure is undergoing a major renovation and will soon offer luxury apartments and street-level retail space. Below, Woodward Avenue's Merchants' Row is seen stretching from State Street to Grand River around 1910. By this time, Kresge had opened a store at State Street (foreground). Just behind the streetcar is the jewelry store of Frederick Rolshoven, the father of American painter Julius Rolshoven (1858–1930).

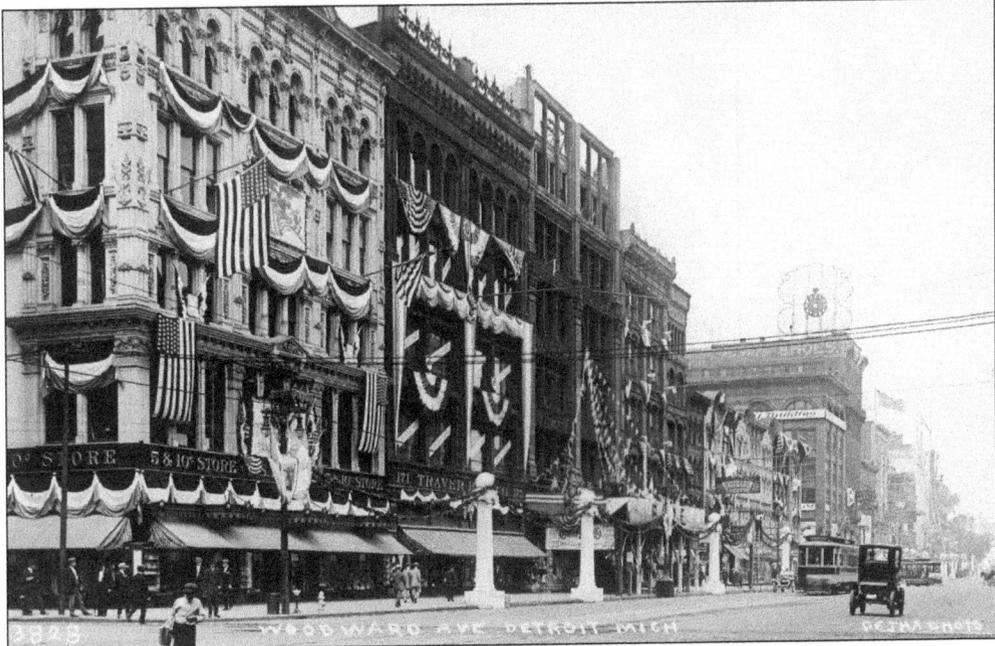

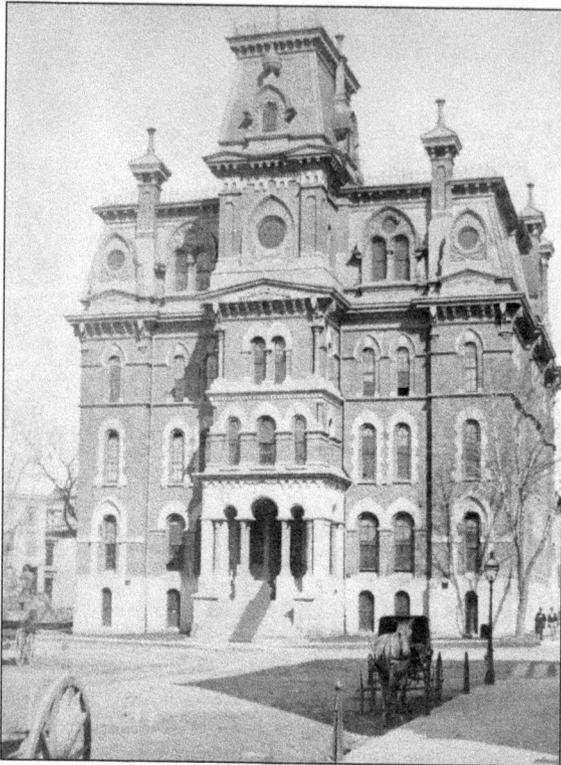

WATCH THIS SPOT. One block east of Woodward Avenue, Grand River crosses Capitol Park. As the name suggests, it was once the site of Michigan's capitol. Constructed in 1832 as the territorial courthouse, it became the state capitol (below) in 1835. Michigan's first governor was Stevens T. Mason (1811–1843), known as "the Boy Governor" because he took office at the age of 23. In 1847, the state legislature relocated the seat of government to Lansing. Left with a large vacant building, the City of Detroit transformed the old capitol into a public high school. By 1875, following a number of additions and a major brick refacing, which included the addition of a "stylish" mansard roof, the Capitol Union School (left) looked quite different. Later, the school was renamed Detroit Central High School, and, though it has been relocated several times, it is still an active school today.

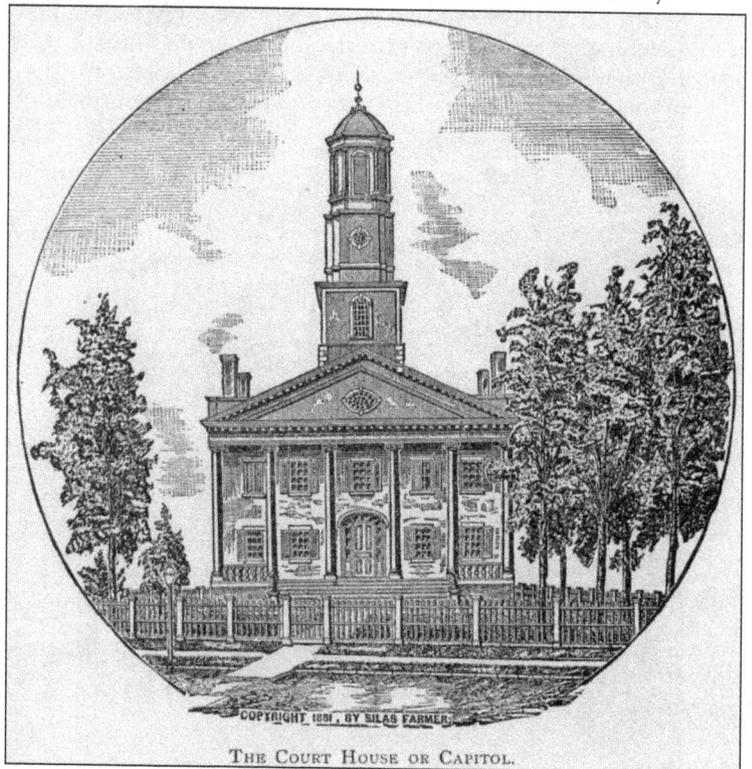

COPYRIGHT 1891, BY SILAS FARMER.

THE COURT HOUSE OR CAPITOL.

CAPITOL PARK. The section of Grand River Avenue that passes Capitol Park has seen a fair share of historical activity. Prior to the Civil War, it would have looked upon the Finney Barn, a livery for guests of Seymour Finney's hotel. Unbeknownst to the guests, it was also a hiding place for fugitive slaves running along the Underground Railroad. It is said that, more than a few times, slave hunters slept in the hotel, unaware that their prey slept in the barn just around the corner. After the capitol and the school were gone, the park remained a busy place. In the view from Grand River Avenue at right, the David Stott Building towers above the park and the Penobscot Building (once Detroit's tallest) looms in the distance. Michigan's first governor still stands over Capitol Park, commemorated in a bronze statue by sculptor Albert Weinert. Mason's ashes are interred here too, and, along with the pigeons, he continues to keep watch.

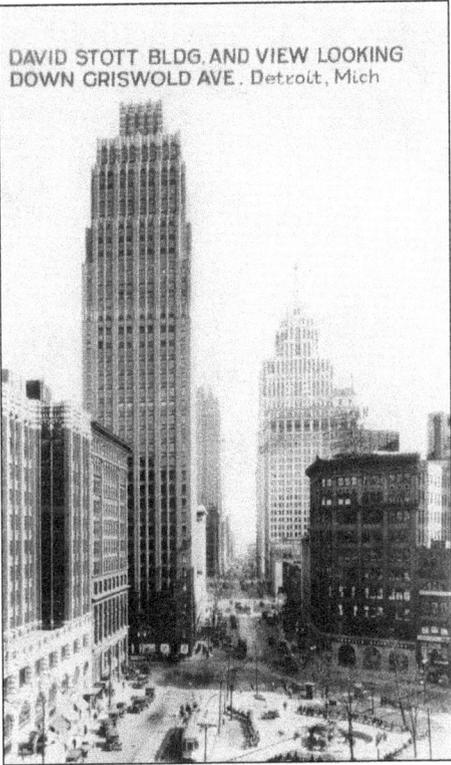

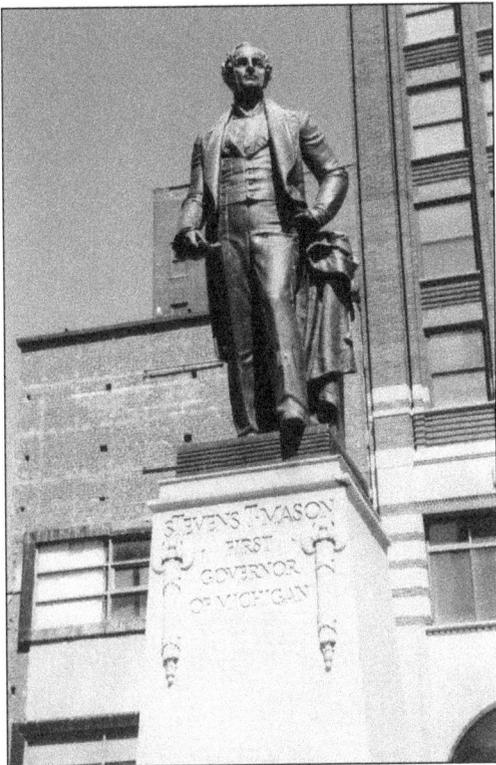

DAVID STOTT BLDG. AND VIEW LOOKING DOWN GRISWOLD AVE. Detroit, Mich

23

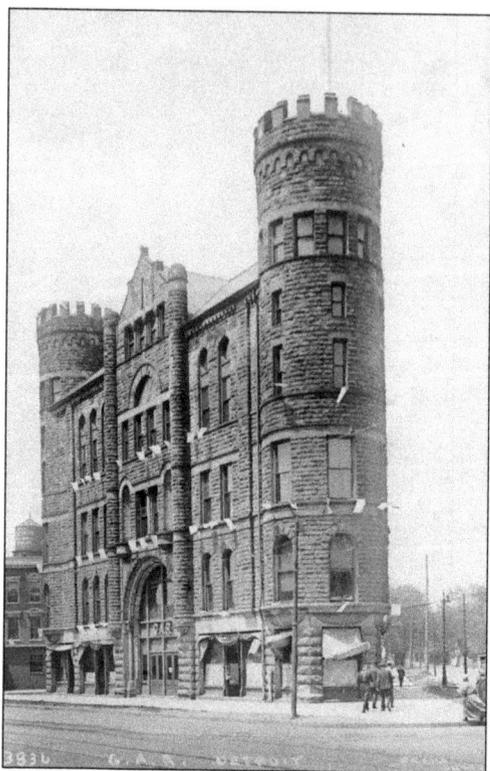

A GRAND RESTORATION. At the confluence of Grand River and Cass Avenues, the castle-like GAR Building, seen at left around 1905, still stands. Though vacant for many years and nearly in ruins, it has recently been given new life through the restorative efforts of Mindfield, a Detroit-based creative, film, and production company. Originally commissioned by the Grand Army of the Republic (GAR), a veterans' organization established for Union Civil War veterans, the building was designed by Swiss-born Detroit architect Julian Hess. Construction began in 1897. Much of its $50,000 cost, impressive for the time, was financed by the city, and the balance was supplied by the GAR with the stipulation that, no matter what use it came to in the future, the building must always include a memorial to veterans of the Civil War. Below, though obscured in darkness and partially covered by protective boards, the building's entranceway still features the original GAR tile mosaic.

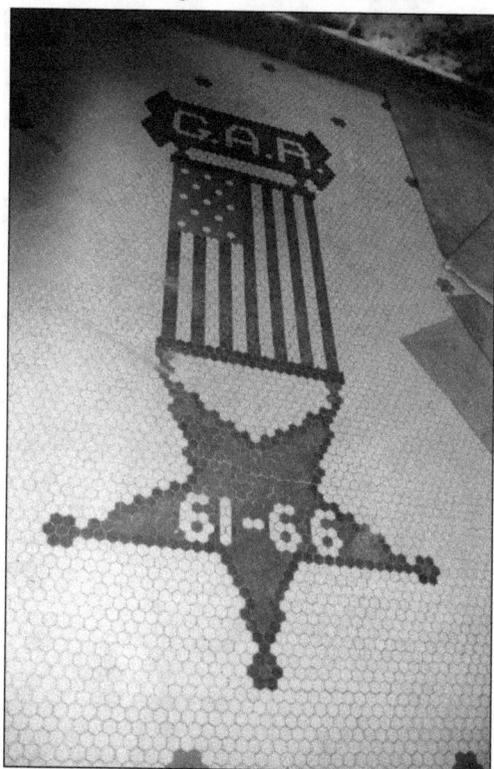

A New Life. By 1940, few Civil War veterans remained, and the city began repurposing the building until it eventually fell into disuse. While coming close to demolition, it was ultimately saved through the efforts of Celestine Hollings, a great-granddaughter of a veteran and a member of the Daughters of Union Veterans of the Civil War, who succeeded in getting it designated as a National Historic Site. Mindfield purchased the building in 2011, and the grand restoration began, which will ultimately return the building to its 1900 appearance. At right, Mindfield's Tom Carleton gives the authors a tour of the restoration in progress, while exterior work continues, seen below. In addition to providing a new home for Mindfield, the project will also introduce two new restaurants to the area, offer additional office space, and provide the veterans memorial mandated by the original construction agreement, all in the center of a city experiencing a grand comeback.

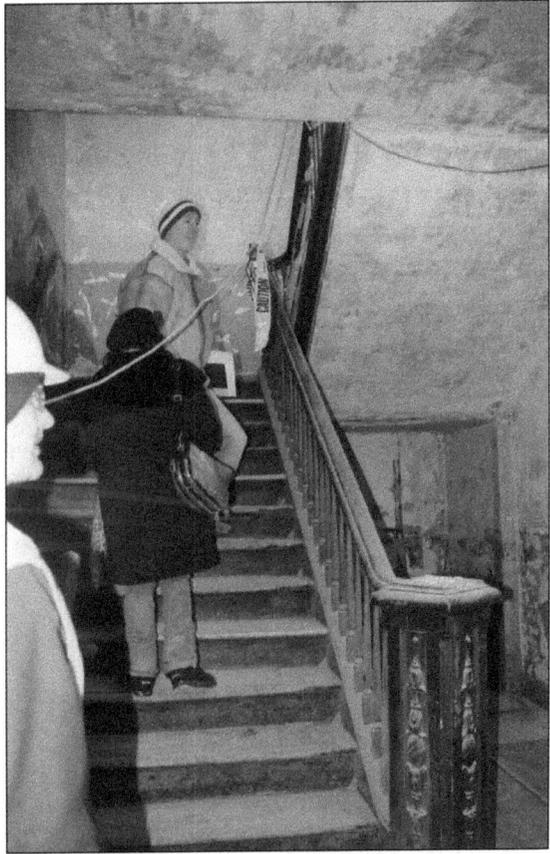

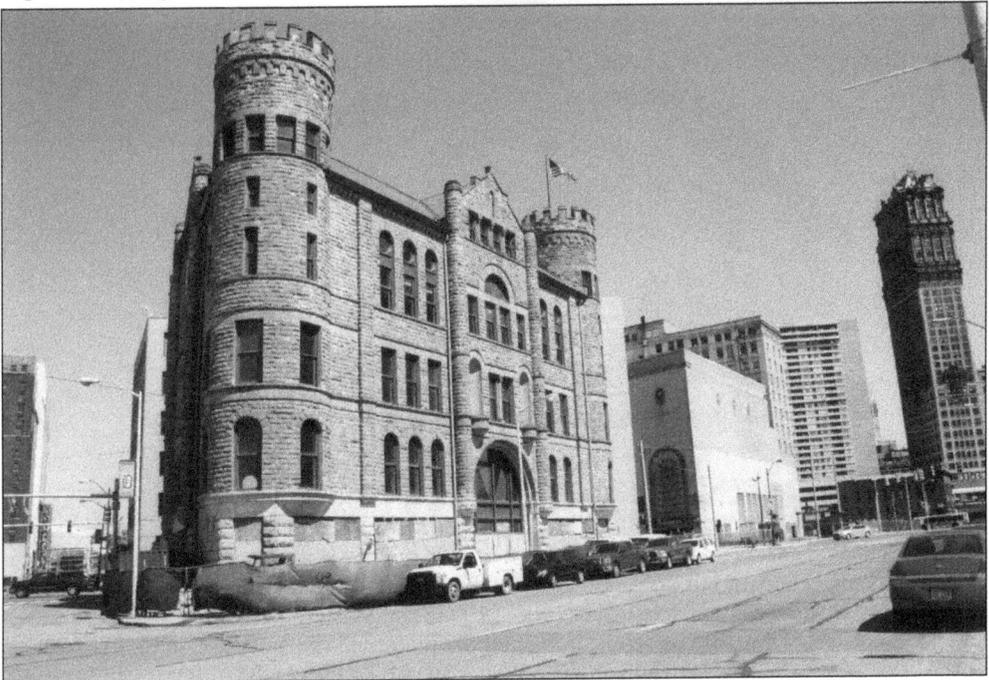

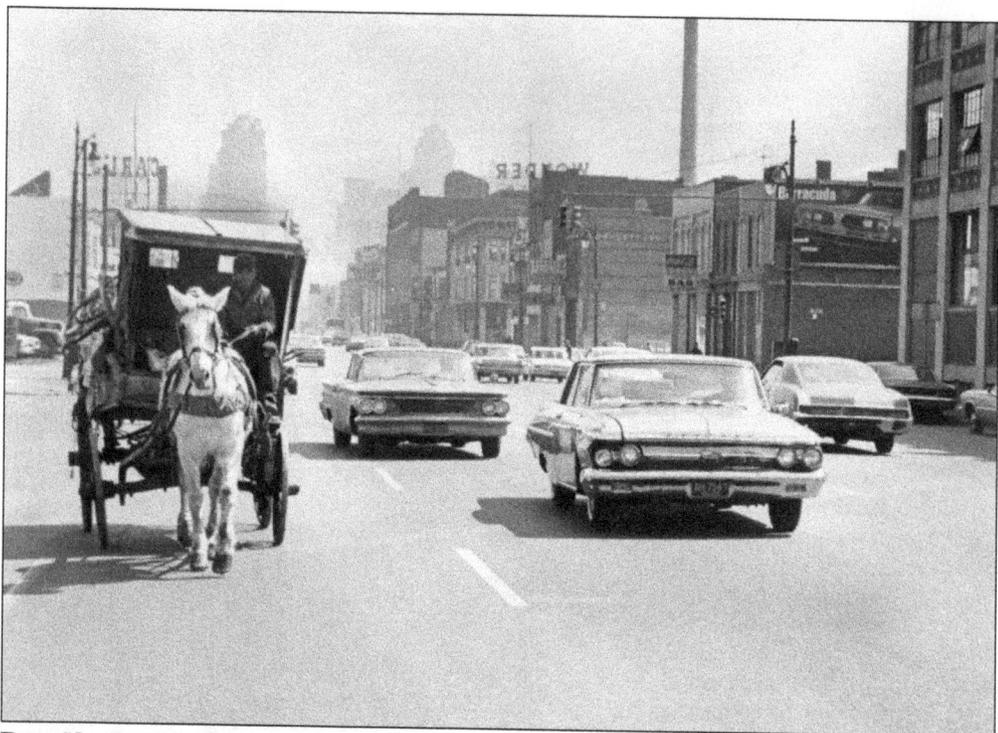

DÉJÀ VU. Tottering along in the slow lane of Grand River Avenue, a solitary junkman shares the old trail with Detroit automobile traffic in 1967. Once a familiar sight, horse-drawn junk wagons were nearly extinct by the time this photograph was taken. Note the sign for Carl's Chop House in the background, just above the wagon, and the old Wonder Bread sign peeking over the buildings at center.

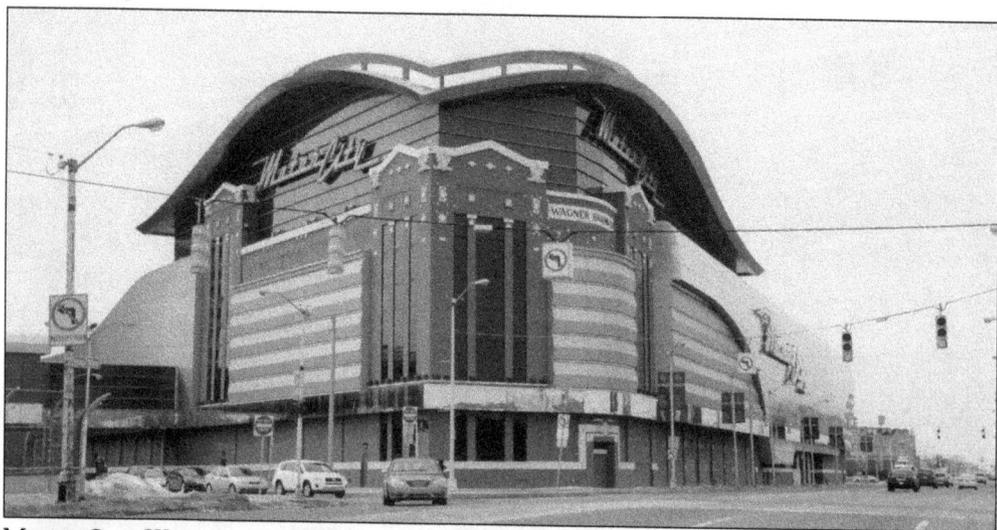

MOTOR CITY WONDER. The Wonder Bread sign seen in the previous image once stood above the Wagner Baking Company building, now completely renovated and repurposed as Detroit's Motor City Casino, featuring an adjacent full-service, 400-room, 33-suite hotel. The casino is one of three located in Detroit, and its renovation carefully preserved the aesthetic architectural lines of the original building, designed in 1915 by Walter W. Ahlschlager (1887–1965).

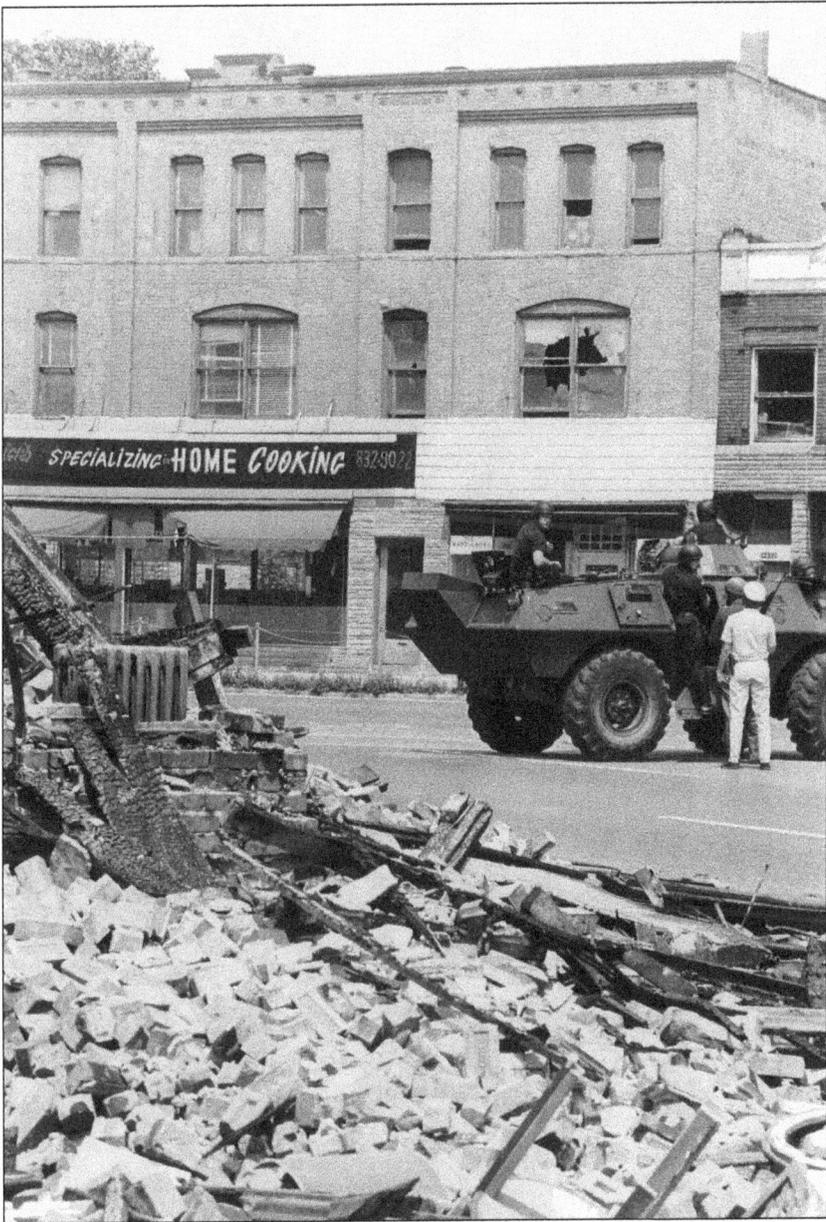

MOTOR CITY BURNING. Soldiers wait out a rooftop sniper at the corner of Grand River Avenue and Fourteenth Street during the 1967 riots. Detroit had once been a hotbed of abolitionism and a final destination along the Underground Railroad. By the mid-1920s, it had become one of America's most segregated cities, often policed with racially motivated brutality and governed by secret real estate covenants. It was only a matter of time before unrest led to bloodshed and rioting. In 1925, when physician Dr. Ossian Sweet, an African American, attempted to move into a home he had purchased in a neighborhood that had been secretly designated "white only," vandalism, threats, and aggravated assault eventually resulted in death. The great trial lawyer Clarence Darrow was called to Detroit to defend Dr. Sweet and his family and put an end to the racist real estate covenants. Unfortunately, the brutality and unrest continued, with devastating race riots breaking out in Detroit in 1943 and again in 1967.

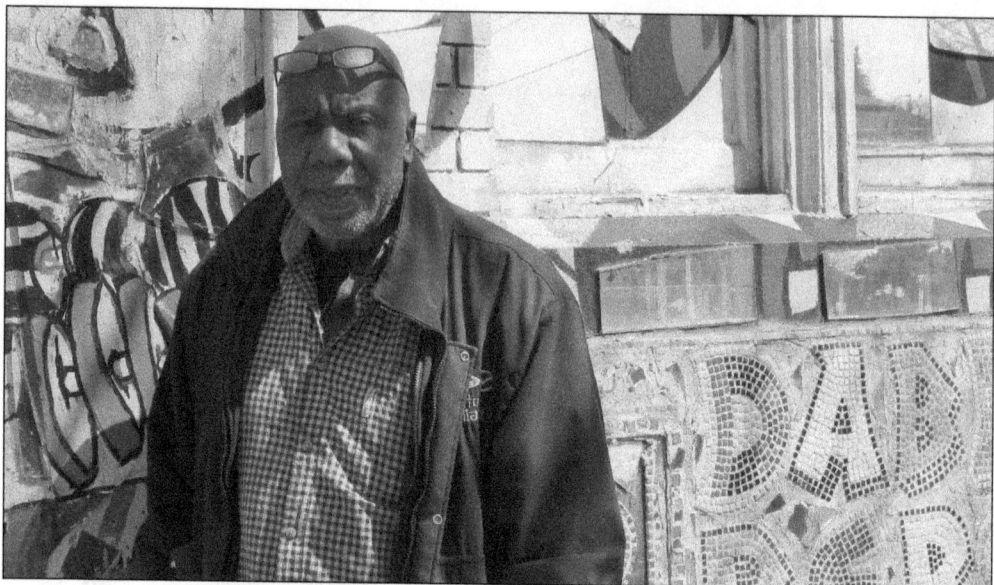

GLOWING. One of the most spectacular (and shiny) buildings on Grand River is a museum where visitors can buy art. The curator, collector, proprietor, and heart and soul of the MBAD African Bead Museum, "Where African Town Begins," is Olayami Dabls. The winner of a Kresge Art Fellowship, Dabls started painting as therapy after an accident. He began decorating the outside of his gallery in 1983 with recycled materials, including sculptures, a stage, and a 150-foot wall covered with words from 24 African languages. Inside, his beads are not just beautiful, they are authentic and instructional; beads were an important part of African trade and culture. "Beads are really like textbooks to us," he says. Visitors sometimes even hear someone playing the kora, in addition to buying beads and, more importantly, meeting Dabls and truly learning about Africa.

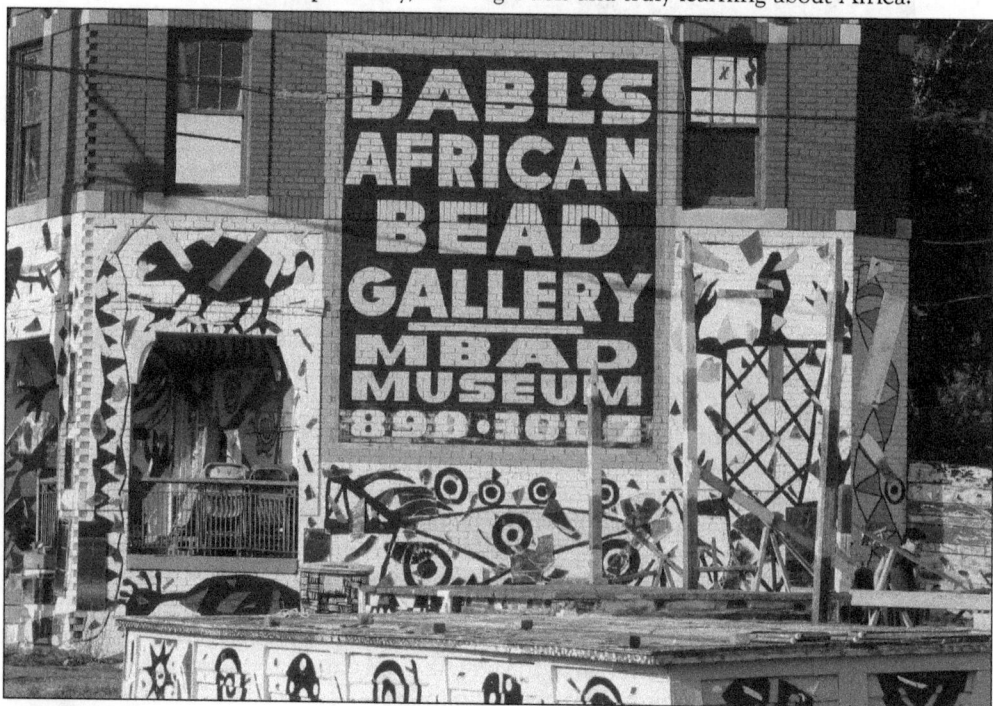

ROCK, ROLL, AND RUIN. The unparalleled history of Detroit's Grande Ballroom can hardly be discerned by the ruins that now stand along Grand River (above). Built in 1928, it was not one of Detroit's premier ballrooms, but, in the mid-1960s, DJ and concert promoter Russ Gibb transformed it into one of the most important venues in rock 'n' roll history. With an eye on promoting emerging bands and psychedelic music, Gibb worked with John Sinclair and Hugh "Jeep" Holland to bring in some of the greatest acts of all time. The house bands included the MC5 and Iggy and the Stooges, and the incredible list of performers includes Janis Joplin, Pink Floyd, the Grateful Dead, and Led Zeppelin. While still a teen, celebrated photographer Joe Crachiola captured the action photograph below of the Who performing at the Grande in the late 1960s. More information on Crachiola is available at www.crachiola.com.

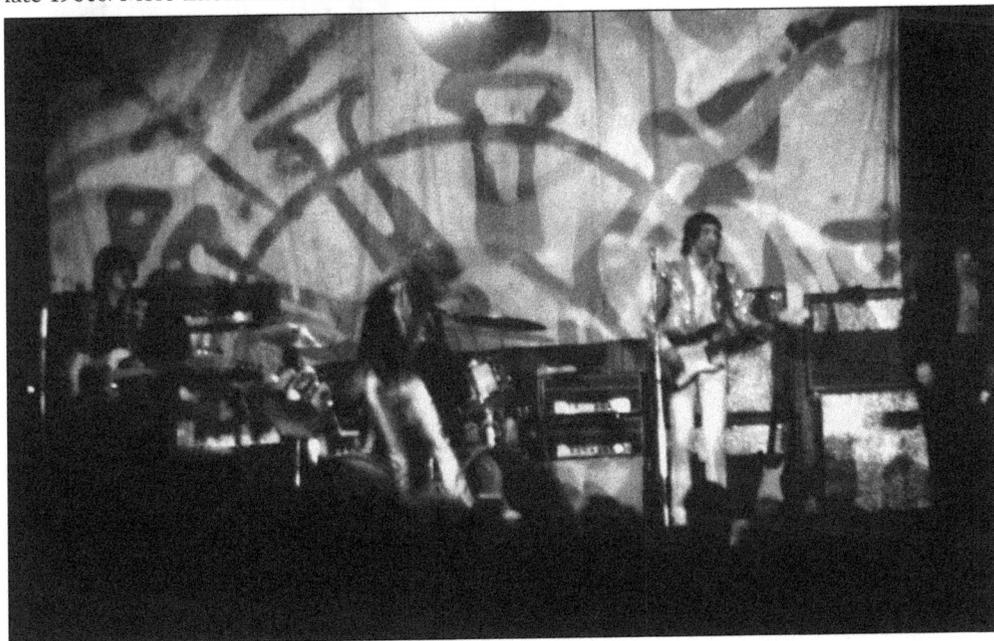

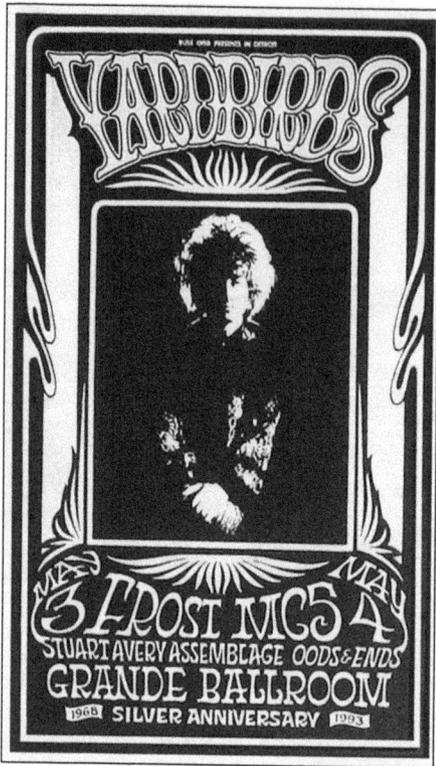

THE ART OF PEACE AND ROCK 'N' ROLL. Gary Grimshaw (1946–2014) grew up just outside of Detroit and displayed a talent for drawing at an early age. Prime age for the draft during the Vietnam era, he opted to join the Navy and was stationed in California, where he took in concerts at the Fillmore and was inspired by the artwork of the emerging psychedelic rock genre. In 1966, he was commissioned to do a poster for Detroit's Grande Ballroom for a concert by the MC5. Soon, the Grimshaw style, along with that of fellow artist Carl Lundgren, became unmistakably identified with the Grande. A lifelong activist, Grimshaw dedicated his life and talent to advocating peace and combating social injustice. In 1971, he created the classic poster for the John Sinclair Freedom Rally. Over the years, he created artwork for Jimi Hendrix, the Who, Buddy Guy, the B-52s, and many more. An incredible talent, Grimshaw added his indelible signature to a turbulent era and an entire genre of popular American music. More information is available at www. garygrimshaw.org. (Left, art by Gary Grimshaw.)

OLYMPIA. One of the most familiar structures that ever graced Grand River Avenue was Olympia Arena, the original home of the Detroit Red Wings hockey team—one of the "original six." Built in 1926, the "Old Red Barn" was used for many sporting and music events. The Beatles performed there in 1964 and 1966, and it was home to the Detroit Pistons basketball team between 1957 and 1961. The arena was demolished in 1987.

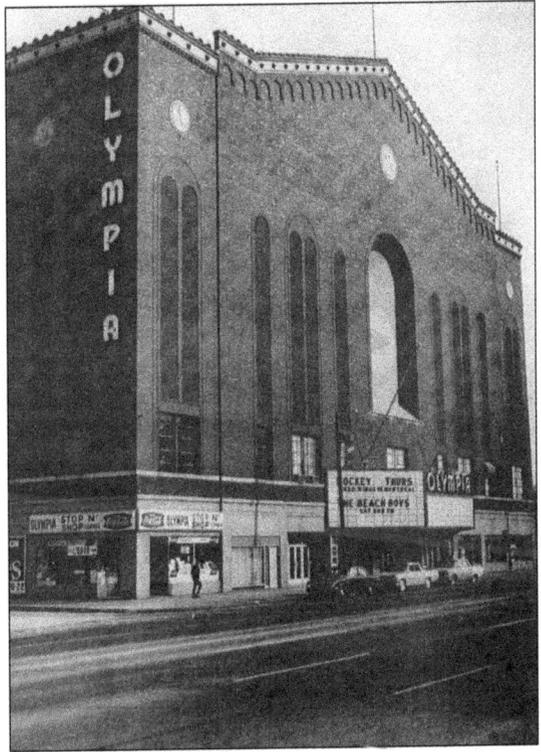

THE GRAND RIVIERA. Many people still fondly remember the Grand Riviera Theatre, one of Detroit's most opulent movie palaces. Designed by John Eberson and built in 1925 at a cost exceeding $1 million, the massive theater originally seated 3,000 patrons and was soon expanded to accommodate a total of 4,800. It was converted to a live theater in the 1950s, but it ultimately fell into disuse and was abandoned. Sadly, it was demolished in 1996.

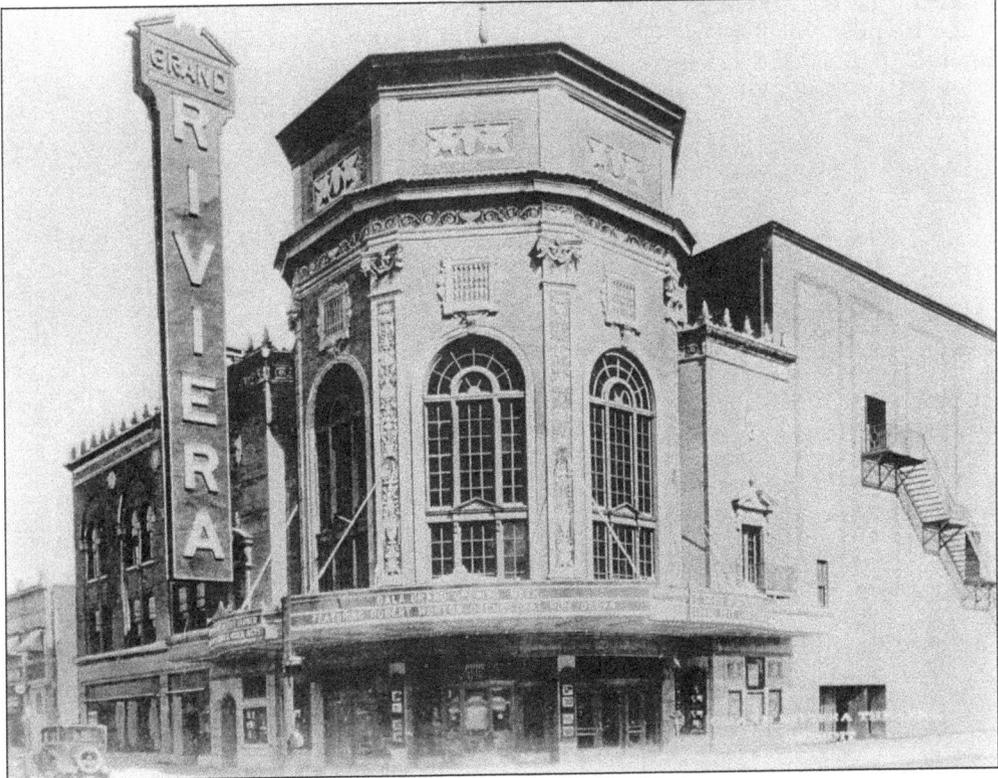

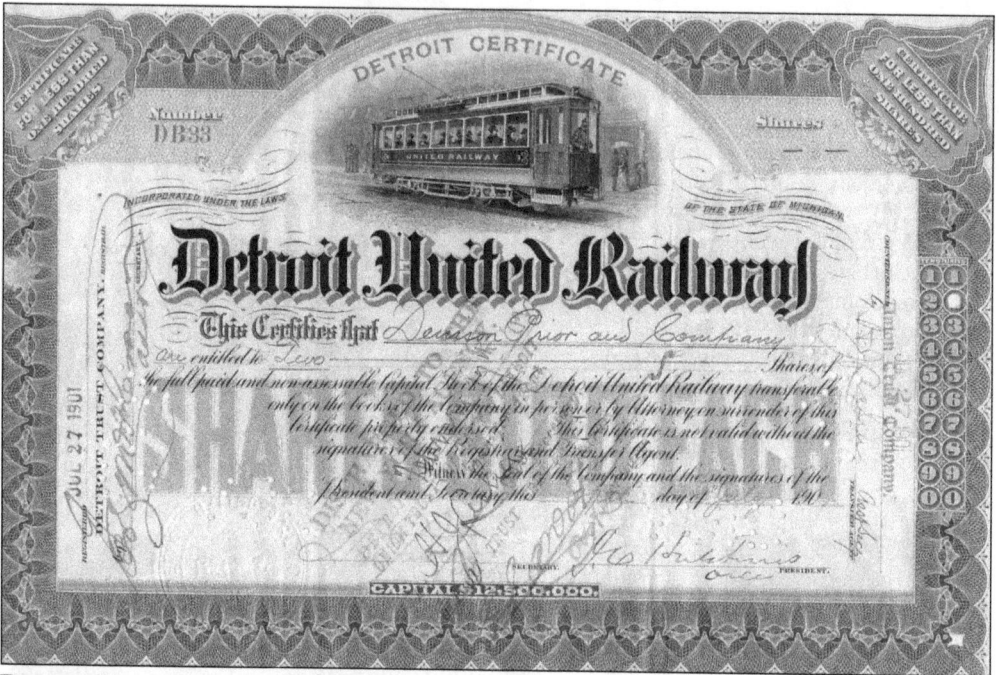

DETROIT UNITED RAILWAY. Beyond the northern stretches of Detroit's "New Center" area, Grand River Avenue continues on into the urban and suburban stretches of Redford. As transportation evolved from horseback to automobile, one emerging solution for traveling between Detroit and its outer limits was the Detroit United Railway (DUR) interurban. From 1900 through the early 1920s, travelers could "sail" up Grand River on a DUR train via the Orchard Lake Division. (Courtesy of Brian M. Golden.)

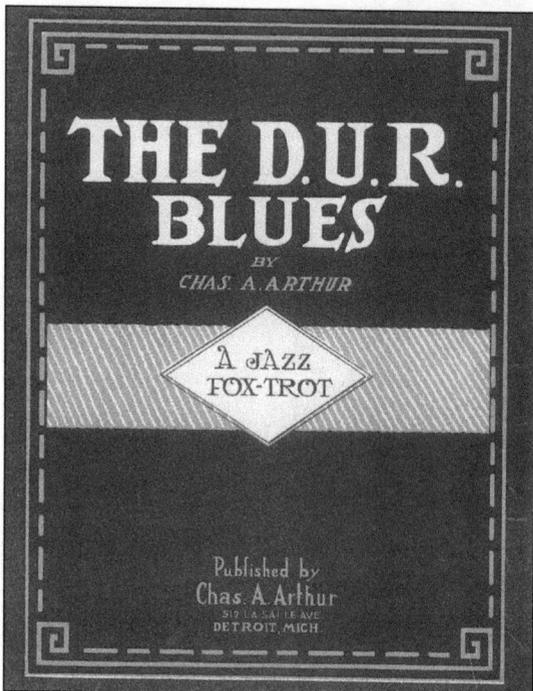

TRAIN RIDE BLUES. For a time, the DUR seemed a perfect solution for getting in and around the city, especially for folks without the means to buy an automobile. In 1919, when "The D.U.R. Blues" was published, interurban service was a popular choice. Sadly, the composition was not, and the sheet music is quite rare today. While not actually a blues number, or even remotely sad, the semi-descriptive piano piece does include some melodic and rhythmic train-like ornamentation. (Courtesy of Terry Parrish.)

THE RED FORD. Northwest of Detroit, the Grand River Trail crosses the River Rouge (from the French for "red") at a point where the river often runs shallow and was easily forded by Native Americans and early settlers. For that reason, it was known as the Red Ford, or Redford. Local historian Fred DesAutels identifies the stretch of the river above as alongside Berg Road, north of Grand River Avenue and south of Seven Mile.

PLANKS ALONG THE TRAIL. In 1850, the Michigan Plank Road Act allowed for the creation of a plank road along the Grand River Trail. The Detroit and Howell Plank Road, seen here, linked to the Howell and Lansing Plank Road, completing a route between Detroit and Lansing. Plank roads were literally dirt roads covered with wooden planks, creating a more passable roadway. (Courtesy of Brian M. Golden.)

Tollhouses and Ticket Takers. Converting the Grand River Trail into plank roads made for a smoother and better-maintained road, but it was not without cost. The newly surfaced plank roads were also toll roads, with tollhouses stationed at intervals along the route. The rare photograph above shows a tollhouse along the Detroit to Howell Plank Road (later Grand River Avenue) near Inkster Road. At the time of the photograph, the plank road was no longer being maintained, and residents are seen using the keeper's platform as a shaded porch. Much like tickets used on modern-day turnpikes, the plank roads' toll tickets and tally cards (below) were handed out to travelers at their first entrance point and turned in to the last gatekeeper they encountered before leaving the roadway. (Both, courtesy of Brian M. Golden.)

Toll ticket and tally card for the Detroit and Howell Plank Road

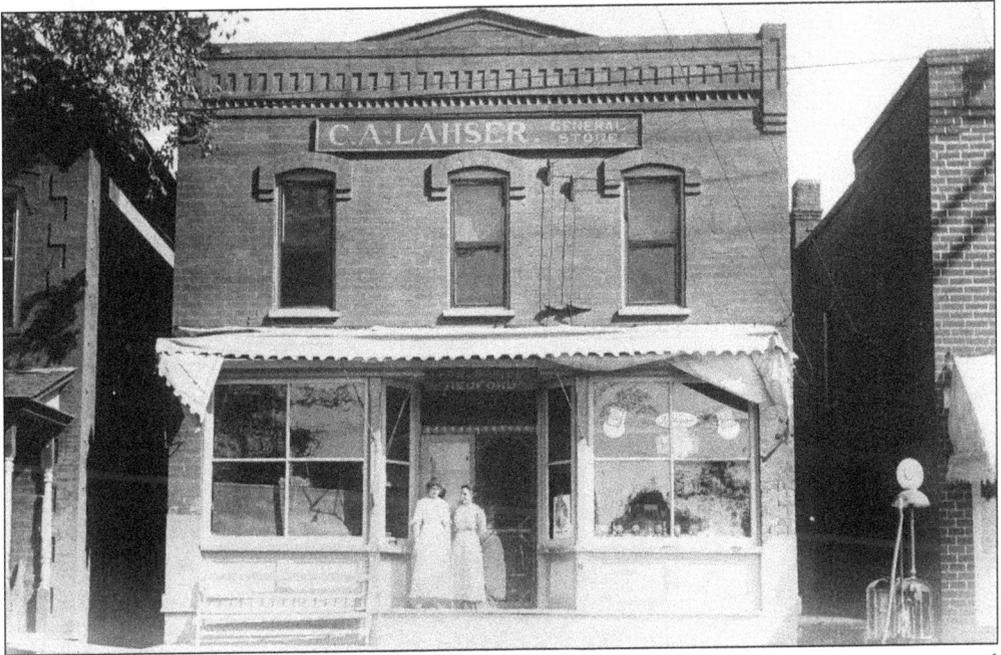

"YOU SAY LAHSER AND I SAY LASHER." The pronunciation of Lahser Road remains a regional toss-up. Technically, the *h* comes before the *s*, as in "ahs," rather than creating the shushing sound of "sh," but, regardless, the road name has divided people along Grand River Avenue in Redford since the 19th century, when Charles Lahser settled in the area around 1849. His son Charles Jr. opened a general store, seen above, that stood near the corner of Grand River and the street bearing the family name. The entire block along Grand River and Lahser is seen below, with the Hawthorne House on the corner at left, next to Lahser's Store, Burgess Hardware, and Davidson's Harness Shop. Most of the structures pictured here were destroyed by fire in 1914.

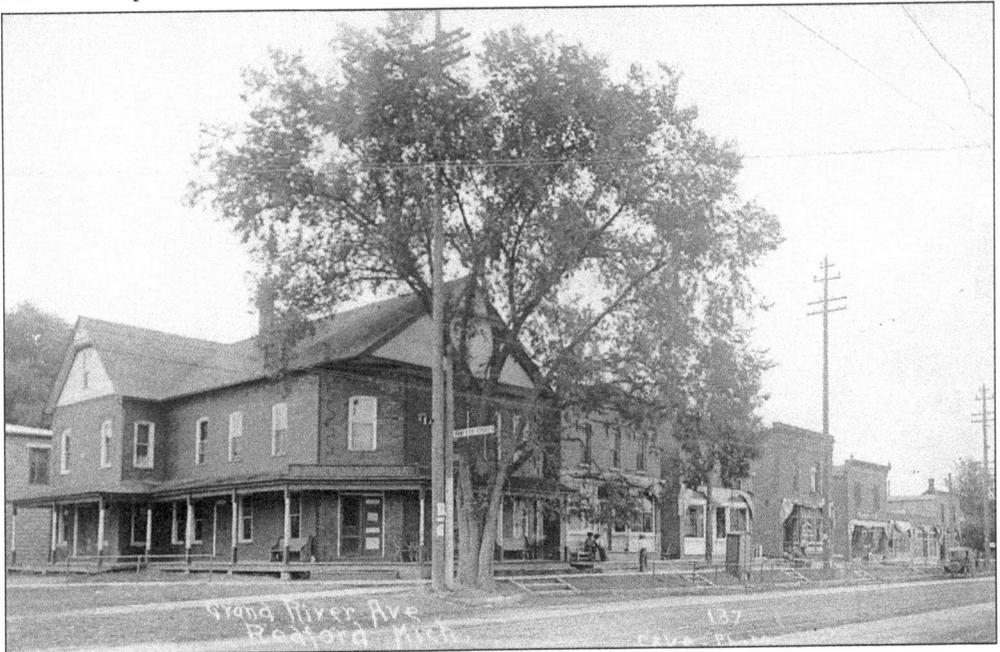

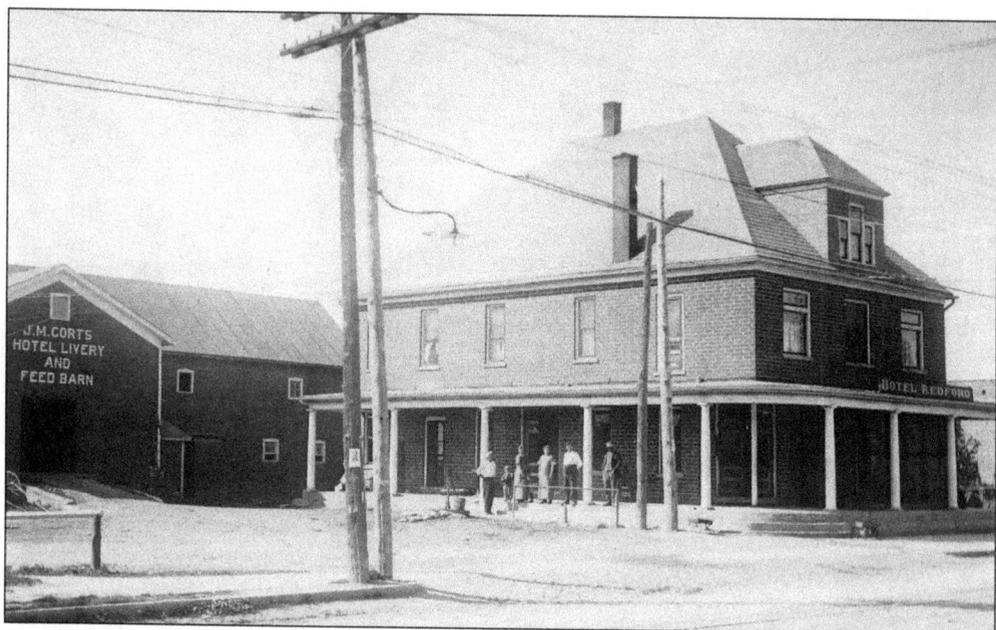

EVERYTHING FOR THE TRAVELER BY HORSE OR RAIL. Just across the street from the Hawthorne House and Lahser's Store was the Hotel Redford (above), a comfortable-looking old brick farmhouse with a wraparound porch that stood on the southwest corner of Lahser Road and Grand River Avenue. Judging from the photograph, overnight guests arriving by carriage or on horseback were undoubtedly served by the J.M. Corts Hotel Livery and Feed Barn next door. But, by this time, Redford had a foothold in the 20th century, and travelers along Grand River Avenue were just as likely to opt for train travel, as evidenced by the tracks of the Detroit United Railway's Orchard Lake Division (below) running down the center of Grand River. This service directly connected Redford with Detroit to the east and Farmington to the west.

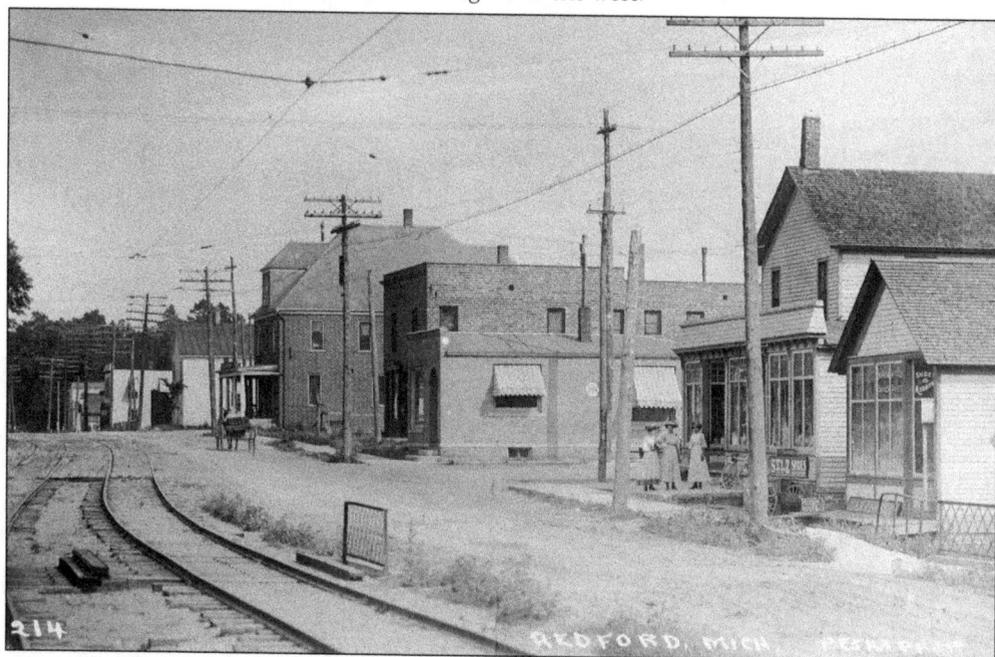

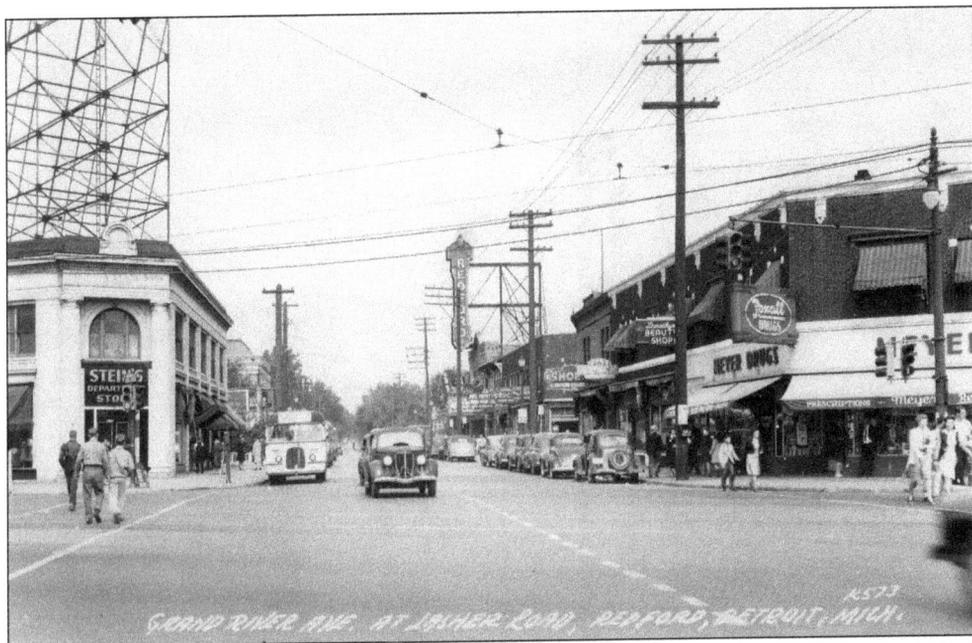

HELD OVER. The city of Redford is a bustling place in the photograph above, taken around 1940 at the corner of Grand River Avenue and Lahser Road. In the background, just a few doors beyond the corner, the prominent blade sign of the Redford Theatre towers over its marquee. Built in 1928, it continues to operate as an entertainment venue in the present day, a proud and majestic survivor of the golden age of movie palaces. Added to the National Register of Historic Places in 1985, the theater, pictured below, is now owned and maintained by the Motor City Theatre Organ Society (MCTOS) and is home to its 3 Manual/10 Rank Barton Theatre Pipe Organ.

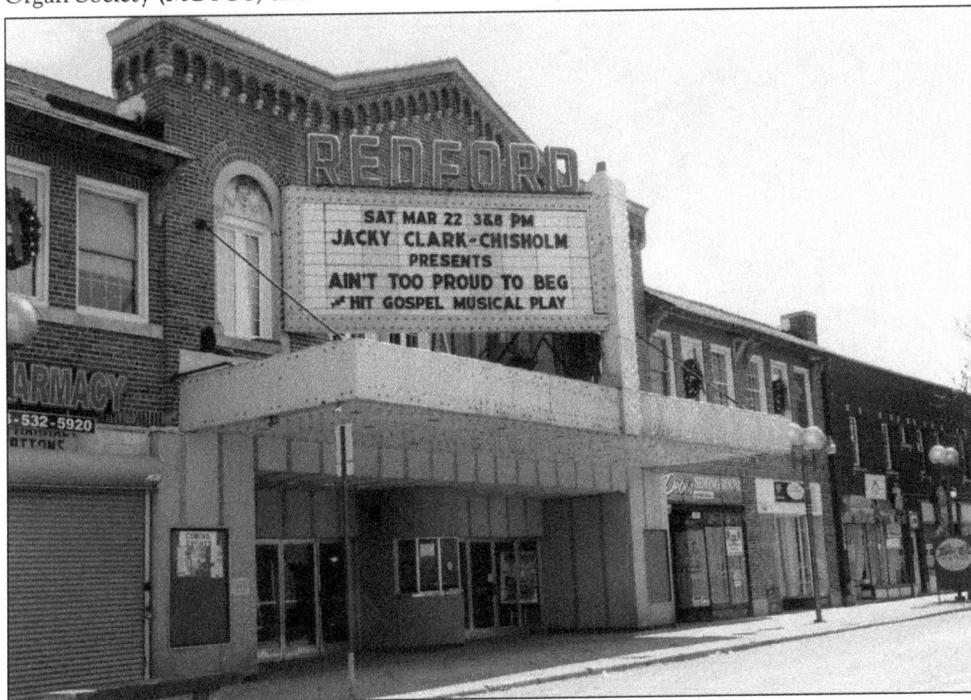

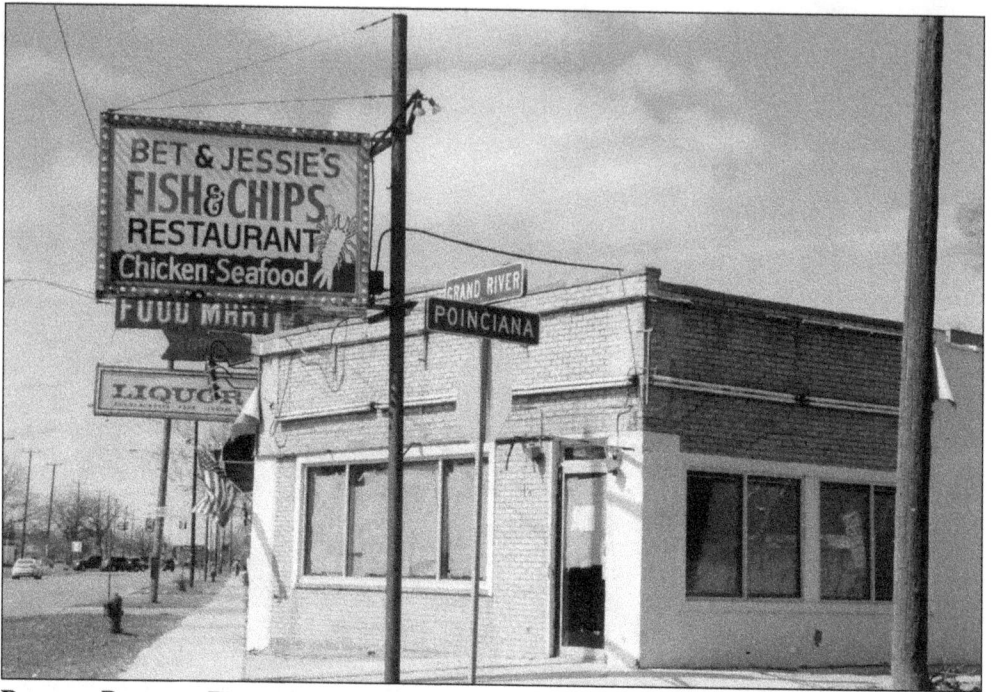

REDFORD ROADSIDE DINING. Travelers along Grand River Avenue through Redford can still grab a taste of roadside America by stopping in at one of the surviving eateries long associated with cruising "the old strip." While the Embers and Bet and Jesse's (above) are long gone, one can still enjoy great old family fare at the Canterbury Palace, have a big Italian meal at Mama Mia's, or head for a snack under the giant hot dog at Hefty's (below). While they are all within a mile of Inkster Road, they came a bit too late for the travelers stopping by the tollgate seen on page 34.

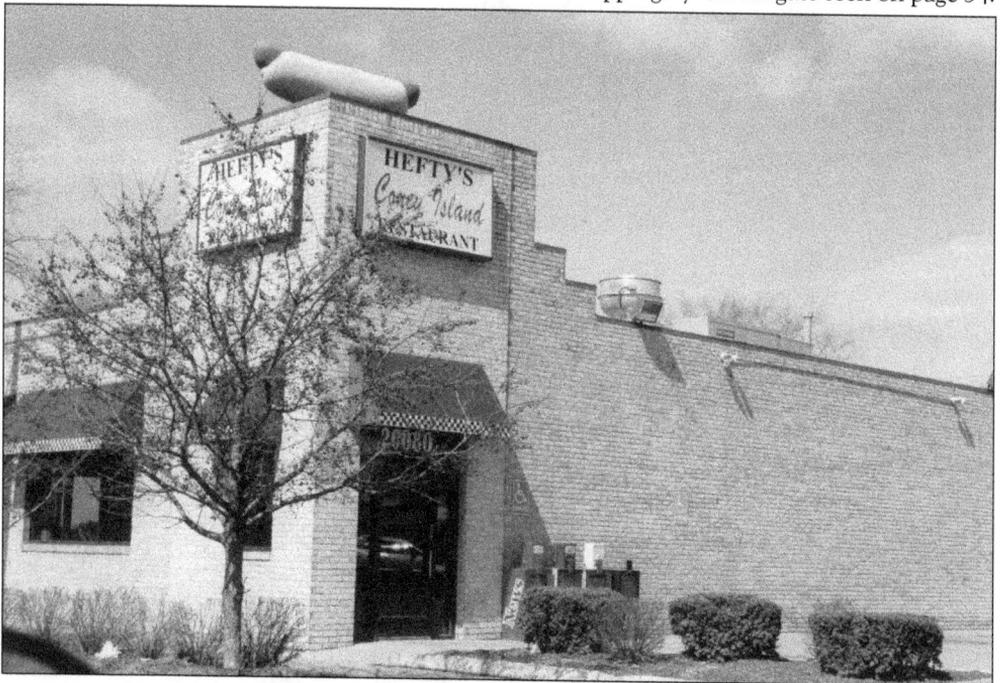

Three

OAKLAND COUNTY

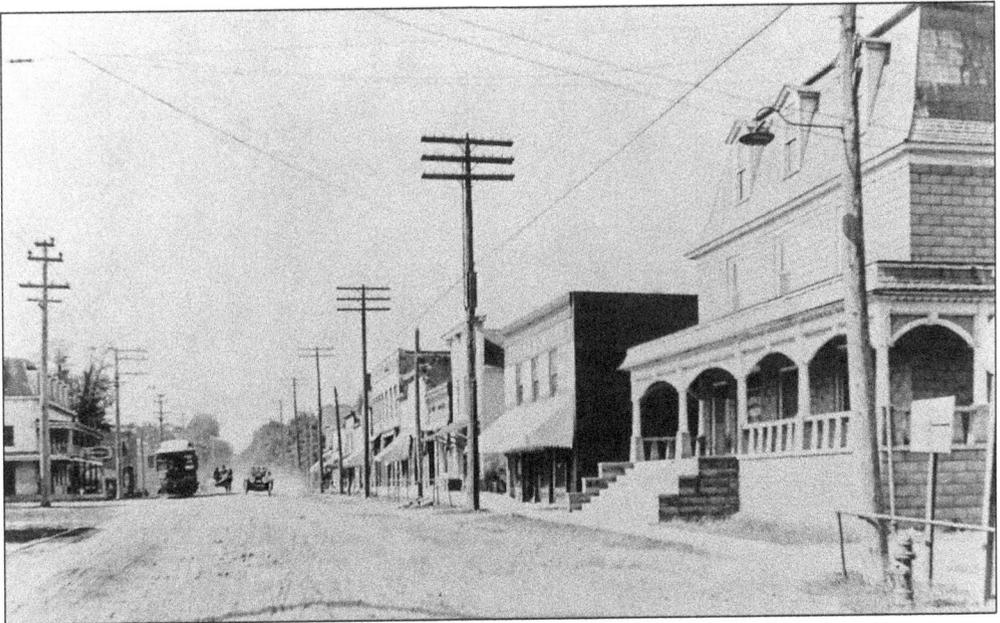

THREE OF A KIND. This early-1920s photograph of Grand River Avenue in downtown Farmington has the rare distinction of capturing all three of the common modes of travel (other than walking) used at the time. The electric interurban trolley is seen at left, with a horse-drawn carriage and an automobile keeping pace alongside. Concerning the three, Farmington historian Brian M. Golden is quick to point out that "only one is pollution-free and doesn't eat oats!"

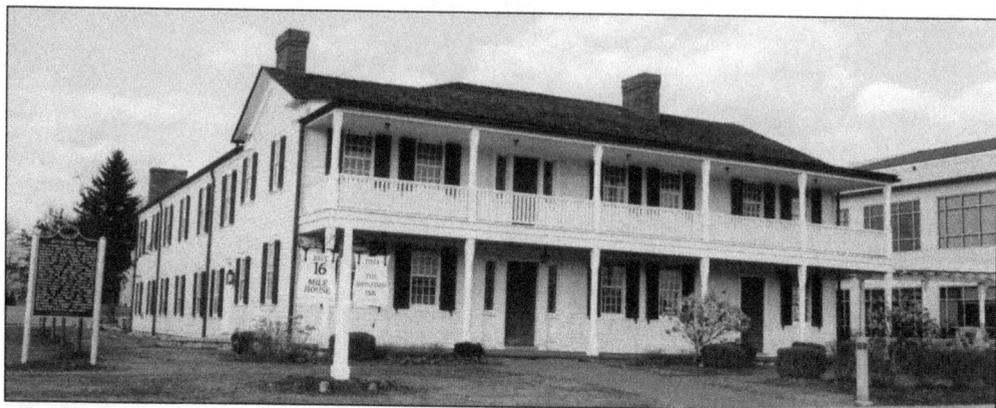

THE BOTSFORD INN. In 1833, an inn was built along the Grand River Trail near Farmington. Originally known as the Sixteen Mile House on Indian Trail, it was purchased by Milton Botsford in 1860. During the time Henry Ford was courting Clara Bryant, it was one of their favorite places to go for an evening's entertainment and dancing. Ford later bought the inn and considered moving it to his Greenfield Village historical park, but left it in Farmington and maintained it as an inn and restaurant for the rest of his life. In later years, the Anhut family operated the historic inn until well into the 1990s. Today (above), it is in the National Register of Historic Places and is part of the Botsford Hospital Complex. The exterior has been restored to its 1900 appearance, and the hospital is currently seeking funds to restore the interior as well. The commemorative ashtray (below) was once a popular item sold in the Botsford Inn gift shop.

Botsford Inn

SINCE 1836

FARMINGTON, MICH.

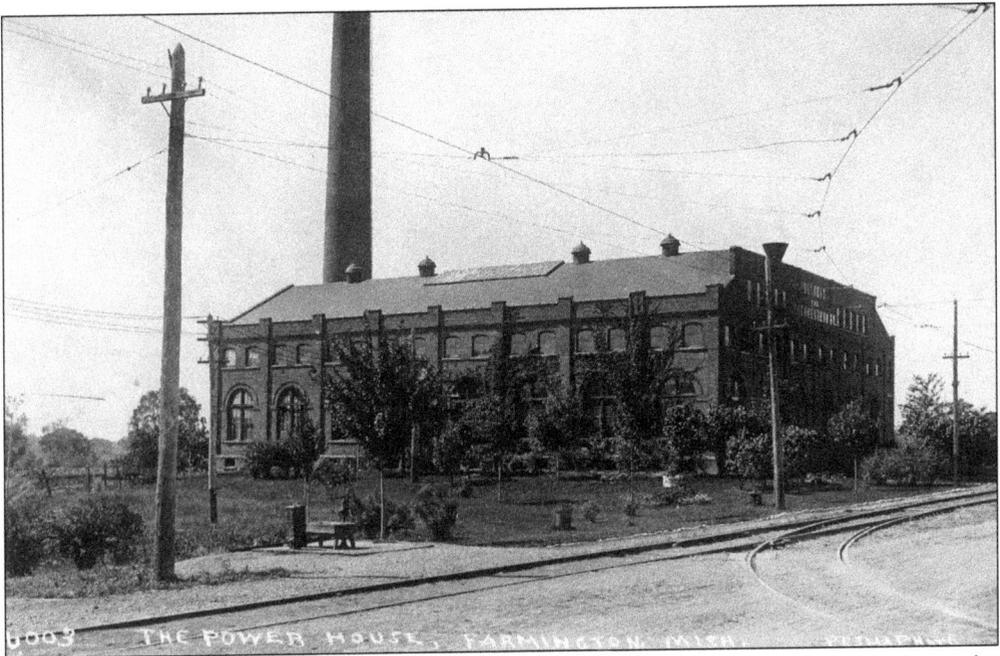

THE DUR AND FARMINGTON. Two structures of the Detroit Urban Railroad were erected near the convergence of Grand River Avenue and Orchard Lake Road (a modern-day interpretation of the Native American Orchard Lake Trail). The powerhouse (above) was built in 1899 to accommodate interurban service from Detroit into Farmington and Northville, and also along the Orchard Lake Route to Pontiac. One line branched north, up Orchard Lake Road, while the other continued west, along Grand River, into downtown Farmington. The massive DUR powerhouse still stands and is today used for private office space. Directly across the street from the powerhouse stood the DUR carbarn (below). This structure was used primarily for storing the 60-foot-long interurban cars, one of which is seen just below the water tower, and is no longer extant.

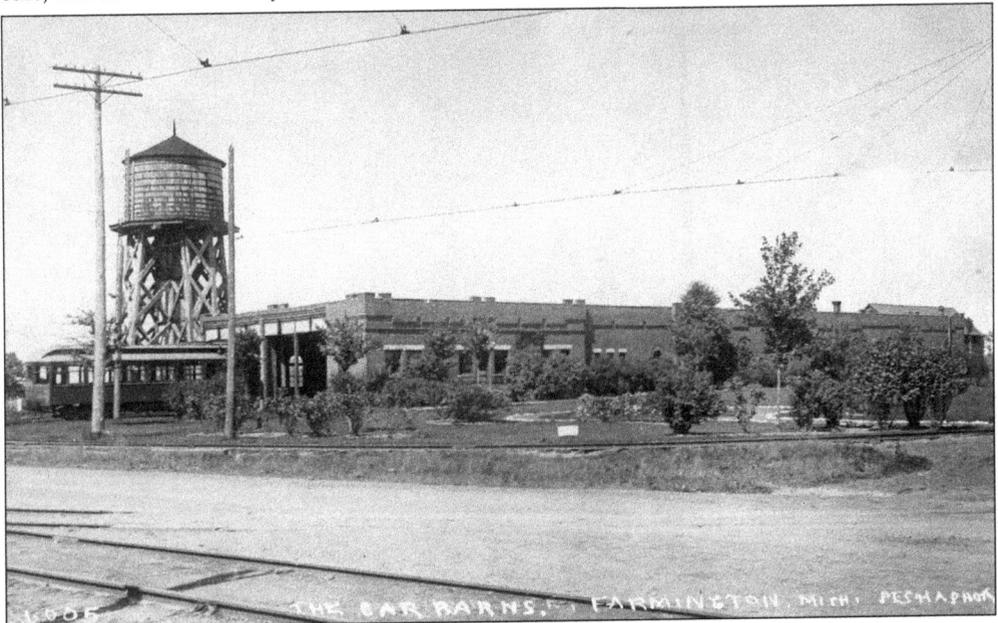

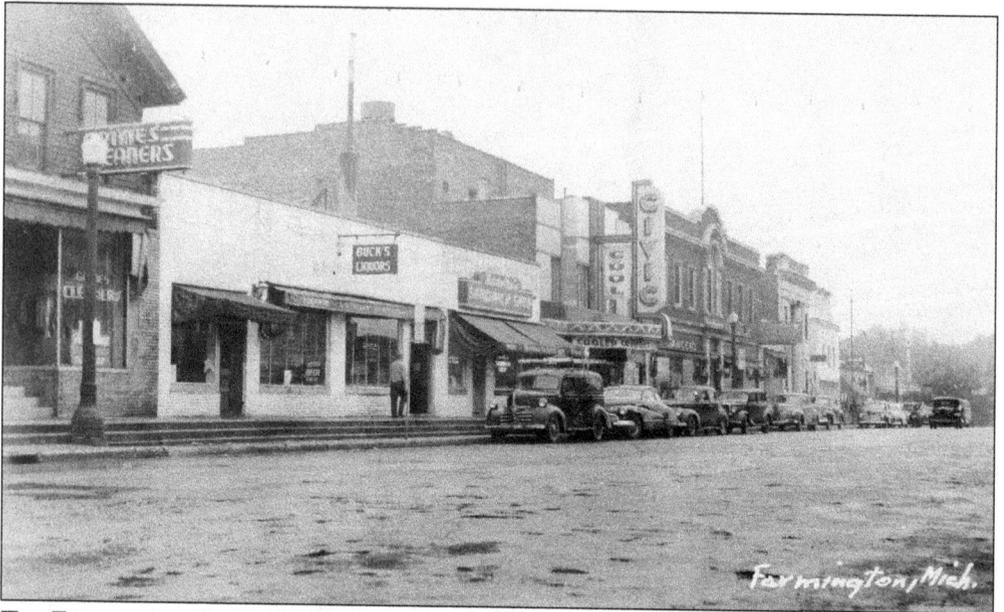

THE FARMINGTON STORY. Farmington was settled in 1824 by Quakers, who initially named the place Quakertown. But, since they were also from Farmington, New York, it was eventually decided that the place ought to be called Farmington instead. Today, despite being in a busy Detroit corridor, downtown Farmington (seen above around 1946) still maintains much of its historic, small-town charm. Most of the buildings in the photograph still stand, and the Civic Theatre (center), built in 1940, is still a popular moviegoing destination. Directly across the street (in the 1914 photograph below), the DUR interurban makes a stop at the Owen House Hotel. According to Brian M. Golden, the main room at the popular hotel's entrance functioned as a lobby as well as a waiting room for the DUR.

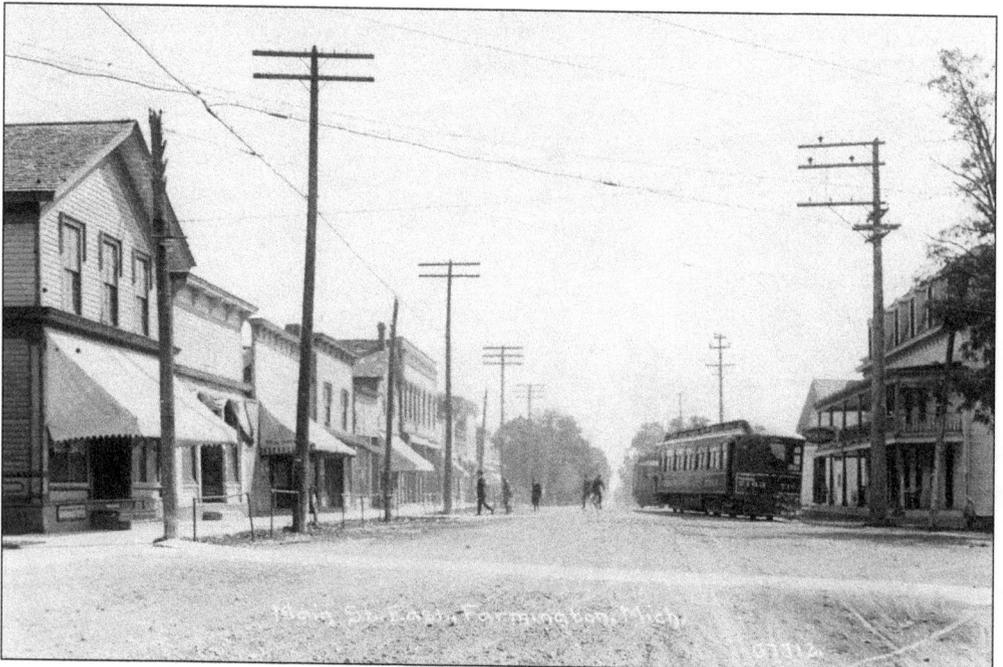

ANCIENT INDIAN TRAIL in FARMINGTON

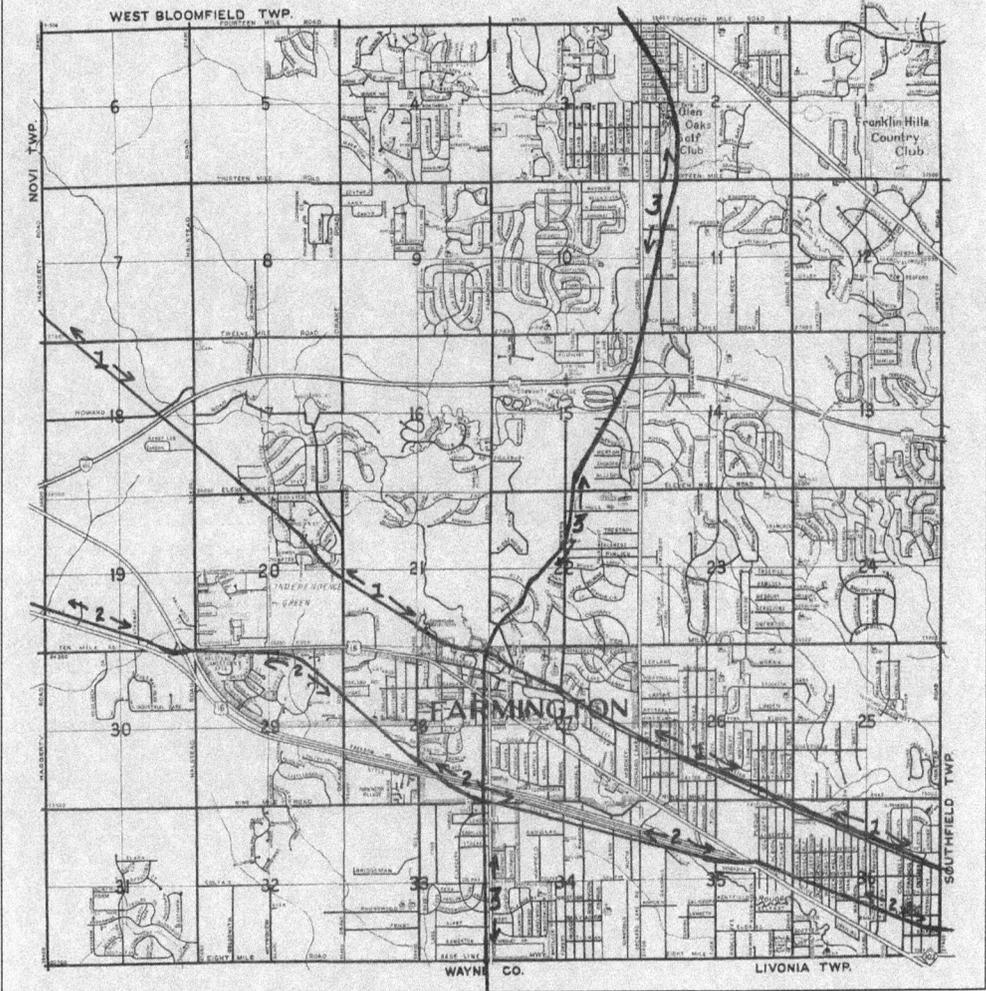

THREE TRAILS, NO WAITING. Farmington was a central crossroads for three important Native American trails—the Grand River Trail, the Orchard Lake Trail, and the Shiawassee Trail. In this map, three trails are highlighted and numbered. The Grand River Trail is designated as trail no. 2, and it varies only slightly from the roadway that went into downtown Farmington. Trail no. 1 is the Shiawassee Trail, which ran parallel to the Grand River Trail in this region, while the Orchard Lake Trail (trail no. 3) crosses the Shiawassee Trail just north of town and the Grand River Trail just south of town.

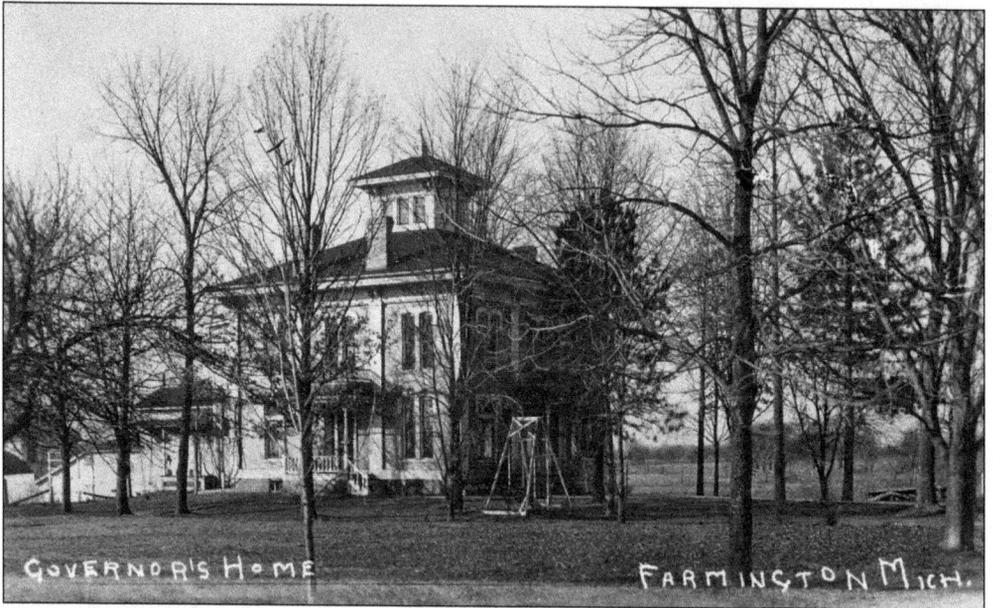

GOVERNOR'S HOME — FARMINGTON MICH.

GOVERNOR WARNER AND THE FARMINGTON CURVE. Farmington was once home to Michigan governor Fred M. Warner (1865–1923). His beautiful mansion and grounds (above) still stand along Grand River Avenue and were donated to the city by the governor's grandchildren in 1980. Today, the Warner Mansion is maintained as a public museum with permanent and rotating exhibits. The Lee Block (below), once home to the Lee Harness Shop, stands at the southwest corner of Grand River Avenue and Division Street (now Farmington Road). The interurban ran behind this building to serve the dual purpose of completing a wider turn than the narrow corner made possible while accommodating the needs of the flour mill and freight house behind the harness shop. From here, the interurban ran south along Division Street to Base Line Road (Eight Mile Road) and then headed west to Griswold before running south to the Northville station.

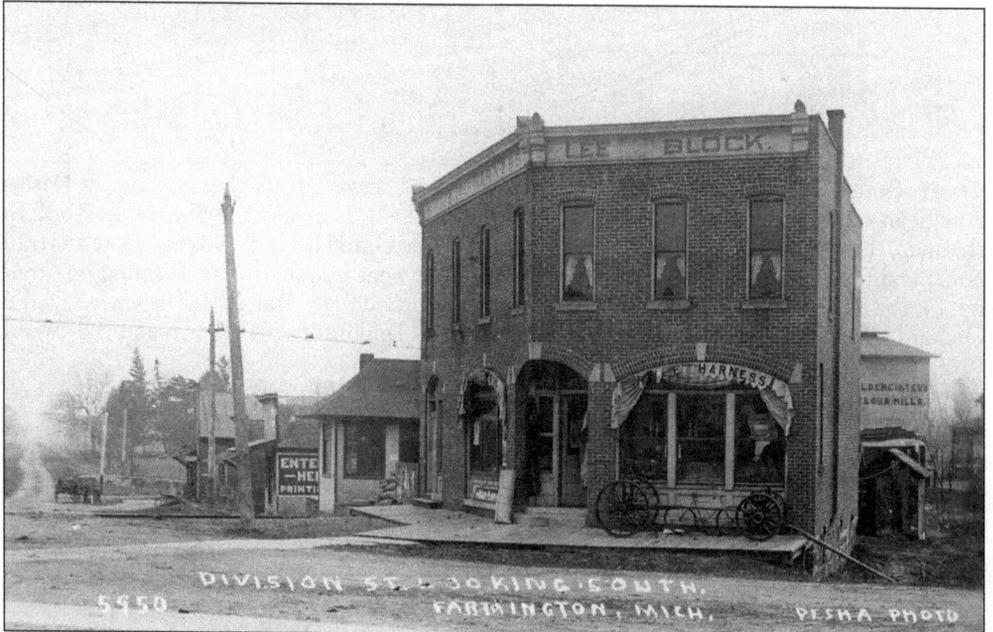

DIVISION ST. LOOKING SOUTH. FARMINGTON, MICH. PESHA PHOTO

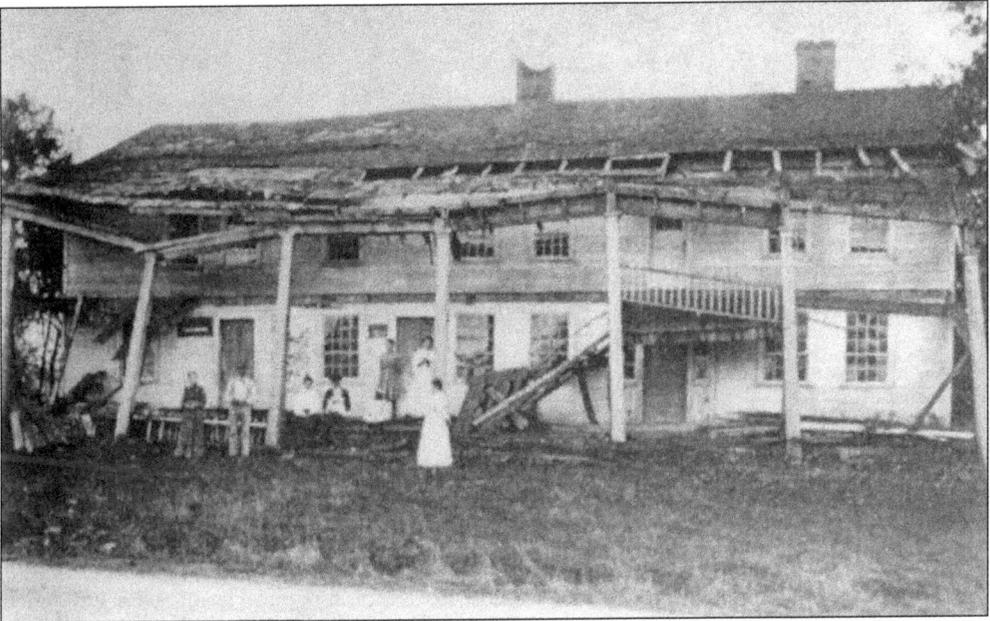

WALKER-WIXOM INN. By the late 1830s, there were two hostelries located along the Grand River Trail in Farmington. Along with the Botsford Inn, there was the Walker, or Walker-Wixom, Inn, which stood near the corner of Grand River Avenue and Halstead Road. In 1827, Solomon Walker constructed a log tavern on the site; by 1830, he had replaced it with an inn suitable for overnight lodging. By the 1840s, it had been acquired by the Wixom family. After the days of the plank road and stagecoach service, traffic along the Grand River route dwindled, and it became a private home for the Wixom family. By the late 19th century, it was in ruins (above) and was ultimately demolished in the early years of the 20th century. Though the inn is just a memory, Farmington historian and model railroader Brian M. Golden has produced an HO scale model of the Wixom Inn (below).

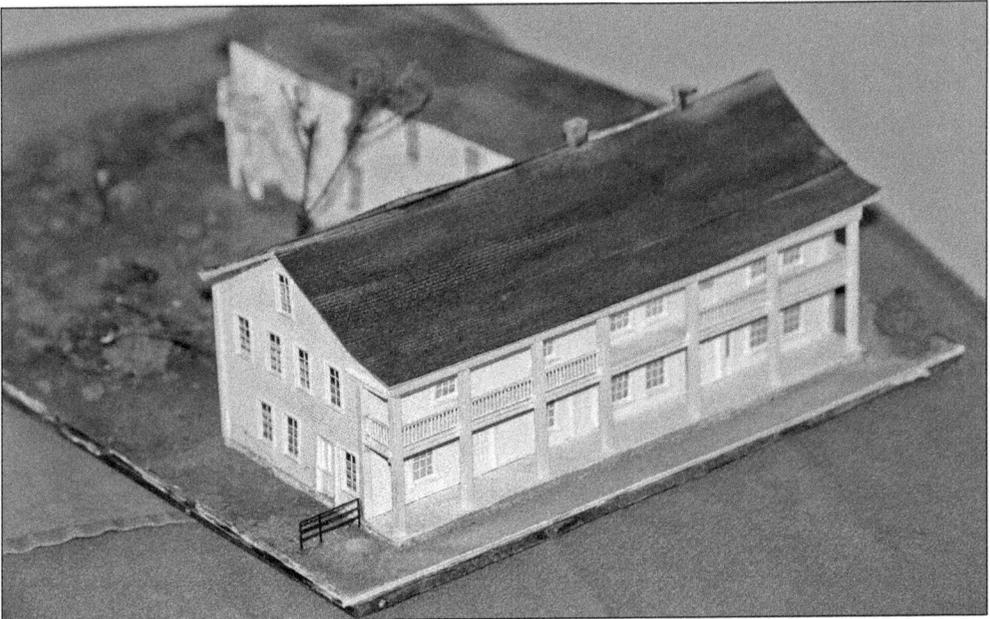

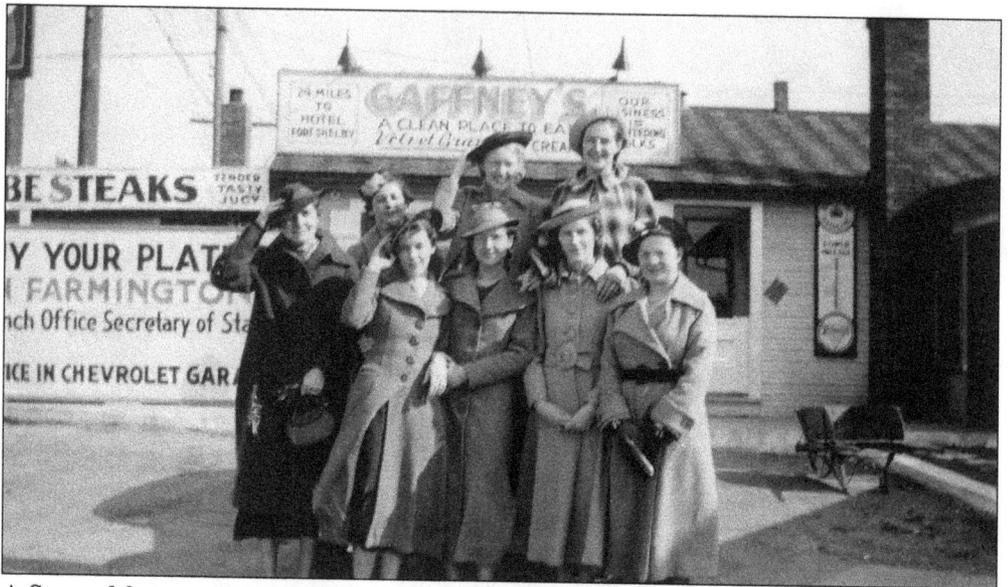

A SENIOR MOMENT. Wisconsin high school seniors stop off along Grand River Avenue to lunch at Gaffney's, near Novi, in 1937. According to a note written on the back, the girls were on a senior trip to Detroit on what looks to be a blustery spring day. The signs behind them entreat passersby to "Buy Your [License] Plates in Farmington" (maybe the lines were shorter) and politely suggest an overnight stay at Detroit's Fort Shelby Hotel—only 24 miles away.

NOT NO. 6. Legend suggests that Novi was named for the Roman numeral VI, as it was either the No. 6 plank road gatehouse, the sixth stop along the railroad, or the sixth stagecoach stop. This is only an urban legend; no plank road, stage stop, or railroad existed here when Novi was established in 1832. The city's name was suggested by a Mrs J.C. Emery, who read about the Serbian city Novi Sad (roughly translating to "New Garden") and liked the name.

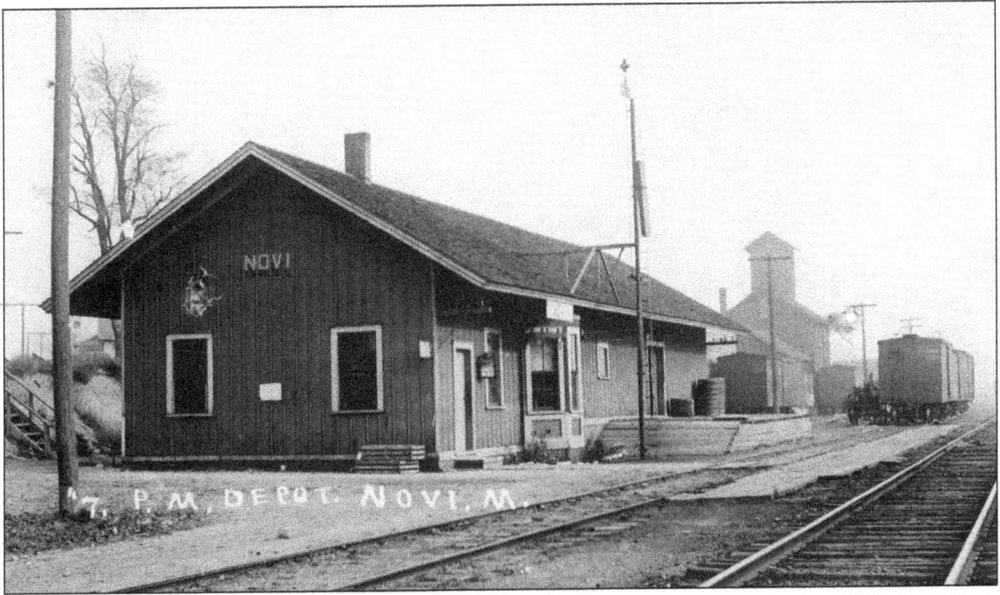

NOVI AND THE US 16 BRIDGE. When first established, Farmington Township included Novi, Wixom, Lyon, Milford, and Commerce. Novi remained a small community until Interstate 96 came through in the 1970s. The Novi Pere Marquette depot, seen here, still stands near the site of the Grand River Bridge, a three-span camelback built from 1924 to 1926 that spanned the railroad. Construction was partly conducted through a program using state prison inmates as laborers, and two men died during the building of the bridge.

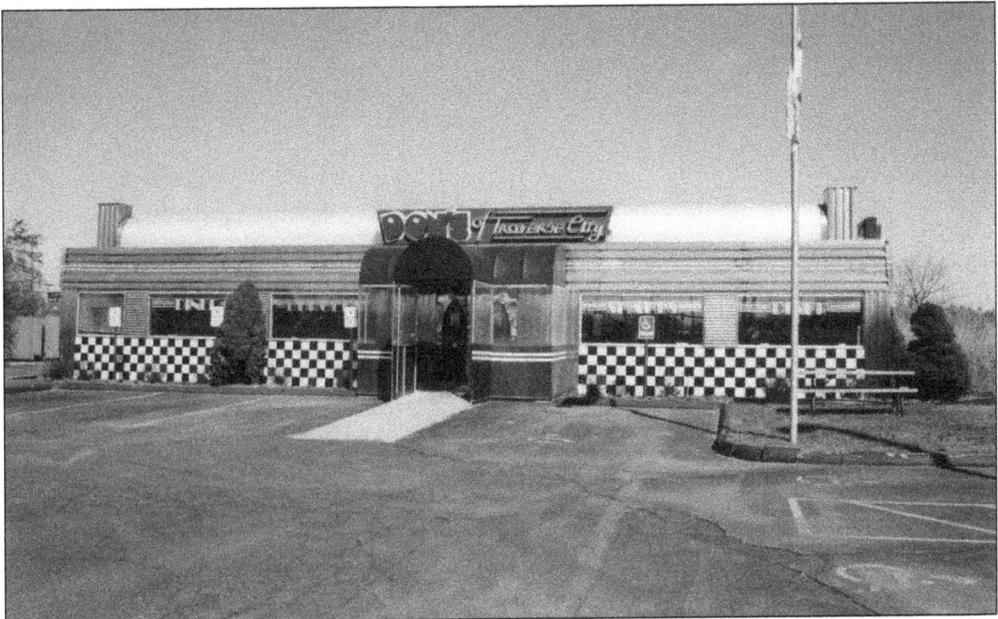

DON'S WIXOM DINER. Though Grand River does not run directly through the village of Wixom, it does run along its southern edge, where travelers can find some tasty roadside diner fare at Don's Wixom Diner. While the original Don's, a drive-in dating from the late 1950s, is still in Traverse City, the Grand River location is a full-fledged diner, complete with counter service and the same burgers and malted milk shakes that made Don's famous.

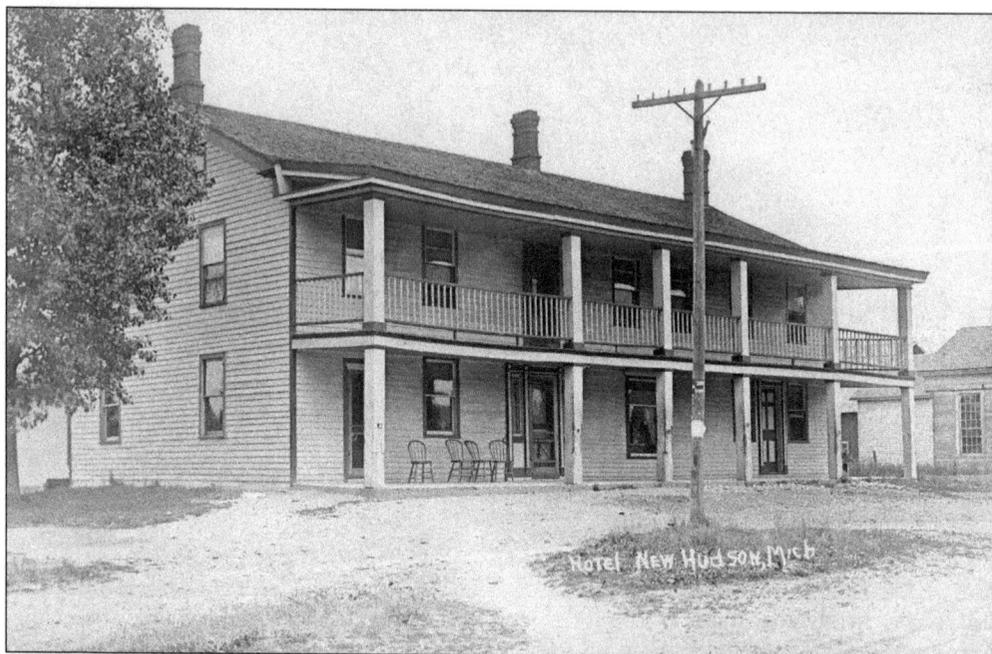

FOOD AND SPIRITS. As Grand River angles into Lyon Township, the road passes into New Hudson, home of the New Hudson Inn, "the oldest bar in Michigan," established in 1831. New Hudson was founded in 1830, and the old inn was its first structure, originally functioning as the New Hudson station, a stage line changing point and tavern along the Grand River Trail. Reported to be haunted, the familiar old landmark is pictured above in 1908, when it was known as the New Hudson Hotel. While it no longer offers overnight accommodations, it continues to welcome travelers for refreshments—with a few more motorcycles than in 1831.

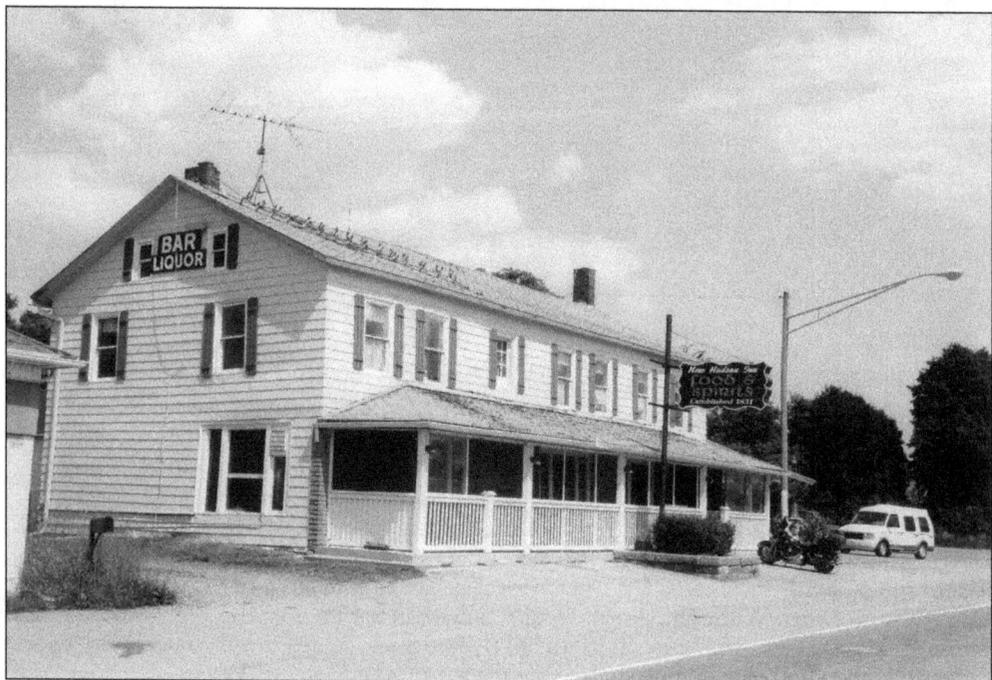

GHOST HUNTER. With all the old ghosts being unearthed along Grand River Avenue, it might be helpful to introduce a ghost hunter along the way, and there is none better than Rev. Gerald S. Hunter (right), of New Hudson's United Methodist Church. He is Michigan's foremost expert and author on the subject of ghost hunting. No stranger to dabbling in the spirit world, Hunter's interests go back to his childhood growing up in a haunted house. Later, after finding his calling in the ministry, he has spent many years balancing his time between more than one aspect of the spirit world. As an author, Hunter has produced three fascinating and popular books on Michigan hauntings and his ongoing investigations: *Haunted Michigan*, *More Haunted Michigan*, and *The Haunting Continues* (Thunder Bay Press). While the original New Hudson Church, built around 1890, still stands directly across Grand River Avenue from the current church (below), it is no longer owned by the church and is in need of some preservation care.

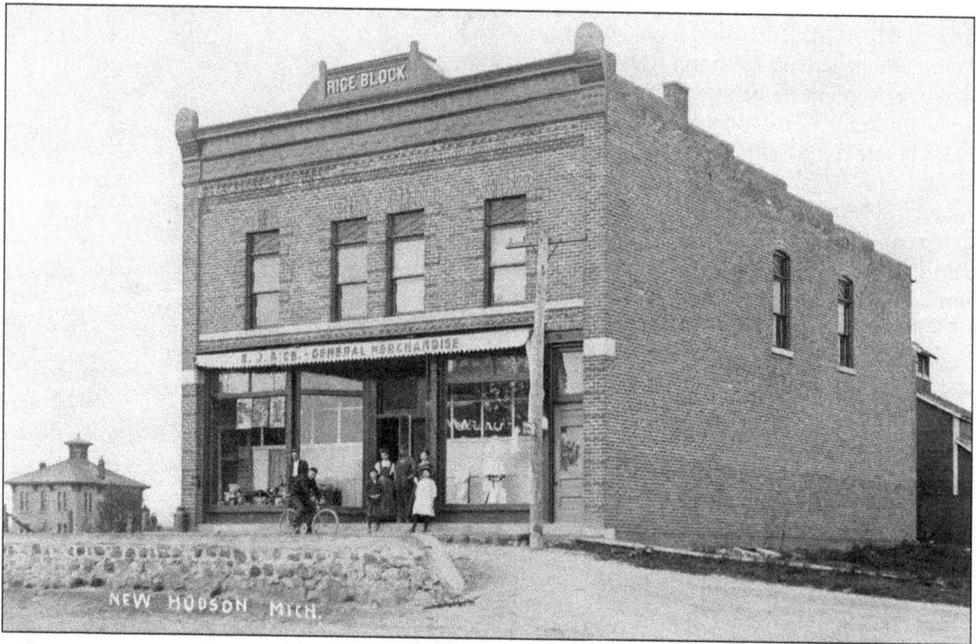

GOING, STILL GOING, AND GONE. New Hudson still looks a bit like the old crossroads it was 100 years ago, a five-pointed intersection where Milford Road crosses Grand River Avenue and the Old Pontiac Trail joins in from the west. The old inn and the old filling station still stand on the corner where all the roads converge. However, the little village has recently been experiencing a population boom and is currently undergoing a good degree of growth and new construction. The old Rice Block (above) once stood just across Grand River from the New Hudson Inn and housed E.J. Rice's General Merchandise Store. Just across the way, diagonally, stood the original post office (below). The old cemetery is visible behind it and to the right.

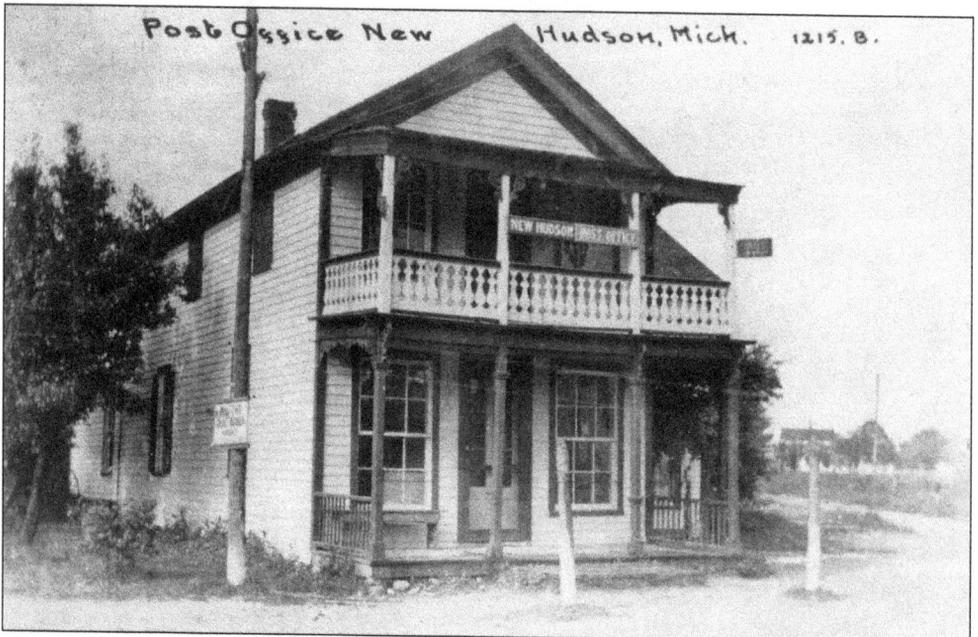

Four

LIVINGSTON COUNTY

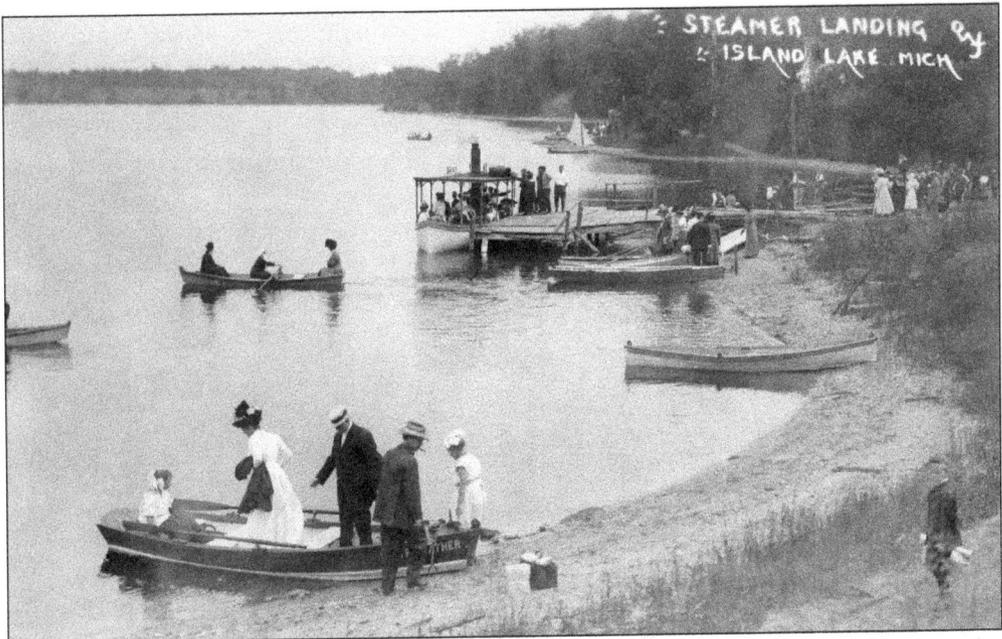

THE BOATING PARTY. The beachwear of choice at Island Lake, while elegant, might seem a bit confining by today's standards, and one can only imagine how difficult it would be to swim in such heavy clothes should somebody fall out of the boat. Nonetheless, the message on the back of this card reads, "This is the place where we are having a fine time!" Just alongside US 16 in Livingston County, Island Lake is still a popular place in summer.

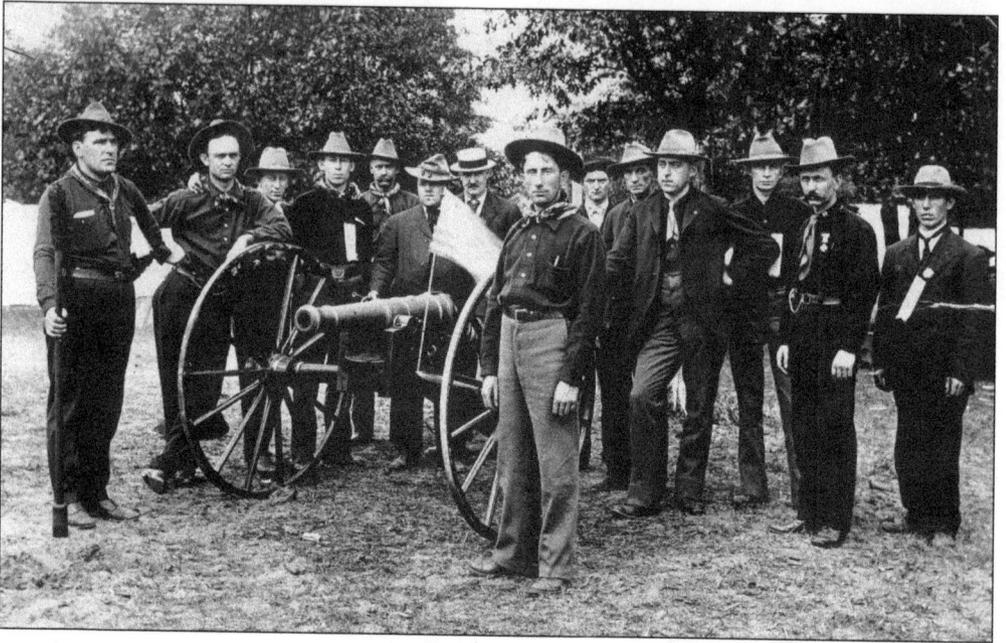

ISLAND LAKE. On the east end of Livingston County, Grand River passes a lovely wooded area of rolling hills enveloping picturesque Island Lake. In the 19th century, the Michigan National Guard used the area as a summer camp. In 1898, five regiments were organized and trained at Island Lake, with two of them seeing active duty in Cuba during the Spanish-American War. The soldiers (above) are members of one of the regiments trained in the area and are shown assembled for a reunion. In peacetime, the Island Lake area was a popular destination for camping, hiking, fishing, swimming, and boating. At one time, it boasted a large population of summer cottage residents, and it even had a hotel (below), an auditorium, grocery stores, and excursion boats.

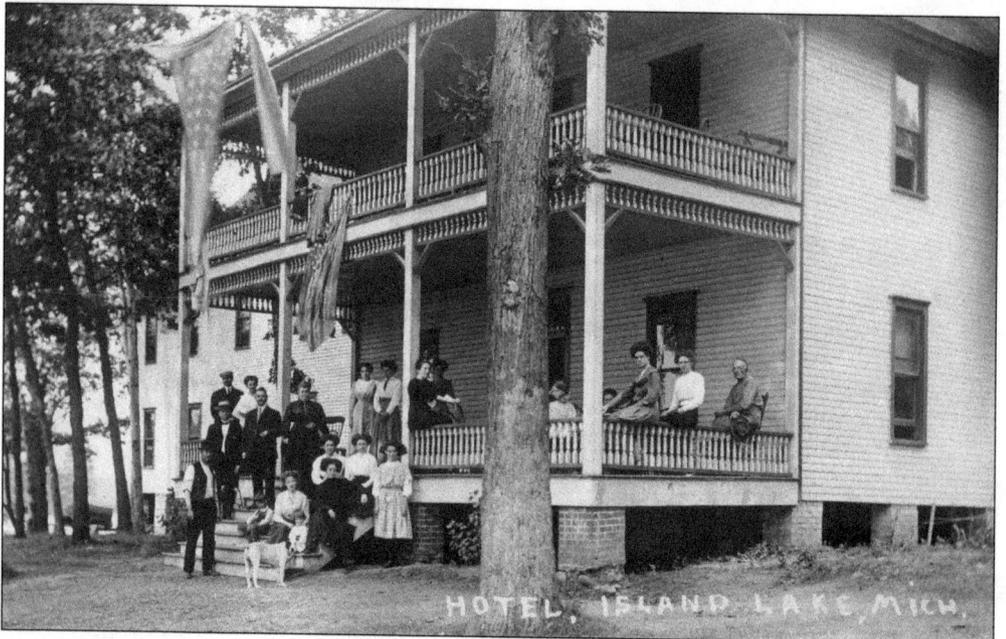

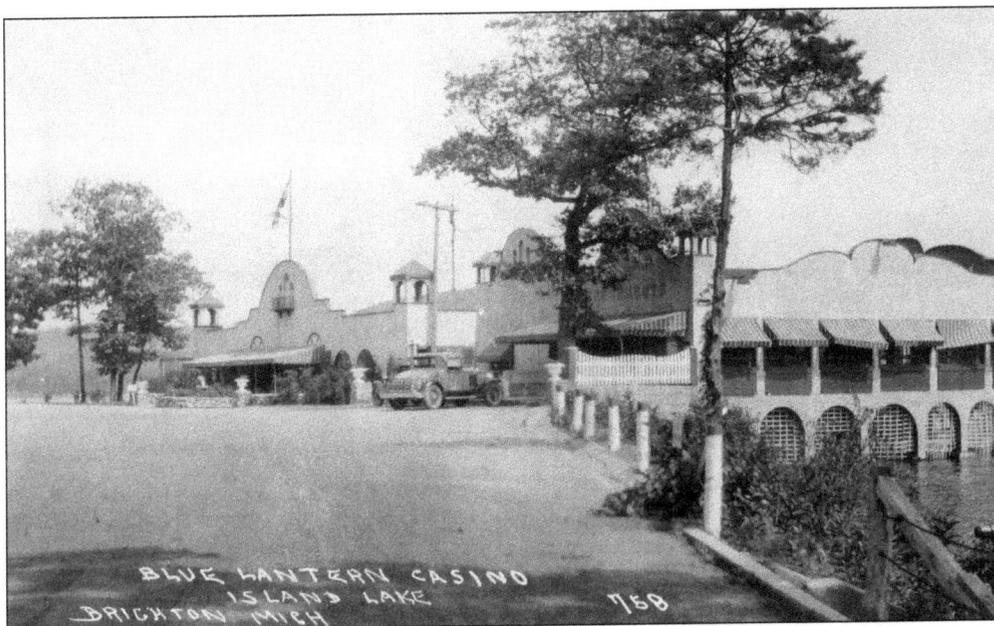

BLUE LANTERN CASINO
ISLAND LAKE
BRIGHTON MICH
1168

"SHIM-ME-SHA-WABBLE," "ZONKY," AND "HULLABALOO." With its years as a Spanish-American War boot camp long behind it, Island Lake soon reverted to a place of recreation and relaxation. By the 1920s, a dance and roller-skating pavilion known as the Blue Lantern (above) was constructed along the lakeshore, and soon the sounds of nationally known bands, including Jean Goldkette's Orchestra and McKinney's Cotton Pickers (below), were hovering over the lake on moonlit summer nights. McKinney's was a Detroit-based band with international appeal and a major recording contract on the RCA Victor label. The promotional card shown was sent out in 1929. Some of the group's hit numbers included "Shim-Me-Sha-Wabble," "Zonky," and "Hullabaloo." While the Blue Lantern is now long gone, Island Lake is still a popular recreation area and is now a state park.

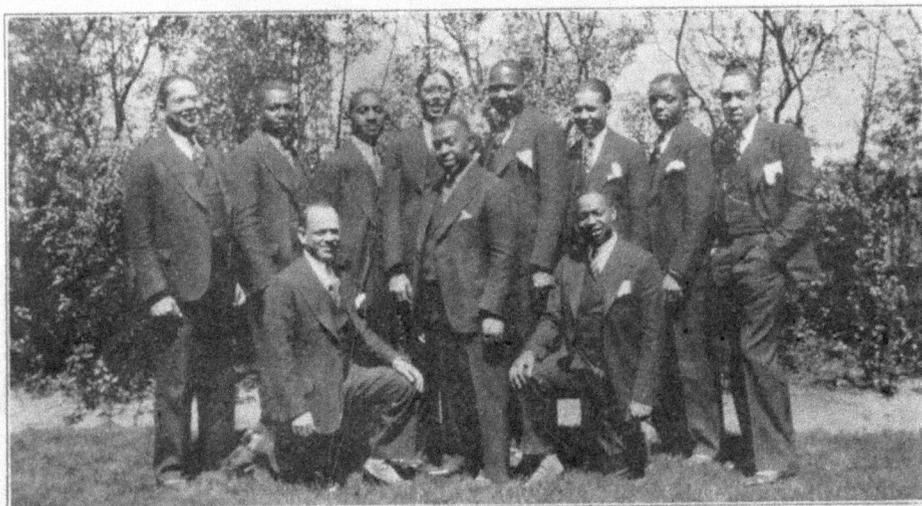

BLUE LANTERN ORCHESTRA

Island Lake McKINNEY'S COTTON PICKERS On Grand River
1½ Mi. E. of Brighton

53

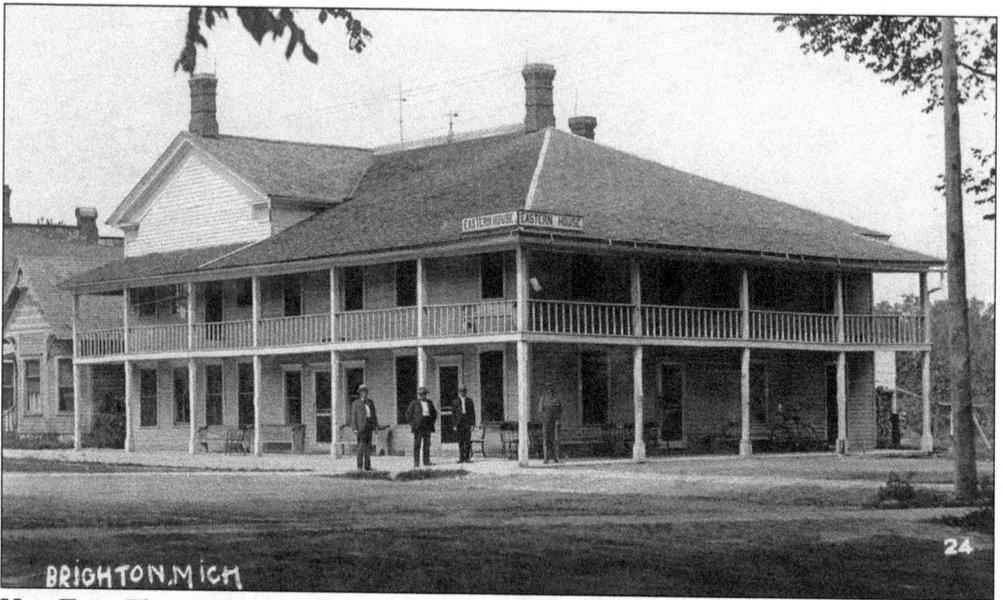

BRIGHTON, MICH

HOT TIME. The city of Brighton, established in 1832, is just beyond Island Lake, where there was once a popular stagecoach stop at the corner of Main Street and Grand River Avenue. The Eastern House, seen here, started as the Brighton Hotel in 1850, then went on to provide other entertainment until it burned down in 1926. The second floor had specially constructed floors that gave spring to the step of square dancers. Travelers relaxed on the verandas, and the eight guest rooms eventually had newfangled inventions like telephones and electricity.

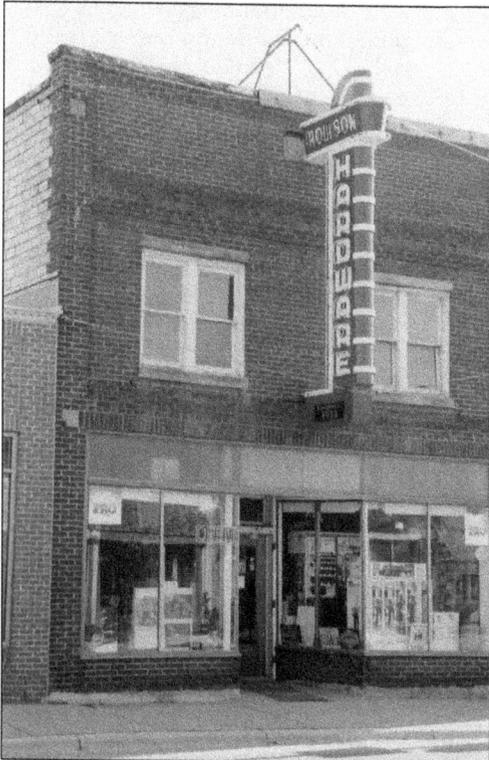

BEYOND THE NEON. A few steps off Grand River Avenue, and worth the detour, is Rolison Hardware, established around 1924, which makes customers both nostalgic and grateful. The wooden floor squeaks, the display cases are original, and customers are helped immediately. John Kudla, whose family bought it from the Rolisons, has an encyclopedic mind for the more than 65,000 products he carries. This authentic hardware store alone is worth the trip to Brighton.

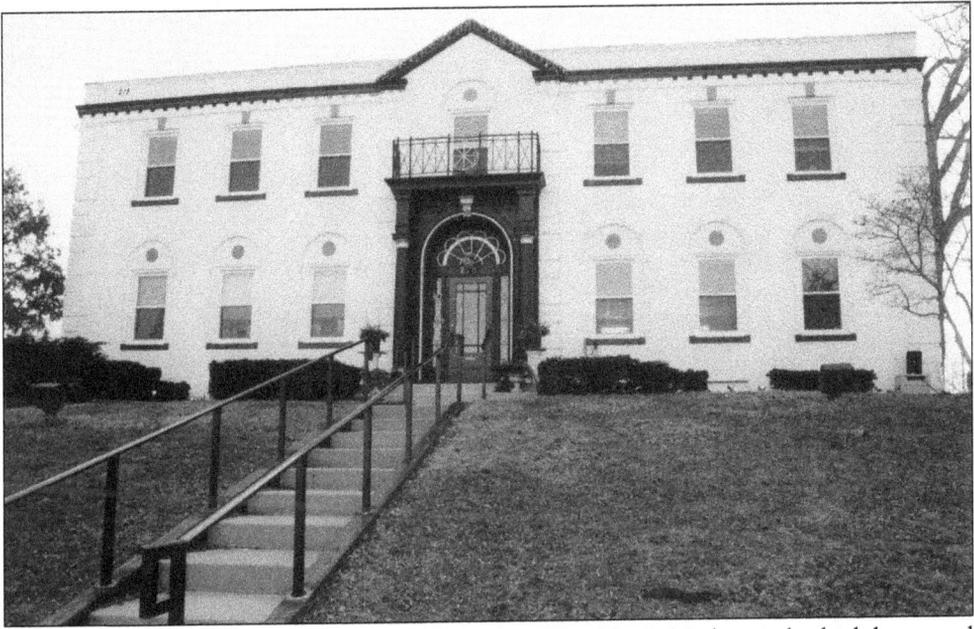

MELLUS HOSPITAL. In 1931, Dr. Horace Mellus opened Brighton's first hospital, which he named after himself. Although Mellus died in 1939, the hospital continued until the early 1960s. By turns a teen center, a bank, and a chocolate factory, the Georgian building is now home to the Brighton Chamber of Commerce. Its basement was formerly a morgue, which may be the reason for the many reports of spirits residing there.

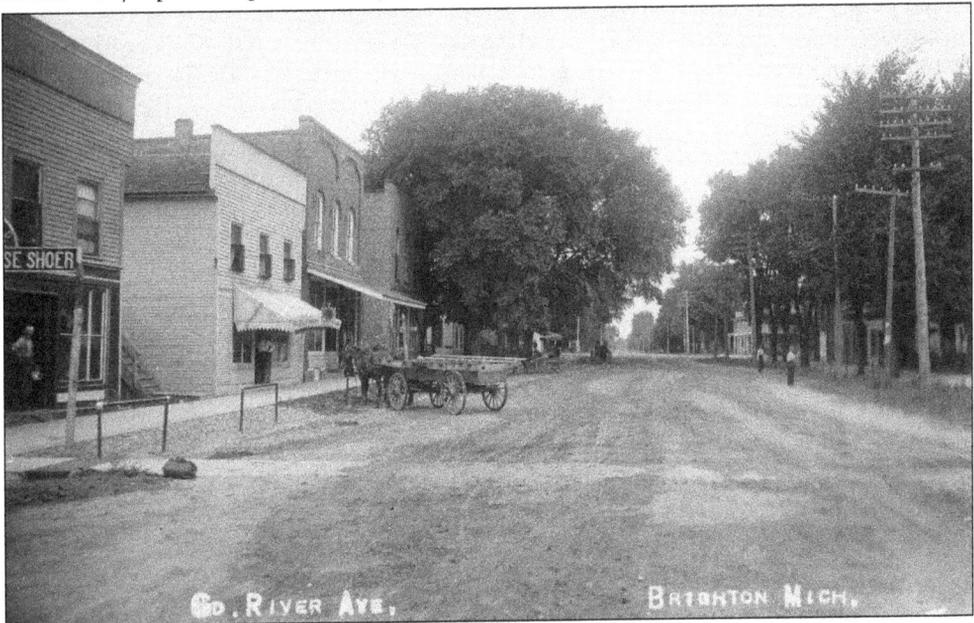

GETTING BENT. Those who enjoy a good burger and fries should stop at Champ's Pub, at 140 East Grand River Avenue. Brighton's own version of the *Cheers* bar was a longtime blacksmith and horseshoeing shop. At one time, there were seven smiths in the area. Adolph Martin, the last one in business here, outlived them all. As horses gave way to cars, he shaped metal to fit them as well. Today, patrons just bend elbows.

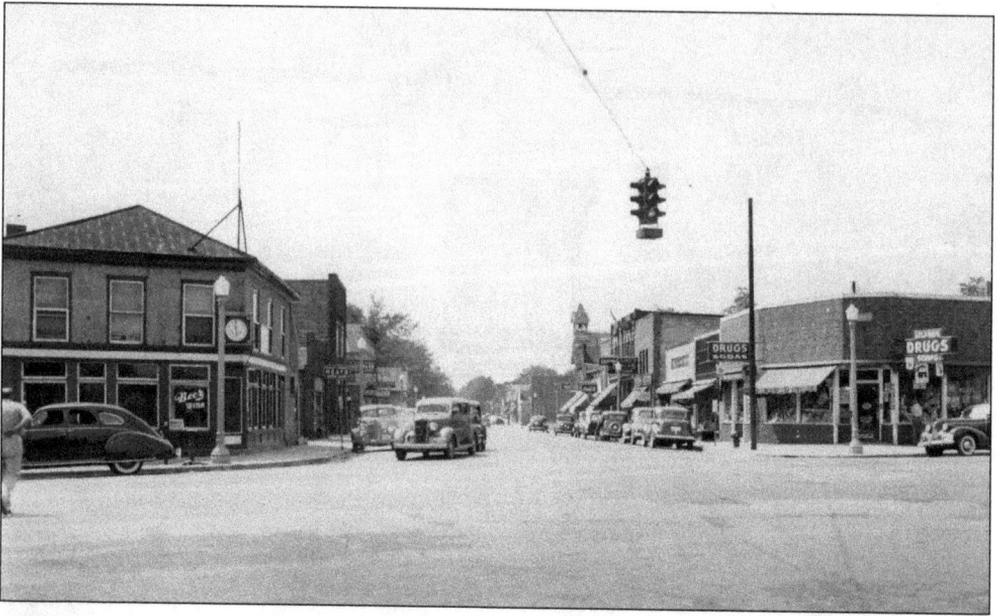

"Brightoned Our Lives." Leland Drugs, on the corner of Grand River Avenue and Main Street, anchors the postcard above, sent in 1945. The writing on the reverse reads, "Just to let you know I haven't forgotten you." Leland was the first building in Brighton to be air-conditioned. Brightonites have many memories of drugstores with soda fountains. Many fondly remember Uber's Drugs, across the street, and its Uber's Special: vanilla ice cream with chocolate sauce and a marshmallow topping—and a cherry on top, of course. The postcard below, dated 1930, shows C.F. Weiss Drugs & Barbecue on the left. Farther along Grand River, and much later, was the Canopy Restaurant, one of the truly elegant restaurants of its time. Linen tablecloths, great steaks, and the 30-year run of Earl Williams at the piano made this much-missed place a legend.

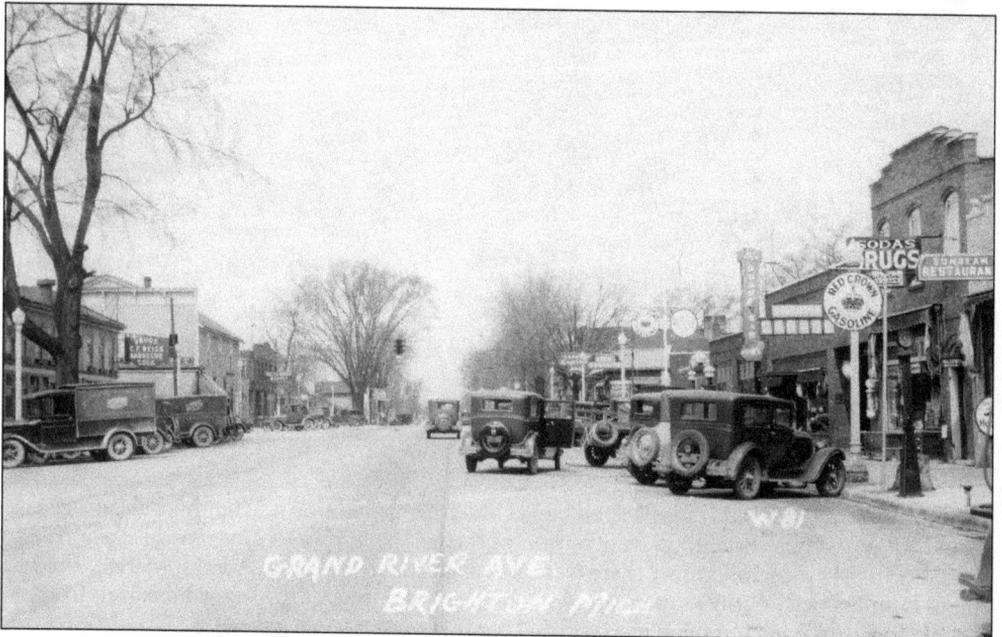

STILL STRIKING. Neon this complete and outstanding is getting hard to find. Family-owned and operated since 1946, the Bowledrome is a great place to roll a few, or down a few in the 11th Frame Lounge. Seeing several generations having fun together renews one's faith in bowling at this Howell landmark with 20 beautiful lanes.

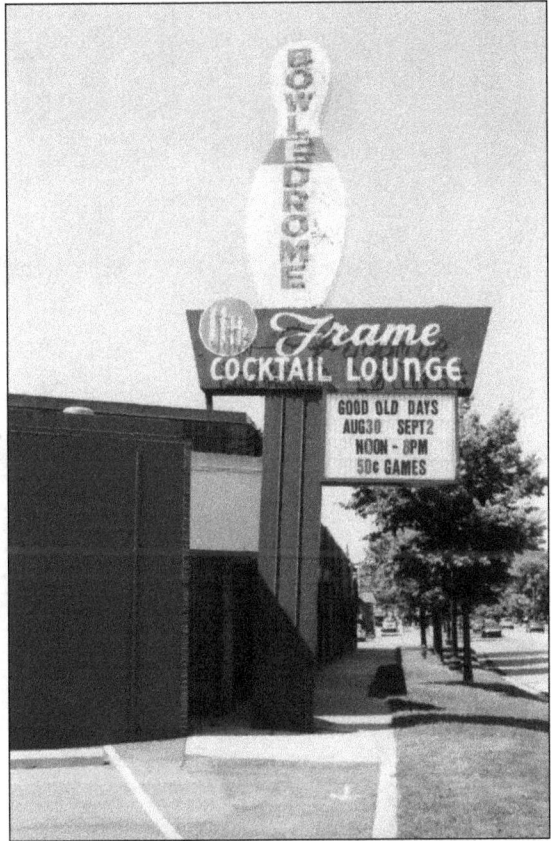

LAKES DRIVE-IN. Lucky ladies at the Lakes Drive-In on opening night in May 1951 received an orchid and saw *Jeepers Creepers*. Offering 700 in-car speakers, a playground, and free pony rides, the Lakes became a summer family favorite, with lines of cars down Grand River Avenue. This ad is from 1964. The theater closed in 1989, though the blue neon marquee with waves could be seen from Interstate 96 for much longer.

57

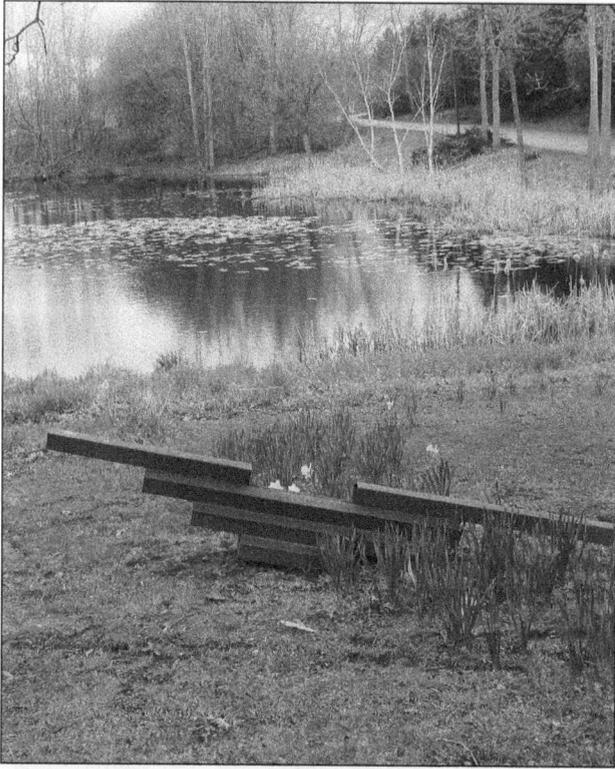

WORD OF MOUTH. A trip to the dentist becomes a thing of beauty at Oaken Transformations. Part sculpture park, part poetry center, it is a peaceful place behind the dental office of Dr. Frederick Bonine. On weekdays year-round, one can stroll the half-mile wooded nature trail and enjoy native plants and wildlife, in addition to outdoor sculpture and juried poetry installations. Admission is free, and it is a favorite secret spot and a must-see along Grand River.

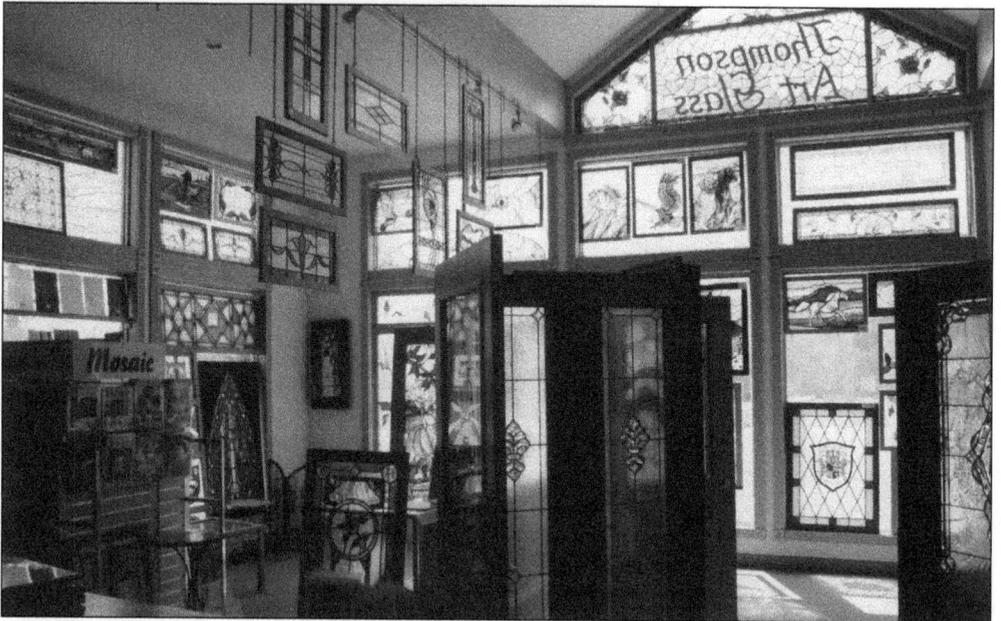

STAYING GLASS. Glass may be fragile, but Thompson Art Glass has survived four generations and is still going strong. Started in 1929 on Grand River Avenue in Detroit by Dirk Thompson, who studied at the Tiffany studios, it moved considerably west to a renovated 140-year-old church, also on Grand River, between Brighton and Howell. The family and artisans still create beautiful stained, leaded, and beveled glass for churches and homes.

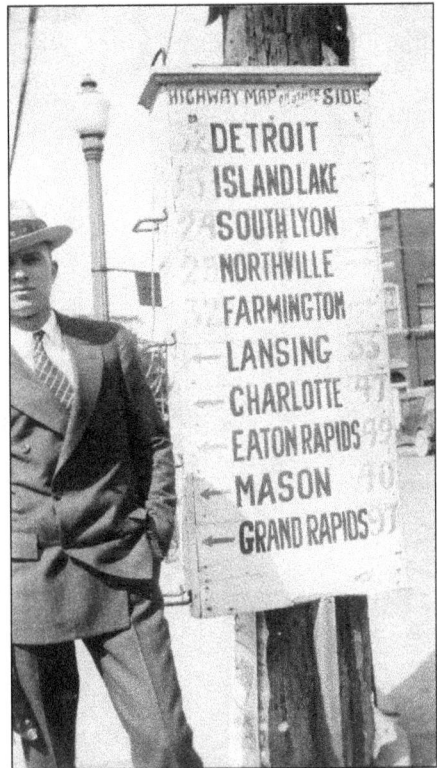

MIDDLE OF SOMEWHERE. An unidentified, somewhat dapper gent stands next to a mileage marker along Grand River Avenue in downtown Howell. According to the sign, he is 52 miles west of Detroit and 97 miles east of Grand Rapids. While seldom seen in photographs, it can be safely assumed that signs of this nature existed in many towns and villages along Grand River.

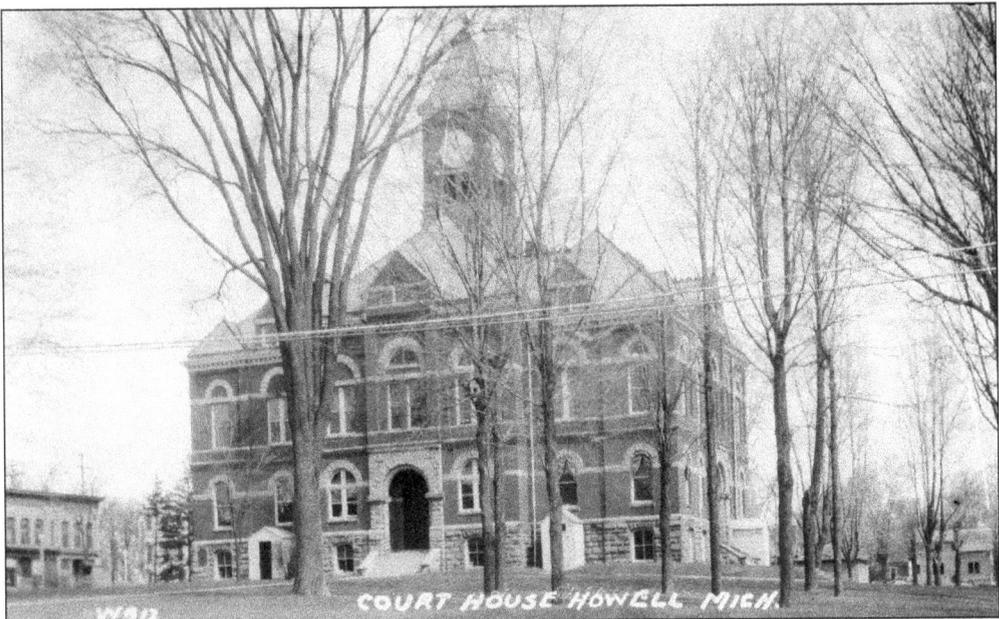

STILL IN SESSION. The Livingston County Courthouse, in Howell, is more than just an imposing redbrick, Richardsonian Romanesque building: It is the town's center. Concerts are held in the outdoor amphitheater. Completed in 1889, the courthouse replaced an earlier structure built when Brighton and Howell were competing to be the county seat. Although cases are no longer tried there, it is a pretty place to get a marriage license at the county clerk's office.

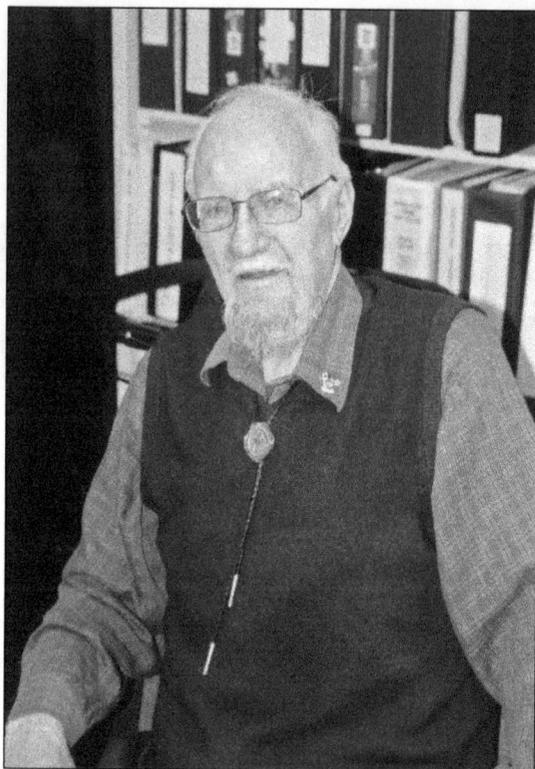

POSITIVELY ZEMP. Usually found behind the lens, Duane "Zemp" Zemper is a longtime Howell photographer and respected archivist. As a photograph officer during World War II, he went on B-17 bombing runs and earned several medals. Postwar, Zemper bought a photography studio that began in 1858, including all of its negatives and photographs. He went on to photograph most of Howell's people and places until the studio closed in 1998.

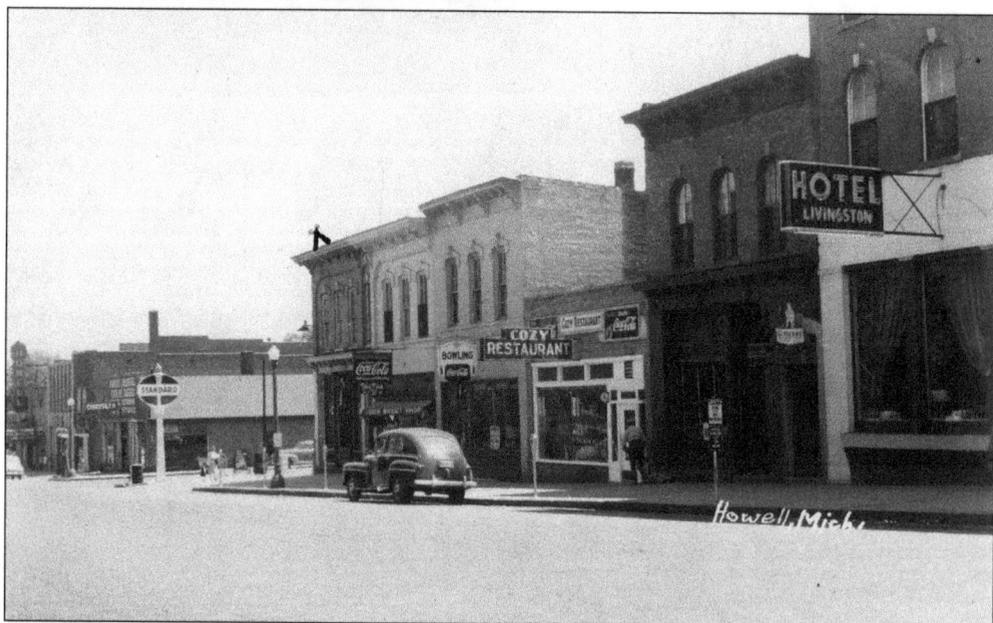

HOWELL. To the right of Johnnie Hall's Standard station (on the left) and just above the Coca-Cola sign (second building right of intersection) is Duane Zemper's photography studio. Next door is a three-lane bowling alley, formerly the Temple Movie Theater. The Cozy Restaurant was later known as the Family Restaurant. Beyond Johnnie's is the blade sign of the Howell Theater. While none of these businesses still exist, the buildings do.

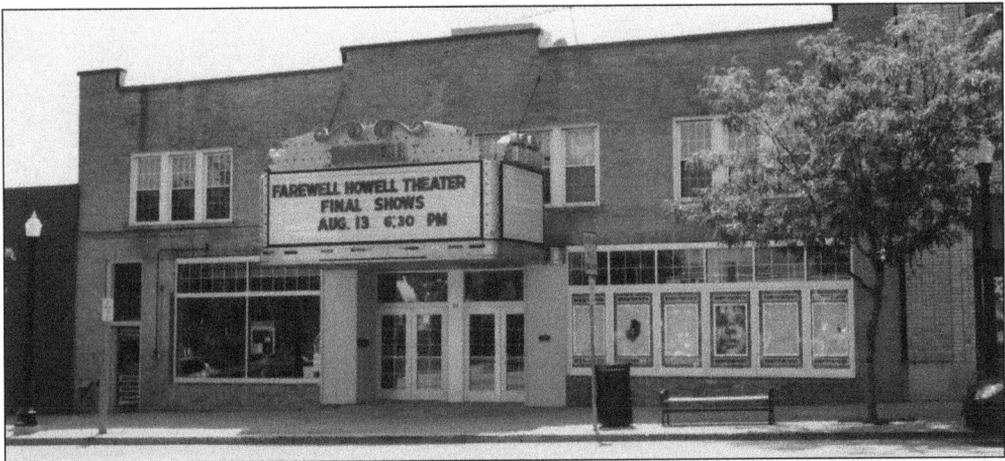

LIMITED ENGAGEMENT. The Howell Theater opened its doors in 1927, and it has opened and closed them several times since then. Built to handle both live and filmed entertainment, it became a full-time movie theater in 1938. Later, it was extensively renovated and split into two theaters. Thankfully, it kept the great popcorn. Though it is currently closed, perhaps someone will turn the lights back on in the near future.

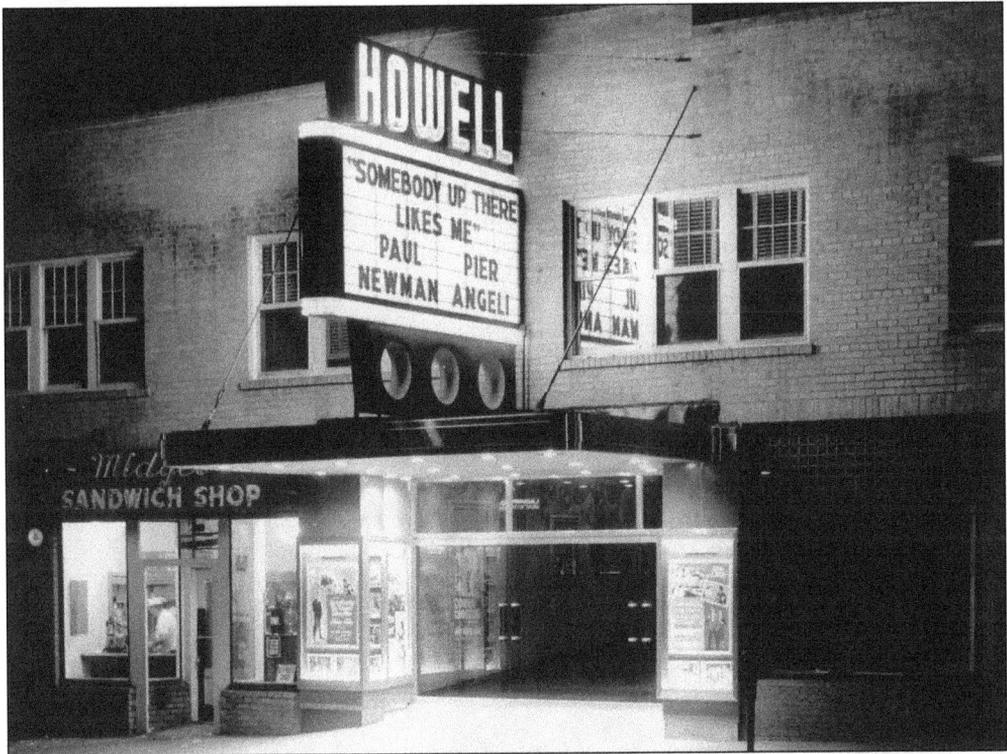

THE MIDGET. Named for its size, not its clientele, the Midget Sandwich Shop is still craved by chili and olive burger lovers. Famous for freshly grinding its hamburgers, as well as "Quick, Courteous Service," it was a 24-hour mecca for everyone from teenagers to truck drivers. People even snuck burgers into the Howell Theater next door, until the familiar smell gave them away. The Midget's motto was "Taste Tells the Tale," and Howell residents still wish they could. (Courtesy of Duane Zemper.)

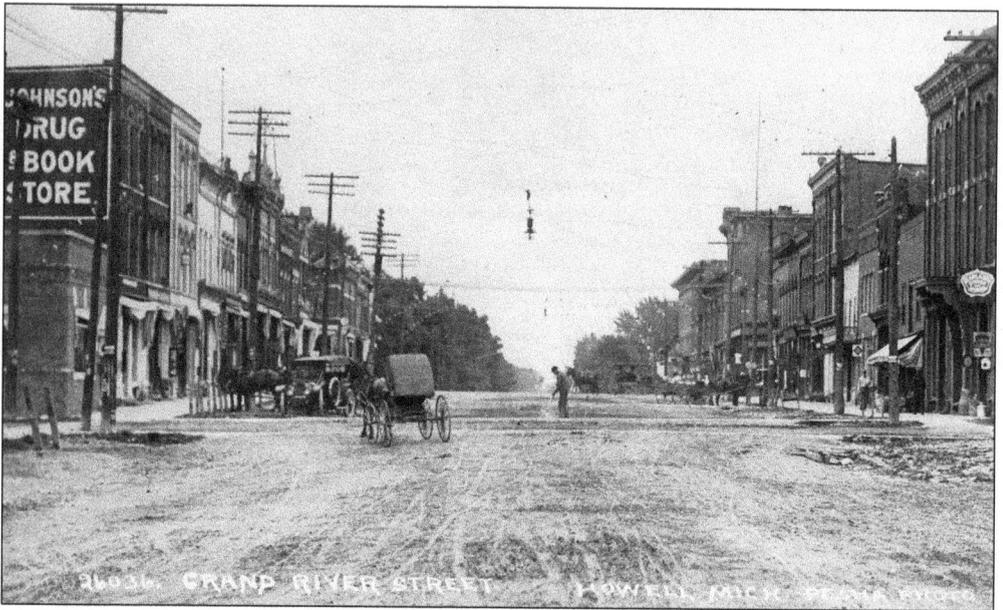

MAIN STREET, C. 1908. The shop at the lower right in the photograph above was always a hardware store. Originally Bennett's Hardware, it was purchased by Charlie Sutton in 1913. Above Sutton's (later Howell's Finest Hardware) was the Howell Opera House. Opened in 1881, it featured everything from Gilbert and Sullivan to Shakespeare to jugglers to William Jennings Bryan. It also served as a courthouse. The opera house closed in 1924 and became a neglected storage space. But it is going to have a happy ending. In 2000, the Livingston Arts Council (LAC) bought the building. The former hardware store on the first floor was renovated and is now open to the public—as seen below—with art shows, classes, and event rental space. The vibrant LAC continues to restore the building, with hopes of opening the grand opera space on the third floor again.

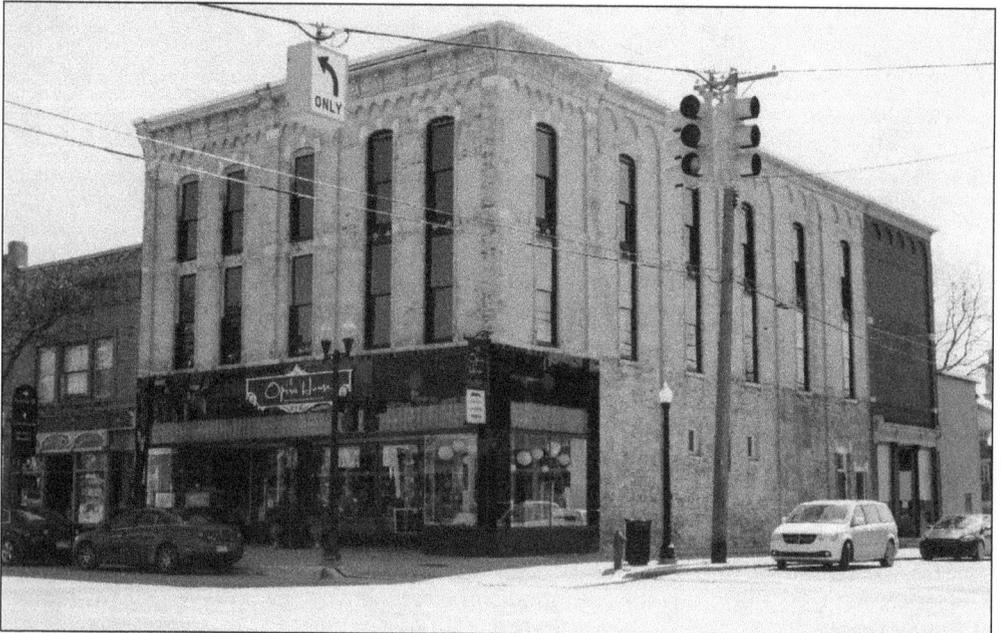

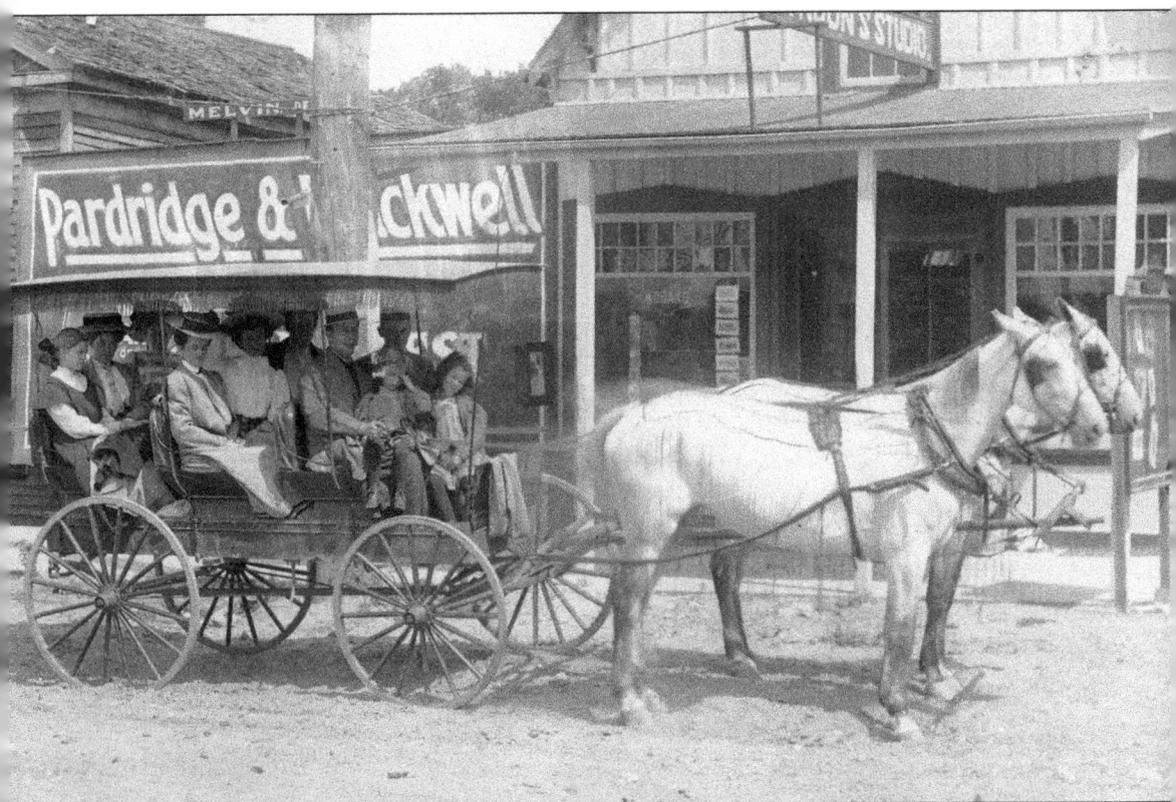

PHOTOGRAPH GRAPHIC. Roy J. Lyndon (1879–1961) was a professional photographer occupying a studio along Grand River Avenue in Howell, seen here, long before Duane Zemper even got to town. Moving into a brand-new studio on Grand River Avenue, as reported in the local papers of 1908, Lyndon established himself by offering portraits, postcards, and even a variety of double-wide, panoramic views of downtown Howell and the vicinity. Much of his success is attributed to his regular participation in photography conventions and exhibitions and keeping up-to-date with the latest trends in photography. He is just one of the more than 8,000 Michigan photographers featured in David V. Tinder's *Directory of Michigan Photographers*, published online by the Clements Library at the University of Michigan.

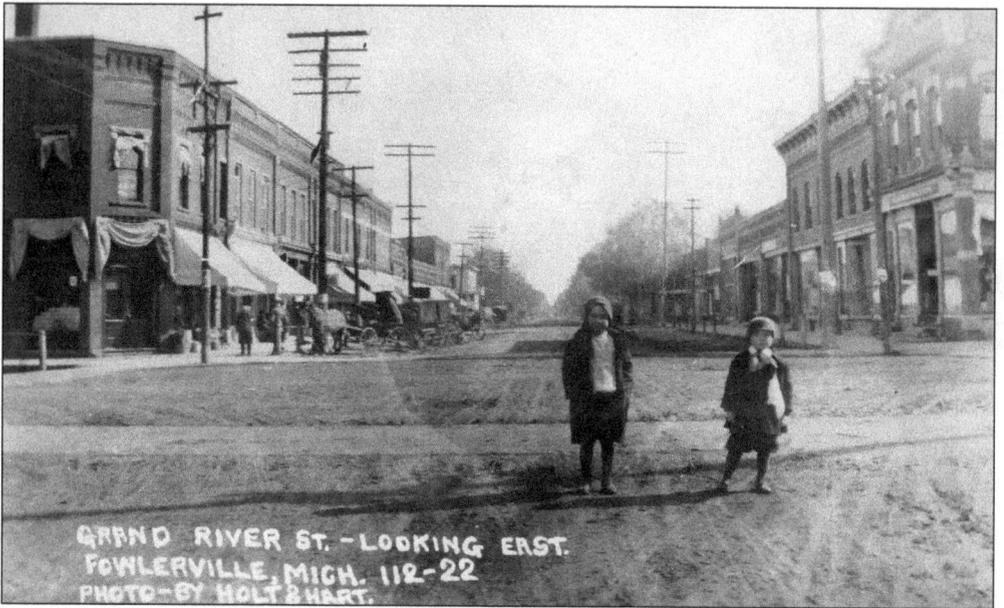

FOWLERVILLE. Just up the old plank road from Howell is the village known as Fowlerville. First settled by Ralph Fowler in 1836, it was initially called Cedar but eventually came to be named for its first permanent resident.

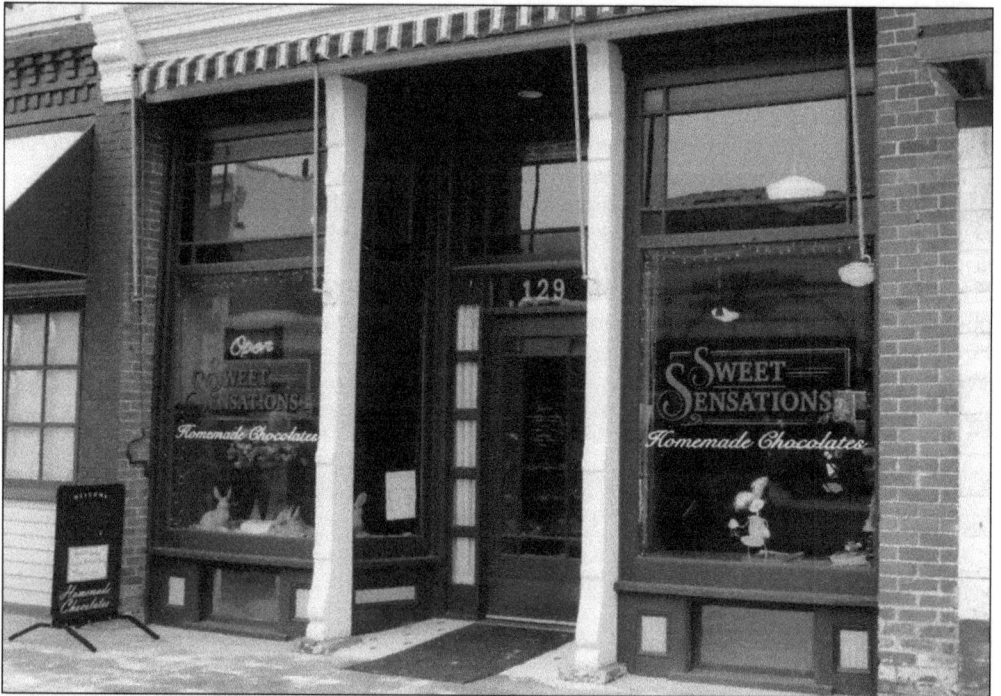

SWEET SENSATIONS. Continuing a tradition started in 1946 by George and Elen Spagnulo, Sweet Sensations, in Fowlerville, is the perfect place to get a sugar fix. Echoing the legendary Spagnulo candy karma, Les and Sherry Pardee restored the building, where they now handcraft delicious treats, sometimes even using the original chocolate molds. Deciding between the chocolate-covered marshmallows, the peanut brittle, or the dark raspberry creams can be tough.

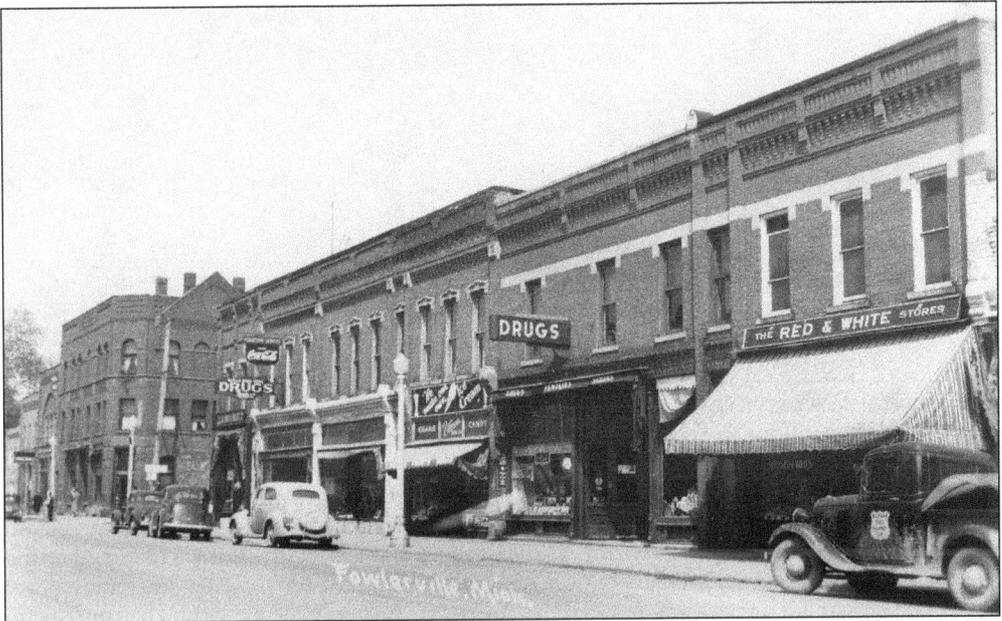

FROM DRUGS TO MUGS. "You are here & have seen the town—the gang" is written on the back of this postcard, postmarked May 1939. Remarkably, the building in the middle with the "Drugs" sign has been a drugstore for over 120 years. It has had many names, including Cooper, Fenton, Tim's, and Proos, but is now simply known as the Fowlerville Pharmacy. The Red & White Store was a grocery store, also known as Westin Brothers. Farther south is another landmark, the Bloated Goat Saloon (right). Around the time of World War II, it was the Twin-Q Restaurant, which was so elegant that people would drive from Detroit to eat there. But what the Goat lacks in elegance, it makes up for in ambience, the Goat Burger (not actually made from goat), and one of the coolest bar names ever.

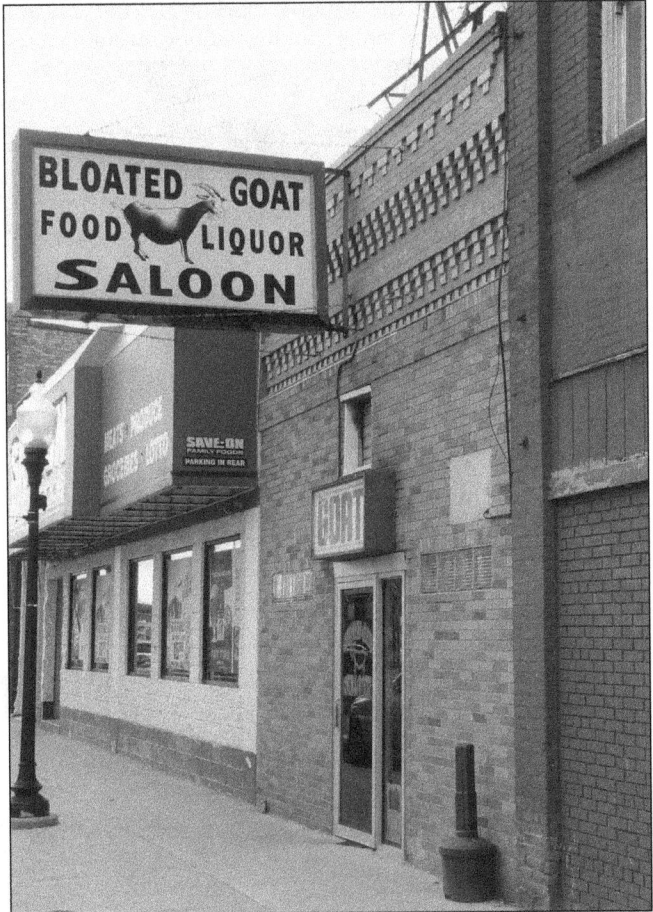

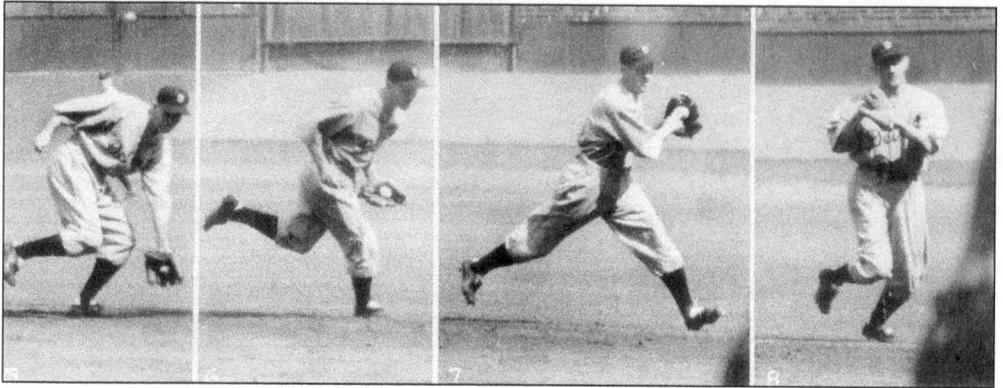

THE PRIDE OF FOWLERVILLE. Baseball Hall of Famer Charles Leonard "Charlie" Gehringer, seen above in 1935, was born in Fowlerville. Though Gehringer (1903–1993) was an athletic star at Fowlerville High School and excelled on the court and the field at the University of Michigan, no one could have predicted that he would become one of the greatest second basemen of all time, known as "The Mechanical Man." Gehringer joined the Detroit Tigers in 1924 and played his entire career with the team, retiring in 1942 to join the war effort. With a lifetime batting average of .320, he accumulated 2,839 career hits, with more than 200 in seven different seasons. A six-time all-star, Gehringer was awarded the American League MVP award and batting title in 1937. He was voted into the National Baseball Hall of Fame in 1949. Below, Lt. Charles Gehringer, US Navy, studies a map while standing among several images from his playing years.

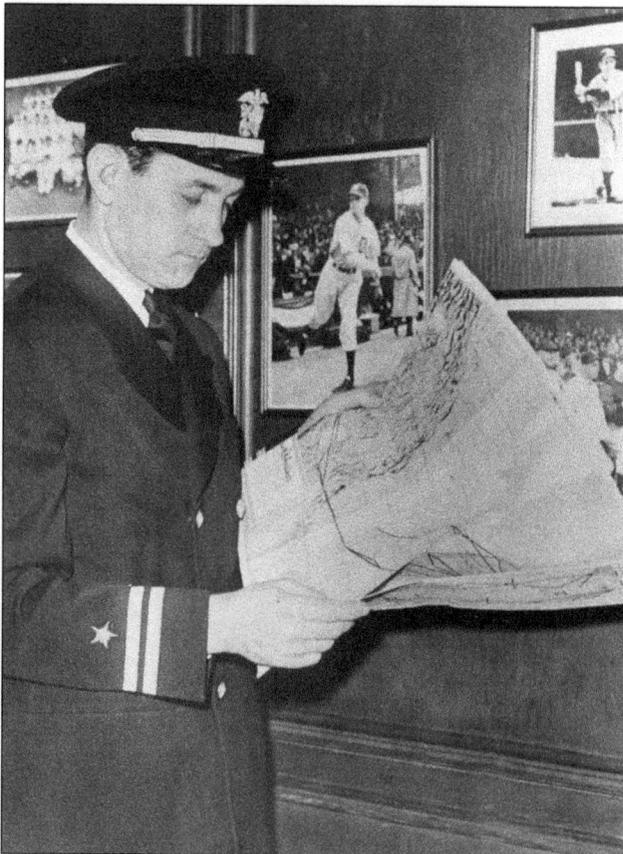

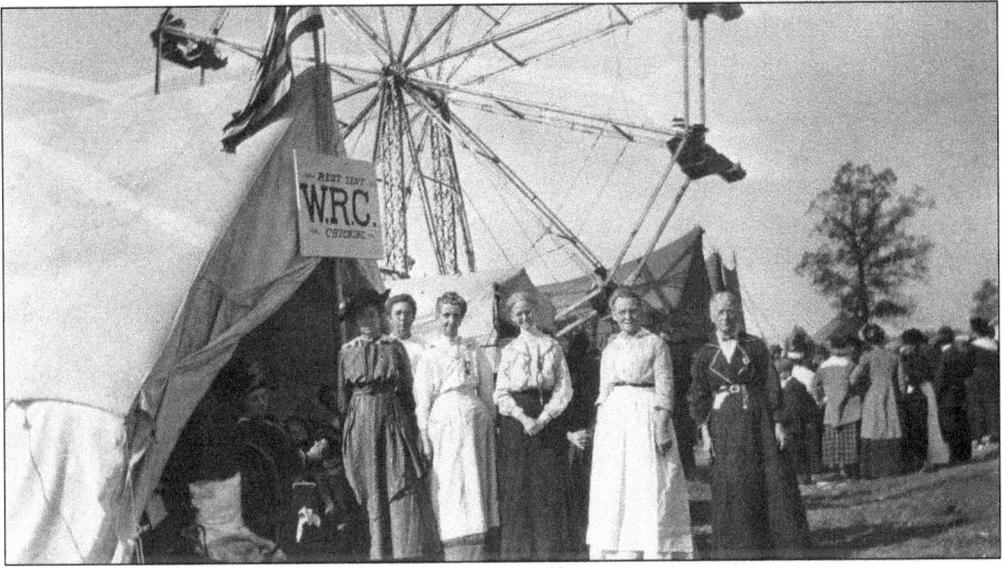

FOWLERVILLE FAMILY FAIR. For more than 128 years, the Fowlerville Family Fair has featured everything from Wild West shows to George Jones concerts. Every July, it is still the perfect place to see 4-H animal judging, eat French fries, pet a pig, ride a Ferris wheel, meet the Homemaker of the Year, and see a demolition derby or tractor pull. It even has a historical village, filled with Livingston County buildings saved from destruction. Above, ladies from the Workers Relief Corps host the rest tent, presumably for anyone who might have had a bit too much sun, or cotton candy. Below, the big excitement of the day in 1911 is a baseball game between Stockbridge and Fowlerville. The score is unknown, and since Charlie Gehringer was only eight years old, it is fairly certain that he was not in the lineup.

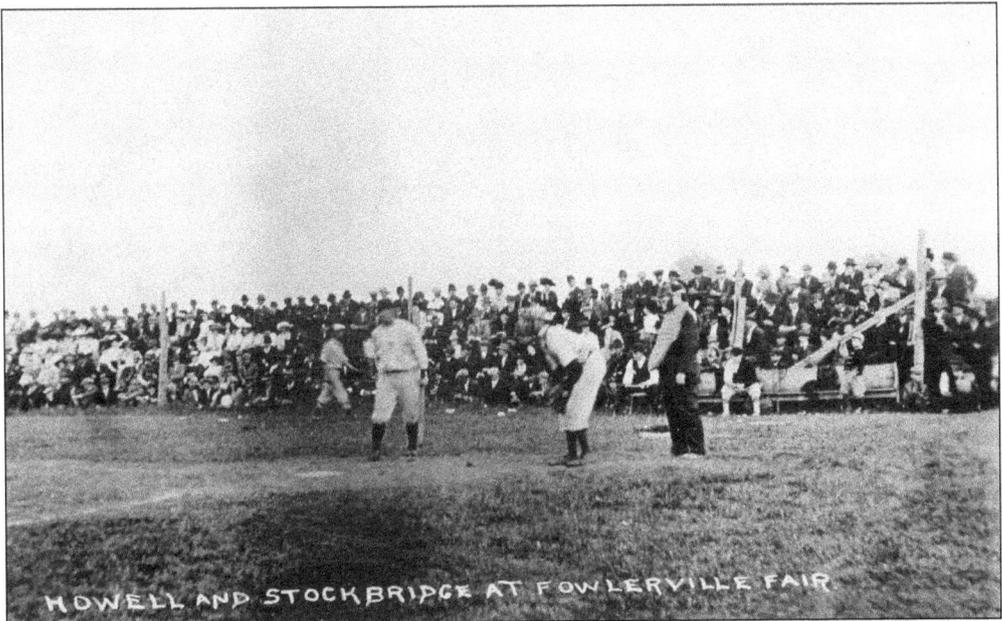

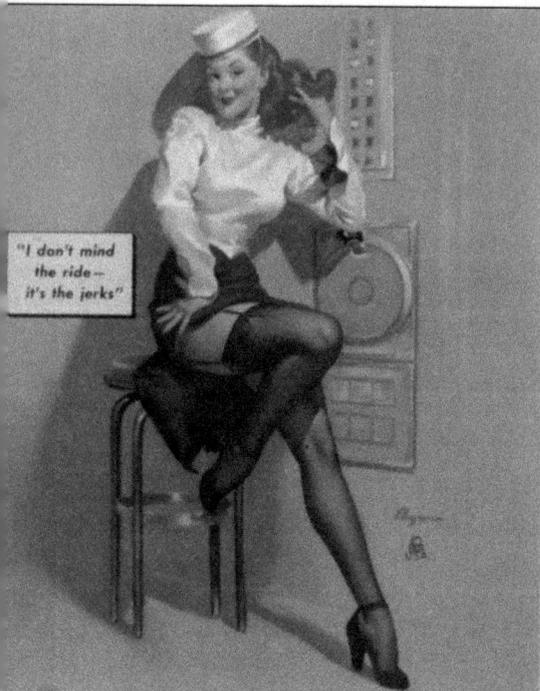

HAVING THE RIGHT EQUIPMENT IS IMPORTANT. This mid-1940s ink blotter, distributed by the Fowlerville Equipment Company, employs a bit of sex appeal to grab the attention of potential customers, who would have been mostly male. The iconic 1940s advertising piece is a bit of a stretch, considering there is not much correlation between the company's products and the sassy pinup girl in the ad. But, to help tie it all together, the heading for Omaha Standard Bodies is prefaced with the "winking" rhetorical question, "Nice, isn't it!" Meanwhile, the redheaded elevator operator quips, "I don't mind the ride—it's the jerks."

Five

INGHAM COUNTY

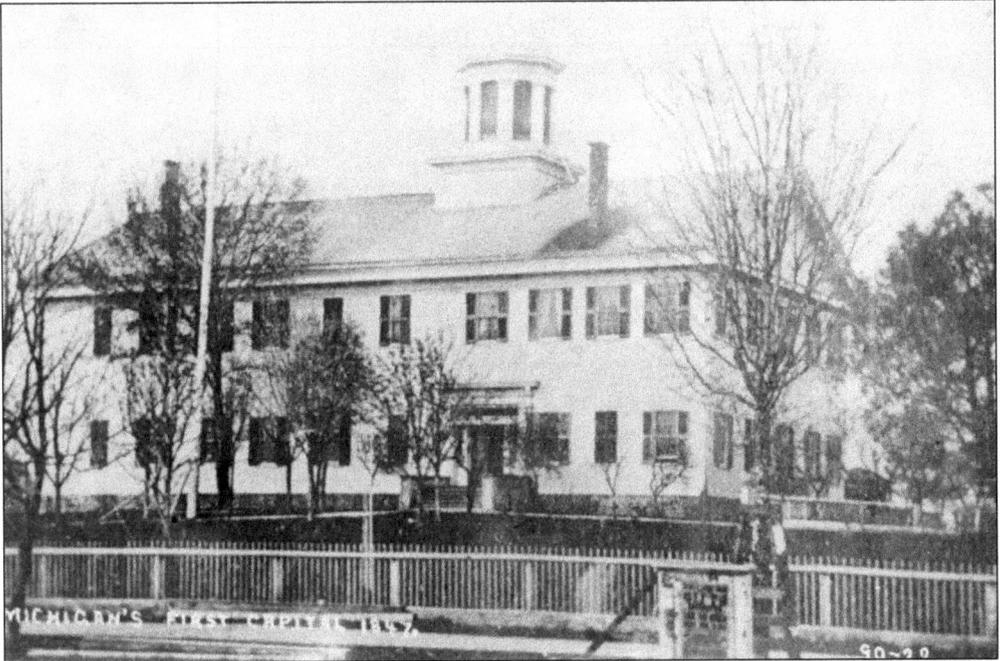

GONE TO LANSING. By 1847, the Michigan State Capitol was being moved up Grand River Avenue about 100 miles to Lansing. Construction began on the new capitol building, seen here, in 1847. This building served that purpose until it was replaced by the current building in 1879. Grand River Avenue (US 16) crosses the Grand River for the first time at Lansing, and, from there, the two move along together (and apart) as they progress to the other side of the state.

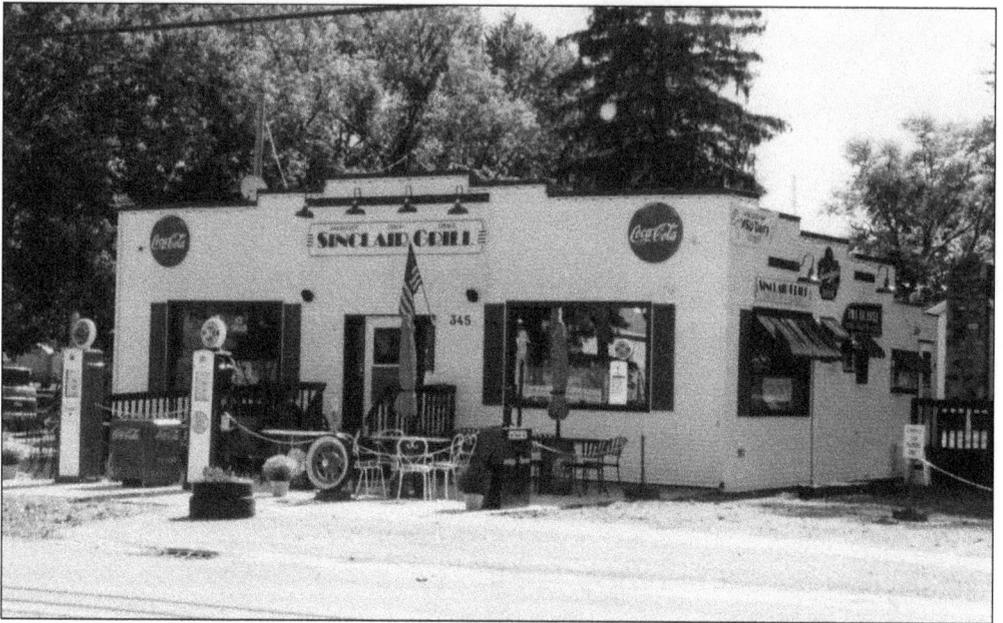

BRING THE DINO DINER GANG. For anyone craving a good burger or Blue Moon ice cream along Grand River Avenue, the Sinclair Grill in Webberville is edible nostalgia. Built as a gas station diner during the 1930s, this labor of love is packed with car signs, gas pumps, and hood ornaments. Customers even bring in their own stuff to hang on the wall. Cars and motorcycles cruise in for MSU Dairy ice cream, or something stronger.

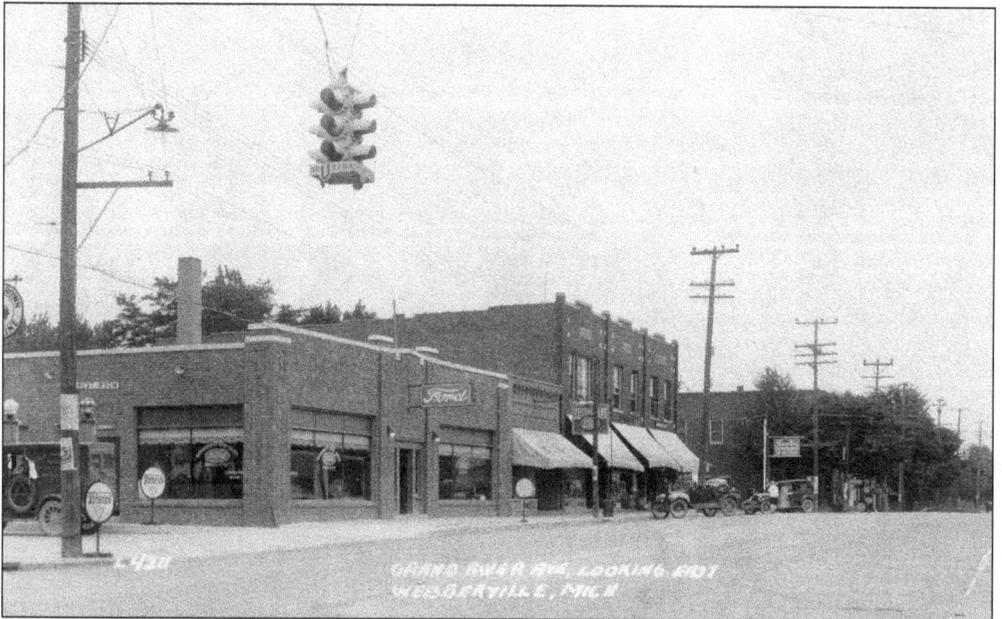

WEBBERVILLE. In 1812, surveyors from Detroit spent three weeks traveling to what eventually became Webberville and were given land in return. Settled in 1837, it was once called Leroy, but another town had that name. It was then renamed Webberville, after postmaster Hubert Webber. The town is seen here in 1928. While the building on the left is no longer a Ford dealership, it still stands and is home to the Viking Sign Co.

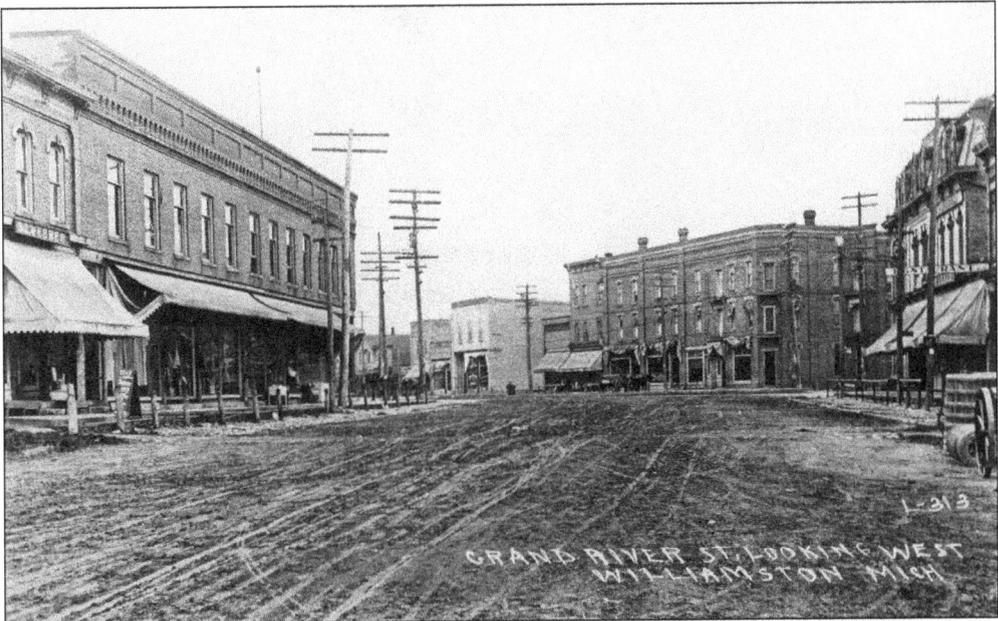

GRAND RIVER ST. LOOKING WEST
WILLIAMSTON MICH

WILLIAMSTON. The summer home of the Tawas band of Ojibwas, Williamston flows alongside the Red Cedar River. Its most famous resident was Chief Okemos (Ojibwa for "Little Chief"), for whom a nearby town was named. By 1839, two brothers named Williams had opened a sawmill and gristmill, and it soon became known as Williamsville, and, later, Williamston. Grand River Avenue looks a bit muddy in the photograph of downtown Williamston above. While the road is now paved, most of these buildings still stand. At center is the old Hotel Glasier, which is still used for housing and retail. The great snowstorm of February 22, 1912, certainly made an impact on Williamston, and the photograph below shows locals proudly posed in the snow canyon they had just finished excavating. Williamston is known for its antique shops and good food, and a local sign once read "Williamston. Stop or smile as you go by."

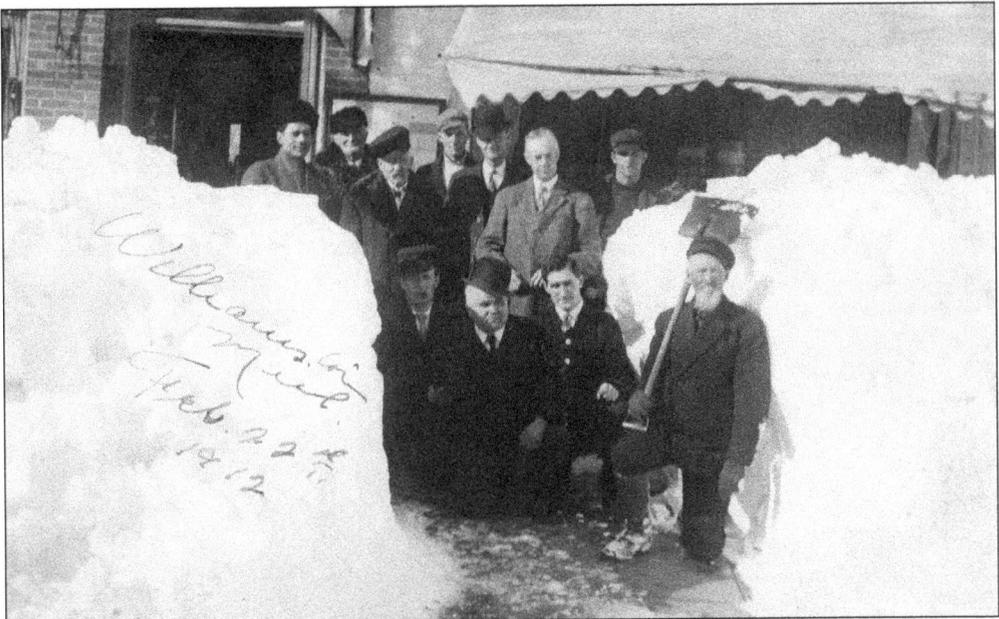

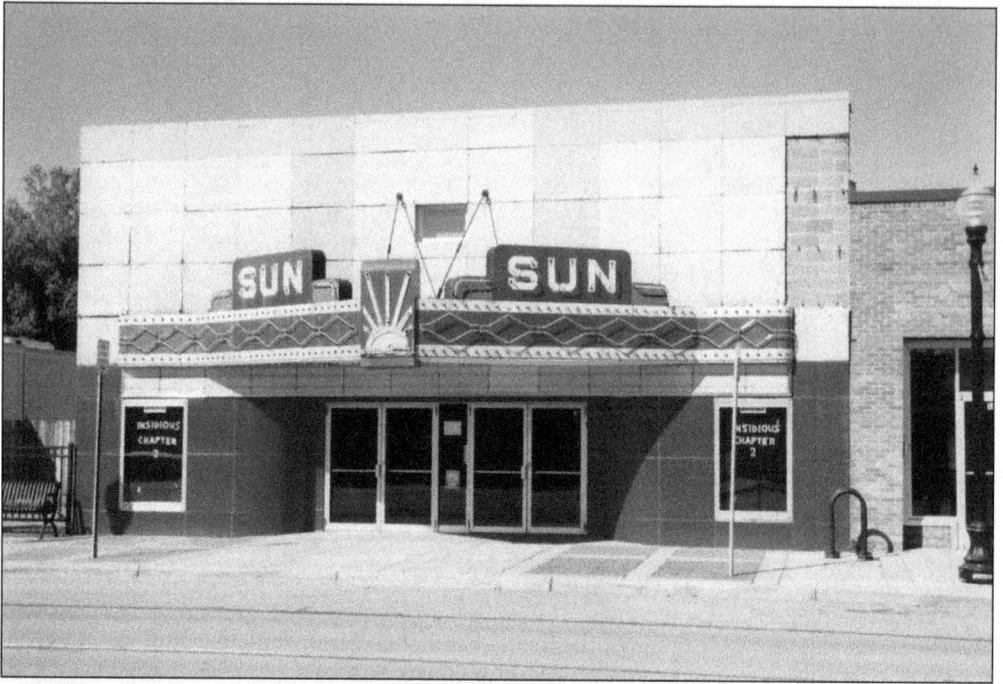

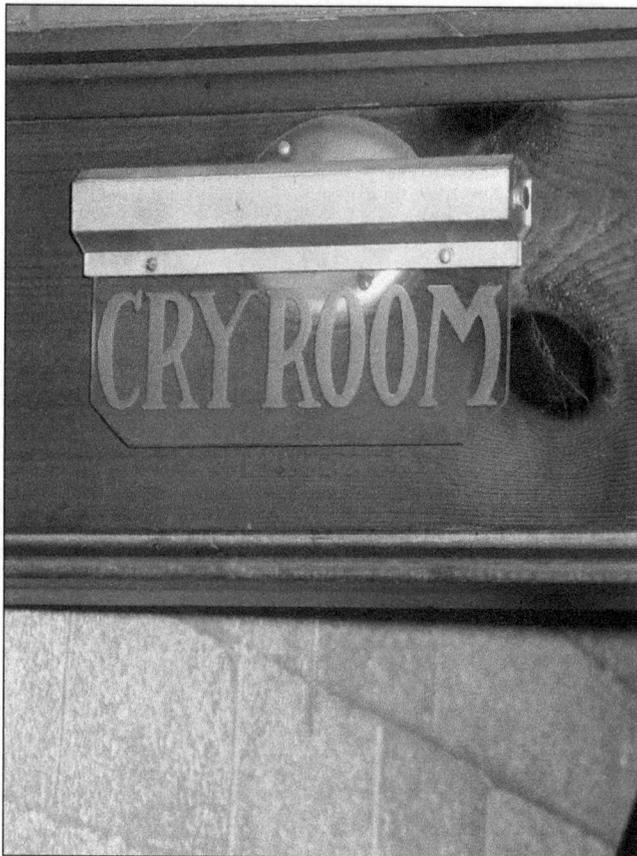

THE SUN RISES AGAIN. A small-town theater thrives in a multiplex age. The Sun Theater, built around 1947, still sports its original porcelain marquee. Dan and Lisa Robitaille, owners since 1979, did a crowd-funding campaign to raise $65,000 to buy a digital projector, and they reached their goal in 50 days. The Williamston community loves its Sun, which seats 300, is reasonably priced, and even has a private upstairs "cry room" for mothers and babies.

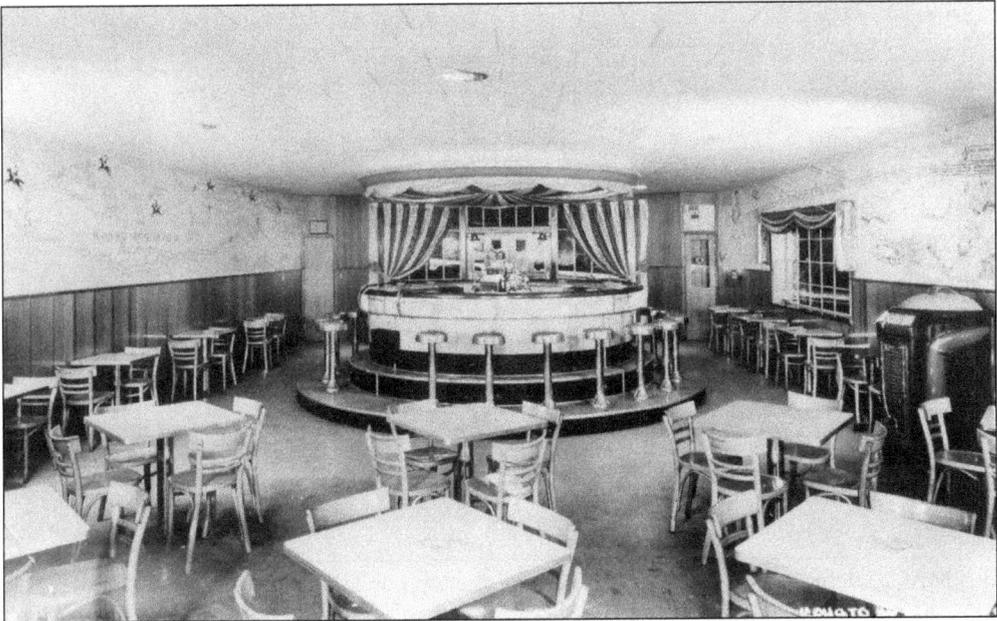

"YOUR COCKTAILS ARE COMING, YOUR COCKTAILS ARE COMING!" Founded in 1948, Paul Revere's once boasted the only merry-go-round bar in Michigan. A true novelty, the bar actually rotated, to the delight of everyone involved, except perhaps the bartender, who had to wait for the bar to become aligned with an opening in order to exit. Apparently, there were also a few falls and spills over the years. Revere's is still serving food and drink, but the bar no longer moves.

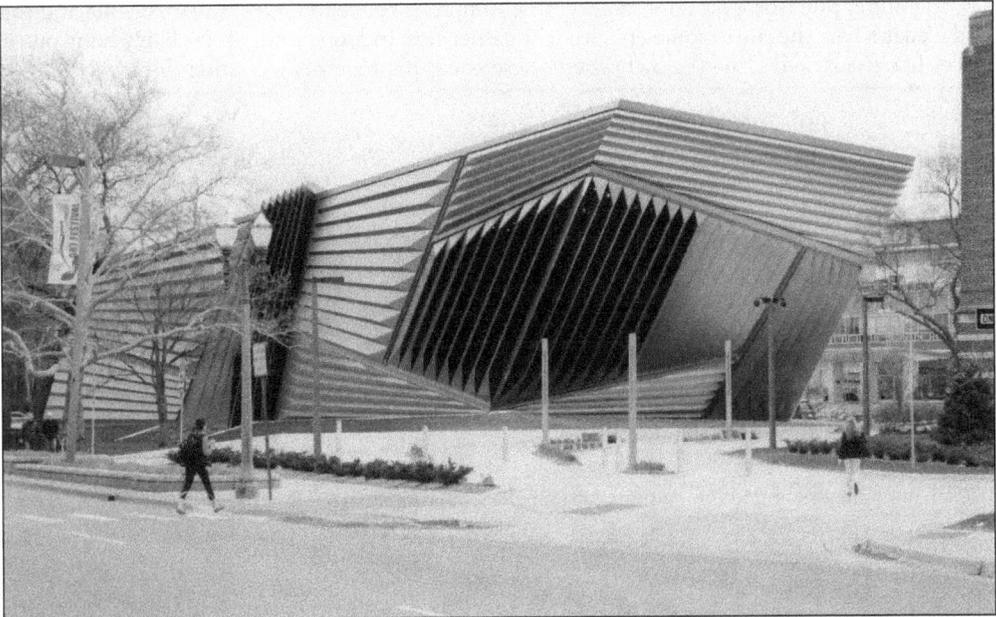

"IT'S A BIRD! IT'S A PLANE! IT'S AN ART MUSEUM!" Worth seeing from every angle, the Eli and Edythe Broad Art Museum is bringing worldwide attention, and tourism, to East Lansing. Designed by Pritzker Prize–winning architect Zaha Hadid, more than 70 percent of the museum is exhibition space. The stainless-steel building looks different depending on the time of day—and one's point of view. (Courtesy of the author's collection.)

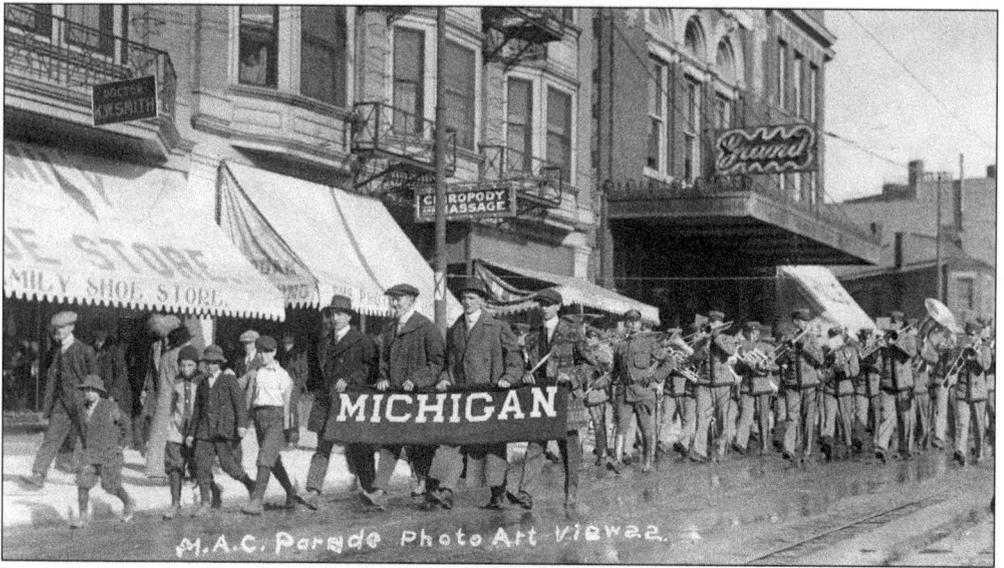

M.A.C. Parade Photo Art View 22.

Big MAC. Michigan State University is one of the top public universities in the country, but, to some, it is still fondly remembered as Michigan Agricultural College (MAC). As the nation's pioneer land-grant university, it was the prototype for the entire agricultural college system, created when President Lincoln signed the Morrill Act in 1862. Today, it has one of the largest student bodies in the United States, which is probably something the students marching above could not have imagined. Although MSU's agricultural studies are still important, "Moo U" has diversified, with medical schools and a veterinary school, among others. It will soon be the national site of a $730 million rare isotope beams facility. The campus is between Grand River Avenue and the Red Cedar River, the site of some epic student gatherings. Indoors, students probably hung out at places like the Rexall Drug (below), where these coeds put together a counter display in 1947.

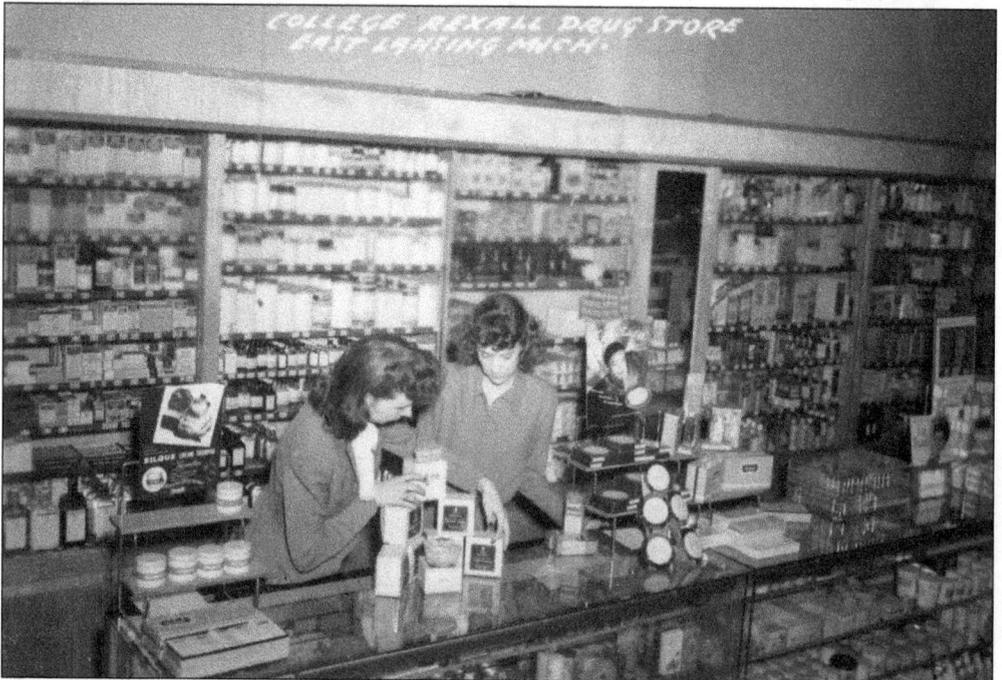

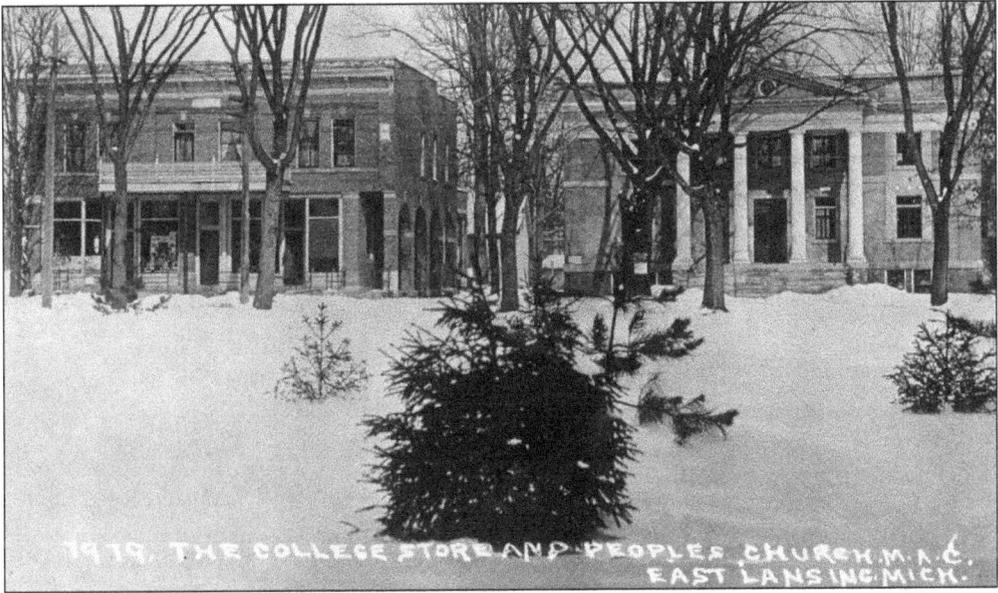

1979. THE COLLEGE STORE AND PEOPLES CHURCH, M.A.C. EAST LANSING, MICH.

PRAYER TO THE PEOPLE. The People's Church started as a congregation in 1907. At the time, it was the only church in East Lansing. In 1924, it began a unique, early experiment when it became an interdenominational church, with Congregational, Presbyterian, Northern Baptist, and Methodist Episcopal congregants coming together to worship. The name later lost its apostrophe and became the Peoples Church, and it still thrives today. This photograph shows the original church, which stood next to the College Grocery.

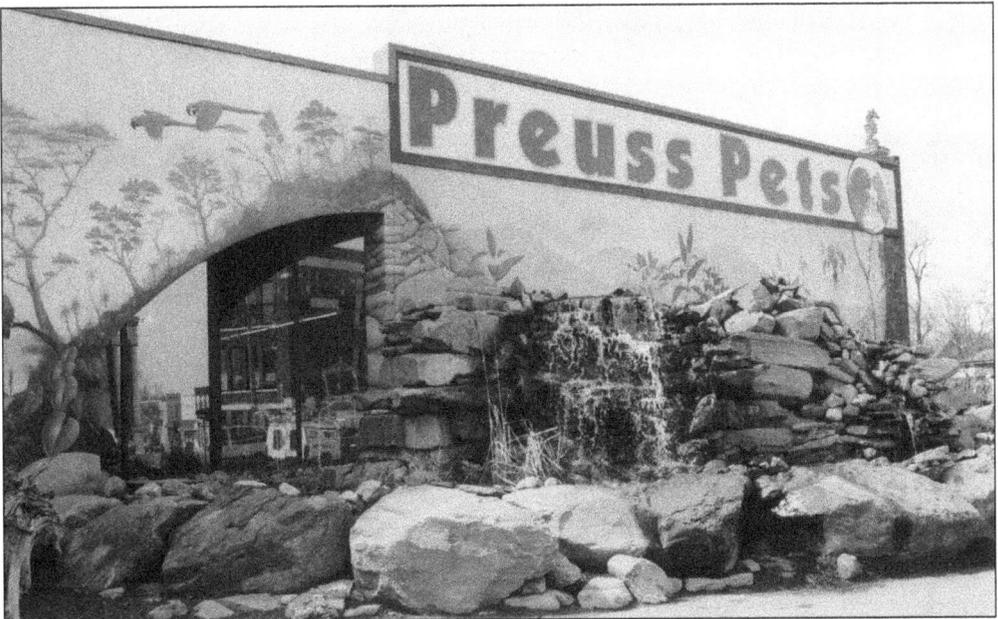

PETS, PICKS, PIZZA, POPCORN, AND PLENTY TO PERUSE. With over 22,000 packed square feet, Preuss Pets is like an indoor zoo for kids and grown-ups alike. From fabulous fish to exotic birds to 75-year-old tortoises Fred and Ginger, Preuss is the soul of Lansing's funky Old Town district, along with antiques shops, boutiques, and unique restaurants like Sir Pizza and Golden Harvest, where ear-splitting music and Cap'n Crunch French Toast keep hungry patrons lining up.

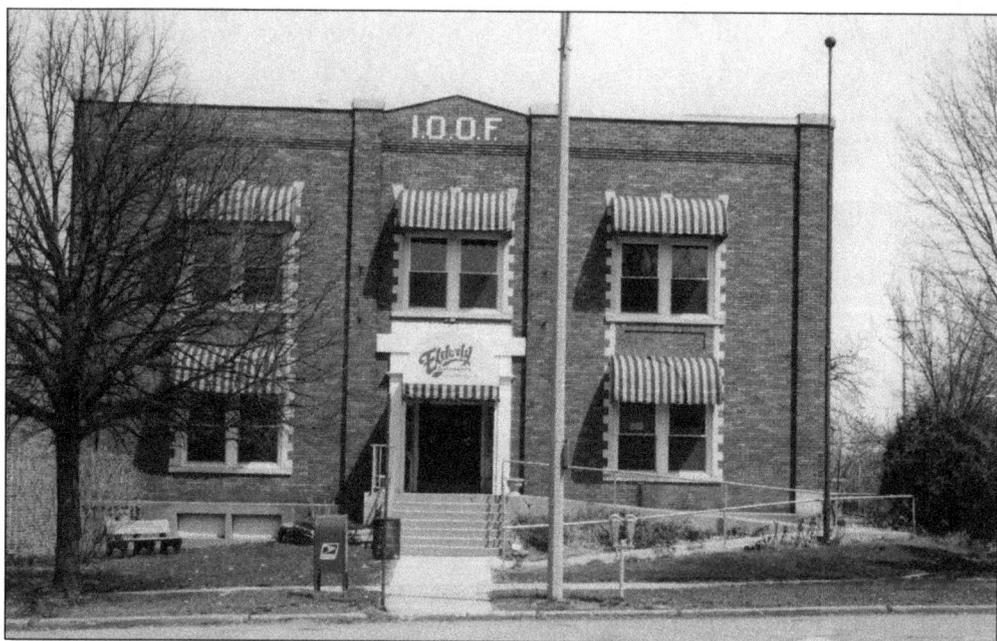

STRUM 'N' CHUM. With a name borrowed from an ad for a vintage Les Paul guitar ("a really nice elderly instrument"), this former Odd Fellows Hall draws music lovers from around the world. Started in 1972, Elderly Instruments is 35,000 square feet of nirvana for anyone who plays anything. Customers strum vintage mandolins or marvel at the ukulele inventory, and the employees really know their stuff. Musicians make a detour to stop here, and customers include Vince Gill, John Mayer, Elvis Costello, and Metallica. After jamming, visitors often stroll down to the Brenke Fish Ladder. Built in 1981, it helps fish swimming up the Grand River pass the dam without injury. It is a peaceful place to sit, relax, or kibitz with fishermen, who catch catfish, sunfish, and other smaller species of fish that inhabit the Grand River.

Six

CLINTON AND IONIA COUNTIES

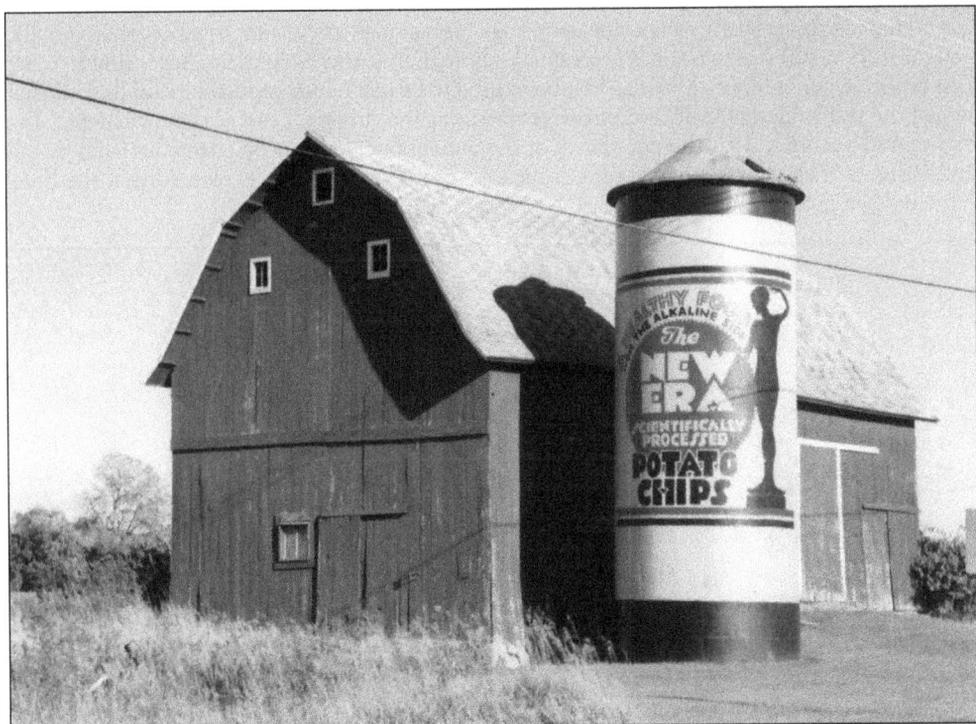

NEW ERA, OLD ROAD. Once out of Lansing and on the rolling, two-lane blacktop of US 16 again, one can still see evidence of the roadside America once enjoyed by motorists of an earlier generation. Near Portland, there is the welcome sight of a barn silo bearing a painted ad for New Era potato chips. It is a restoration, of course; New Era was a Detroit brand dating from the early 20th century that was bought out by Frito-Lay in 1981 and is now, sadly, gone forever.

EAGLE SCOUTING. Along the winding road that Grand River Avenue becomes between Lansing and Grand Rapids, drivers invariably come upon Eagle. It is a small town, and, based on photographic postcards from 100 years ago, it is even smaller now than it was back then. According to Marc Finkbiner, owner of Marc's Marine, "the town used to have a pretty good-size hotel [below] that served the traffic along US 16 and passengers arriving into town via rail at the town depot. But by the mid-twenties, with the popularity of the automobile, fewer people were arriving by rail and business at the hotel dropped off significantly." Finkbiner further explained that the hotel burned down around 1933. Marc's Marine now stands on the same site.

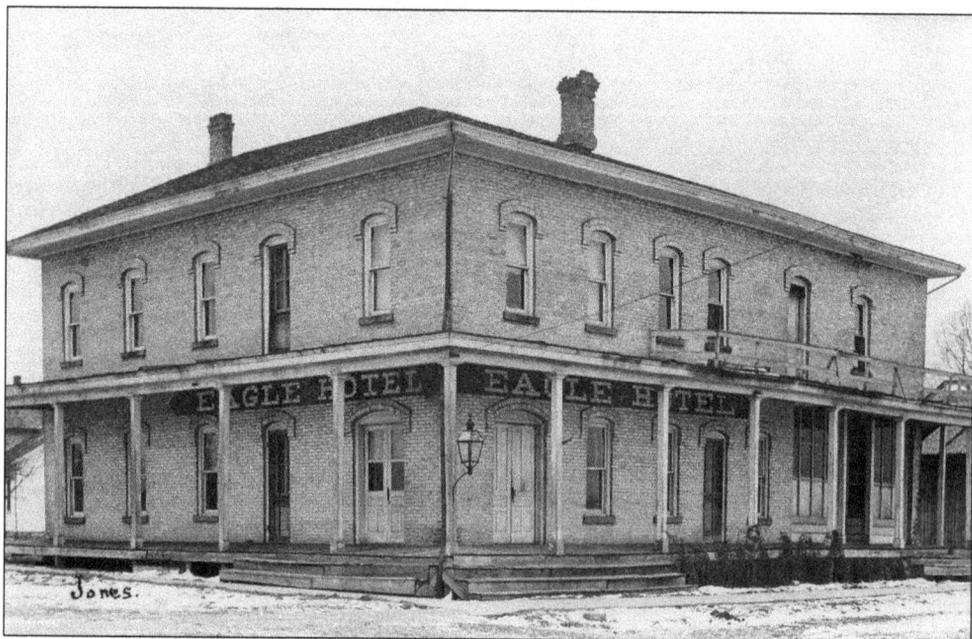

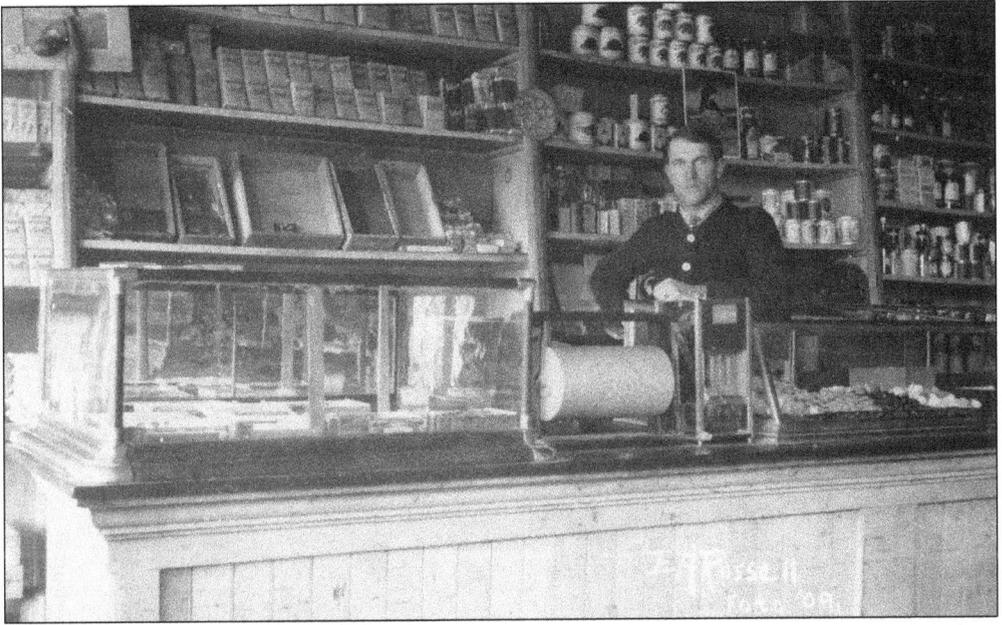

BLUE FLOYD. The back of the postcard above, dated 1909, reads, "This is a picture of the store where I work and myself, from Floyd." Meanwhile, the card on the bottom of the previous page was sent to Floyd and "sealed with a Kiss!," which seems hard to do with a postcard. Still, his admirer wrote, "You old sweet, I was very glad to hear from you. I felt fine after the dance. You said you felt blue, Sunday. Why didn't you come over? Next time you feel that way, you do that!" The dance was likely held at the Eagle Hotel. Finkbiner believes the photograph above was taken in the store, now called Swampers, pictured below and still standing a few doors from Marc's Marine.

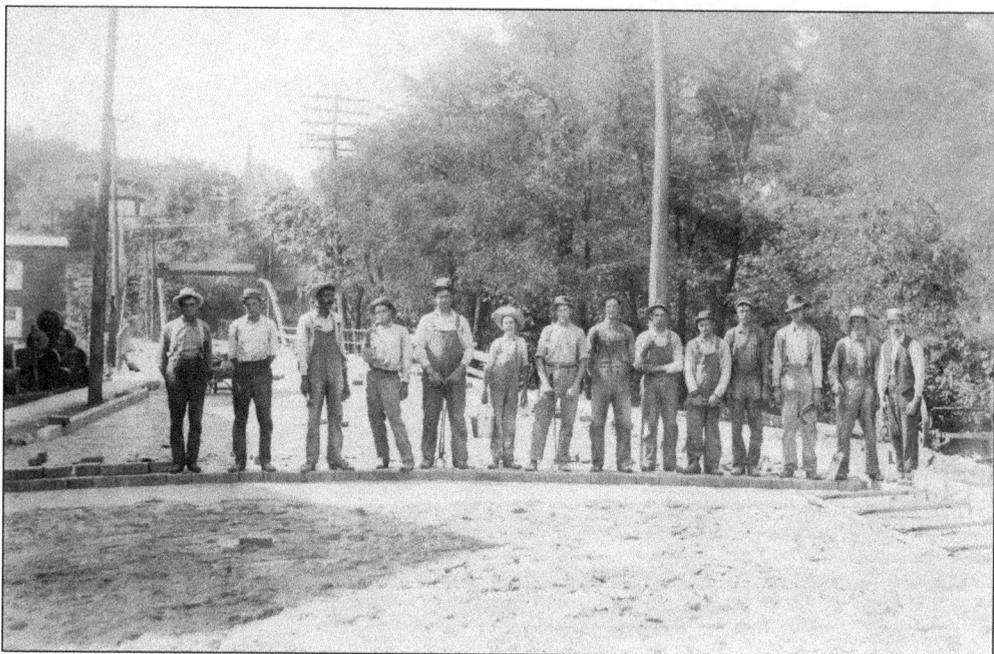

BRICK BY BRICK. Workers momentarily stand for a photograph along the end of their line of progress as they painstakingly lay paving bricks, one at a time, along Grand River Avenue and, most likely, all of the downtown streets of Portland around 1910.

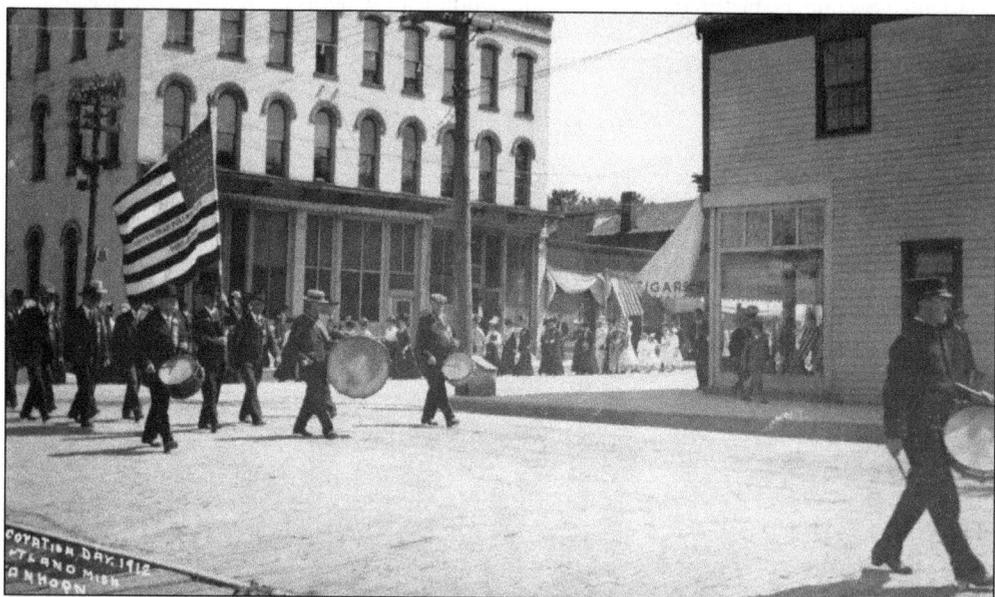

PORTLAND PARADERS. The Portland City Band marches past Kent Street and up US 16 towards the Grand River Bridge on Decoration Day in 1912. The brick paving shown in the previous photograph is quite visibly complete, and a crowd can be seen lining the street in front of the Hotel Divine in the background.

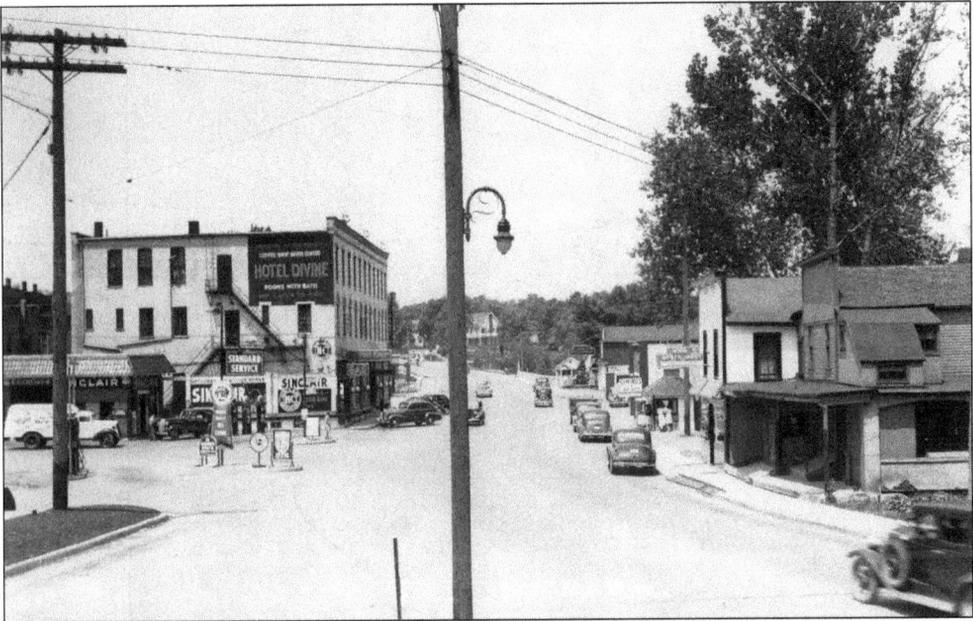

COMING AROUND THE BEND IN PORTLAND. On the reverse of this postcard from around 1938, someone named Minnie wrote, "Do you know this street, Chas? M-16, coming round the bend by your grandmother's! Is that your red car coming out our way? Wish'd it was, don't you?"

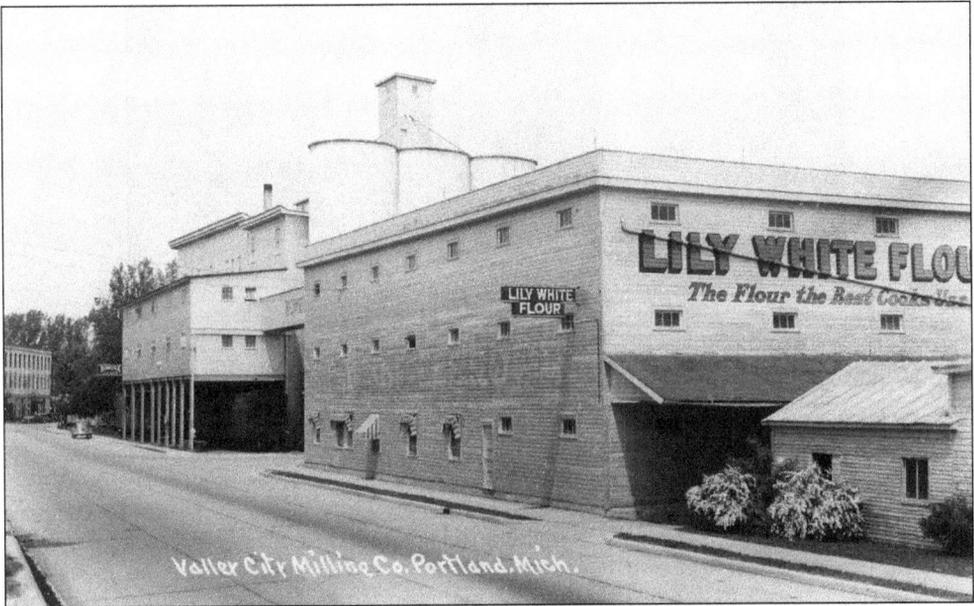

THE LILY IS A LOVELY FLOUR. Lily White Flour was advertised as "The Flour the Best Cooks Use," as seen here on the wall of Portland's Valley City Milling Company around 1947. While the company is no longer in existence, several of the structures shown in the photograph still stand along US 16 at the eastern entrance of town.

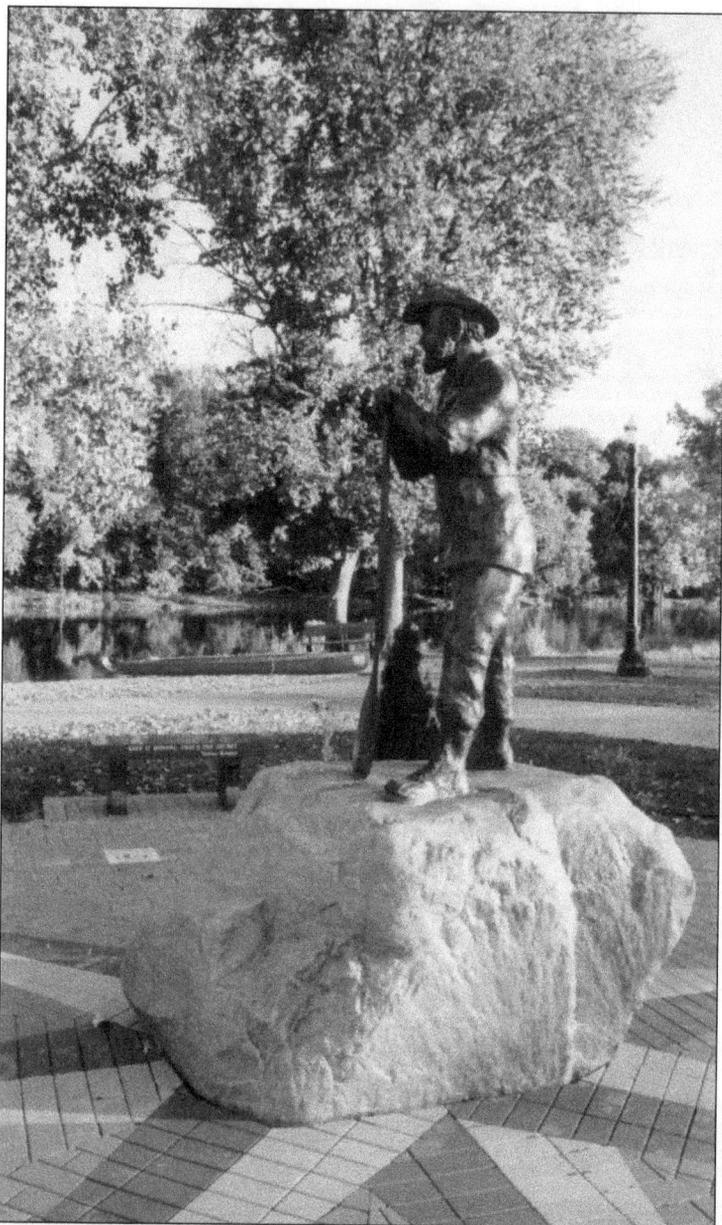

VERLEN KRUGER. Just across the river from downtown Portland, along the Riverwalk in Powers Park, stands this bronze statue of a man leaning on an oar and surveying the lovely length of the Grand River. The man memorialized amid the natural setting is Verlen Kruger (1922–2004), a world-renowned canoe enthusiast who earned his entry in *Guinness World Records* for paddling over 100,000 miles in his lifetime. Amazingly, he did not undertake his first mile until the age of 41. In an historic two-continent canoe journey, he once traveled 18,232 miles, and, along with fellow canoeist Steve Landick, he made another journey totaling 28,040 miles, which he dubbed the "Ultimate Canoe Challenge" and later outlined in a book of the same name, cowritten with Brand Frentz. The bronze statue of Kruger, created by sculptor Derek Rainey, was unveiled in 2010. More information on Verlen Kruger is available at www.verlenkrugermemorial.org.

Seven

KENT COUNTY

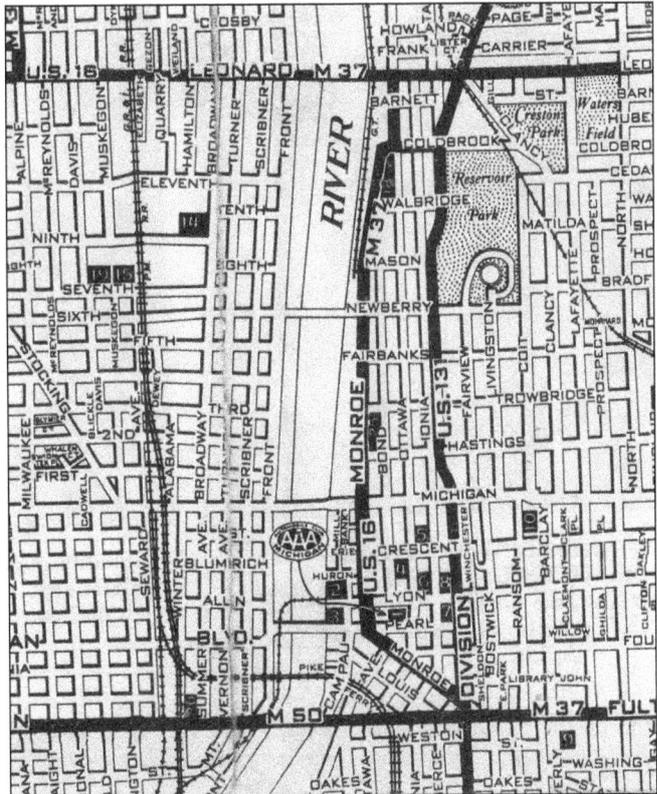

THREE STREETS, ONE HIGHWAY. This 1940 Grand Rapids map illustrates how US 16 runs through the city, sharing designation with several streets. Entering from the east via Cascade Road, US 16 quickly becomes one with Fulton Street. In the downtown district, it turns north onto Division Street, but only briefly, before angling northwest with Monroe Street and following it due north past Michigan and Newberry Streets until US 16 joins Leonard Street, turning westward across the river and on to Walker Station.

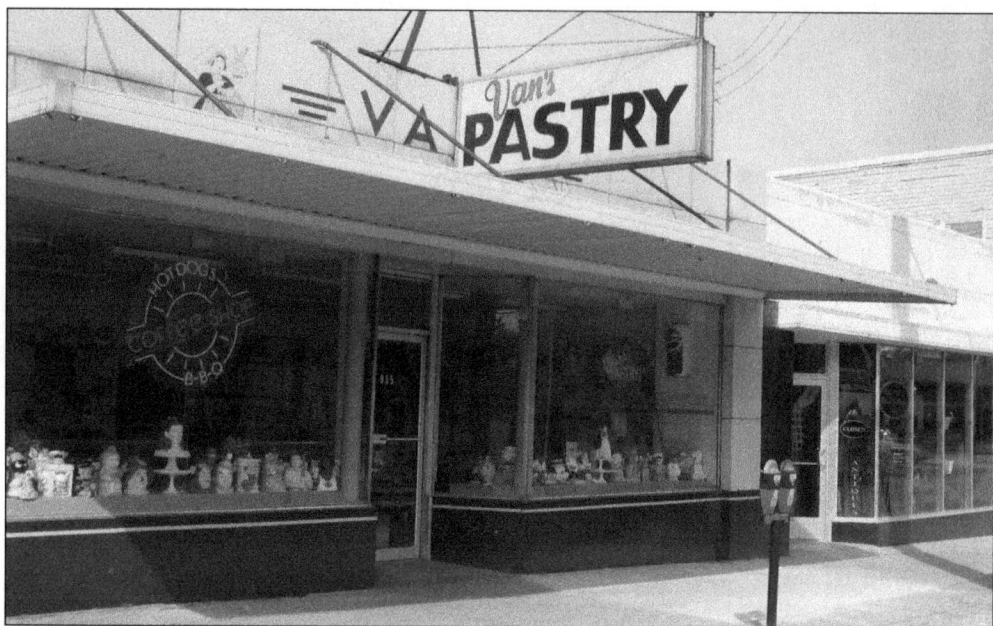

Dutch Treats. Grand Rapids' East Fulton District is a unique part of town with specialty shops, galleries, restaurants, antiques stores, and an 80-year-old tradition known as Van's Pastry. The family-owned bakery, run by John and Donna Vander Meer, serves up old-fashioned Dutch treats from family recipes. Try the Olie Koeken (known as fat balls, a Dutch donut). Delicious pastries aside, it is worth seeing just for the 400 cookie jars adorning the shelves.

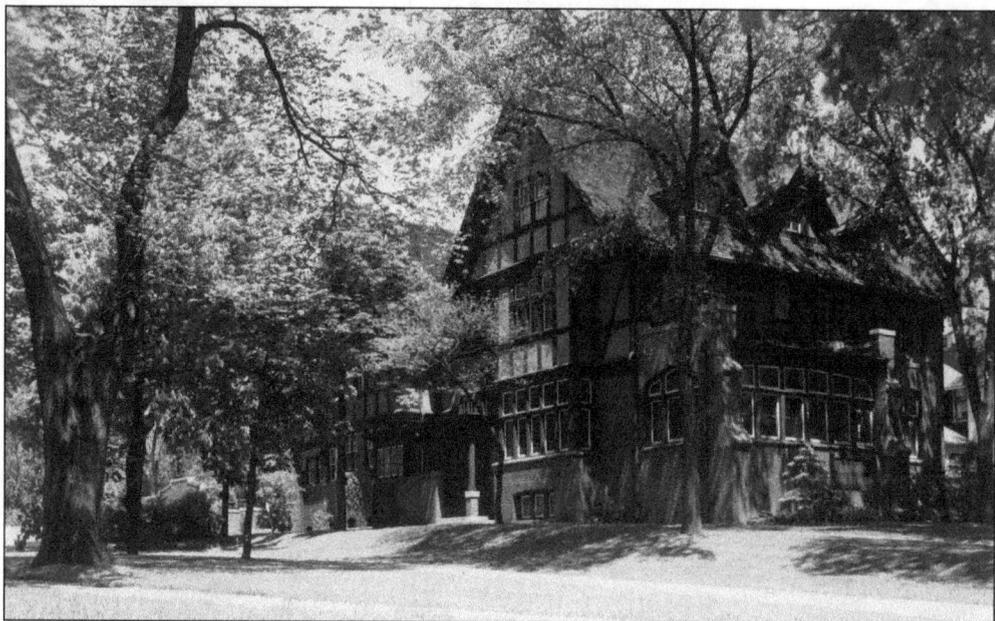

Part of the Furniture. Just past East Fulton, the grand mansions of Grand Rapids' Heritage Hill fill the landscape. Among them is this fantastic Tudor-style manse, which once housed the Grand Rapids Furniture Museum. Now a part of the City Museum, the exhibit displays many of the incredible pieces that once built Grand Rapids' reputation as the "Furniture Capital of the World."

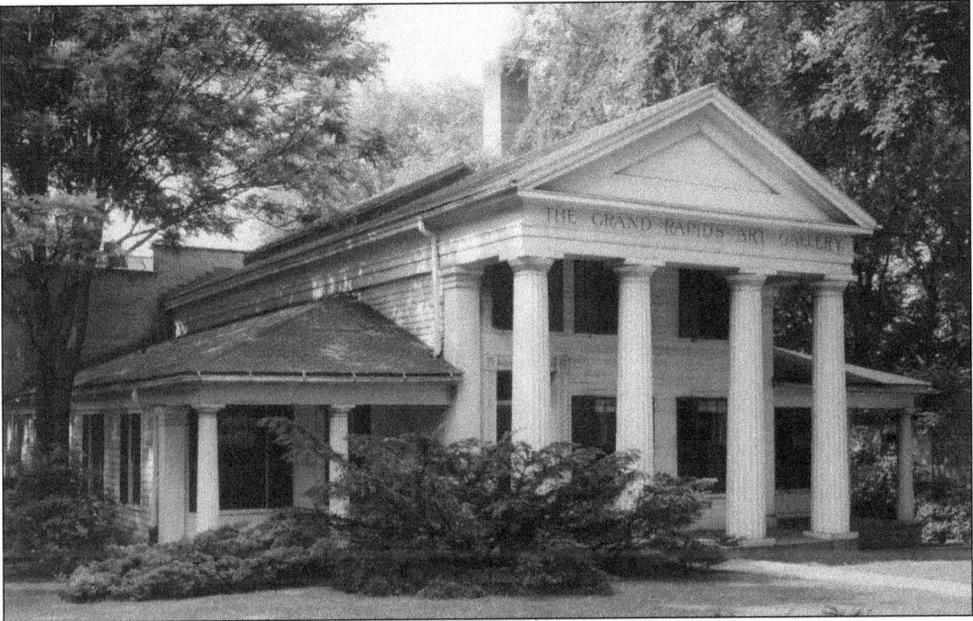

Artistic Perspective. The Grand Rapids Art Museum (GRAM) began as the Grand Rapids Art Gallery on Fulton Street (US 16) in 1910, occupying this Greek Revival mansion. Since then, it has expanded to include more than 5,000 works of art and welcomes more than 250,000 visitors annually. Today, the museum is headquartered in a modern complex at 101 Monroe Center, with additional galleries in the Woodbridge N. Ferris Federal Building.

An Oldie and a Goodie. Proud to be the oldest bar in downtown Grand Rapids, the Cottage Bar is cozy, almost a hideout, and has had only three owners since 1927. Juicy burgers and the namesake cottage fries go best with a drink from the Art Deco mahogany bar. Around the corner is One Trick Pony, built in 1856 as Oliver Bleak's General Store. Signs from the 17 other businesses that occupied this space are on the walls of this fine dining restaurant.

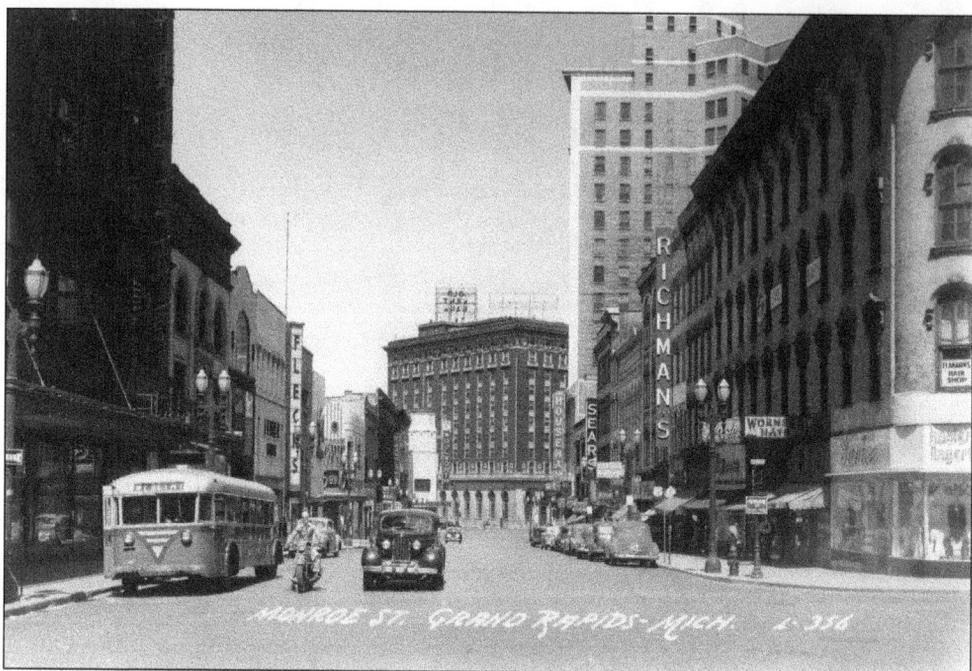

MONROE ST. GRAND RAPIDS-MICH. 1-356

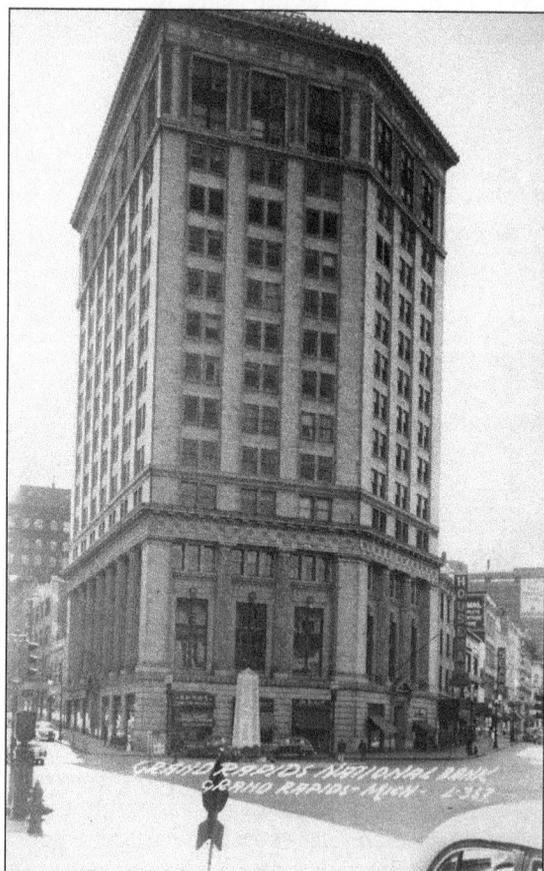

GRAND RAPIDS NATIONAL BANK
GRAND RAPIDS-MICH. 1-358

GRAND CANYON. From Fulton Street, US 16 jumps briefly up Division Street, then breaks left up Monroe Street, seen here, at an almost 45-degree angle, going past Wormser Hats, Richman's, Flecks, Sears, and Houseman's in postwar Grand Rapids of 1946. While many of the stores pictured are long gone, this stretch of Monroe is still a busy shopping district today. At the end of the block in the center is the Pantlind Hotel, now the Amway Grand.

FIRST TO THE TOP. Built in 1914 as the Wonderly Building, the impressive McKay Tower, standing at 146 Monroe Street Northwest, became Grand Rapids' first skyscraper by increments. Originally a four-story bank building, 12 additional floors were added in 1925, followed by two more in the early 1940s. In 1942, millionaire investor and controversial political promoter Frank D. McKay purchased the building and promptly changed its name. At the time, it was the tallest building between Detroit and Chicago.

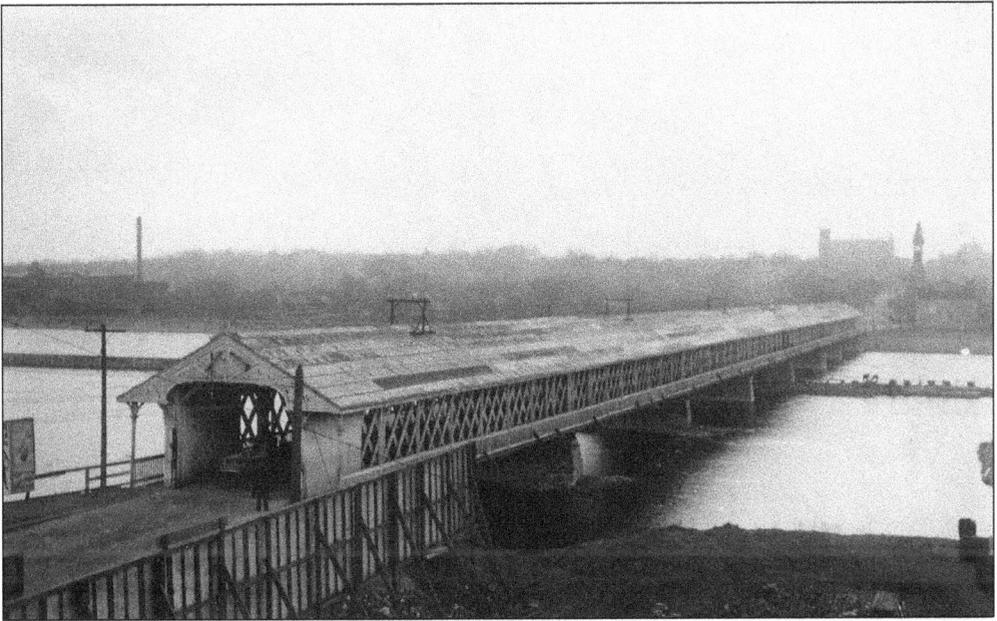

UNDERCOVER. Monroe Street "hands off" US 16 to Leonard Street when the two streets meet at a corner, and US 16 heads west across the Grand River. Here, the view is still an impressive sight, but was once even more noteworthy. The old Leonard Street Bridge (above), built in 1879, was Michigan's longest covered bridge, measuring 832 feet in length. It was actually one of three covered bridges in the city of Grand Rapids, and it was ultimately replaced in 1913 to accommodate the heavier traffic of the automobile age. Today, the Leonard Street Bridge affords a view of Grand Rapids, old and new, as it looks out over the old furniture factories and warehouses that border the Grand River, eventually giving way to the more modern structures towering in the distance.

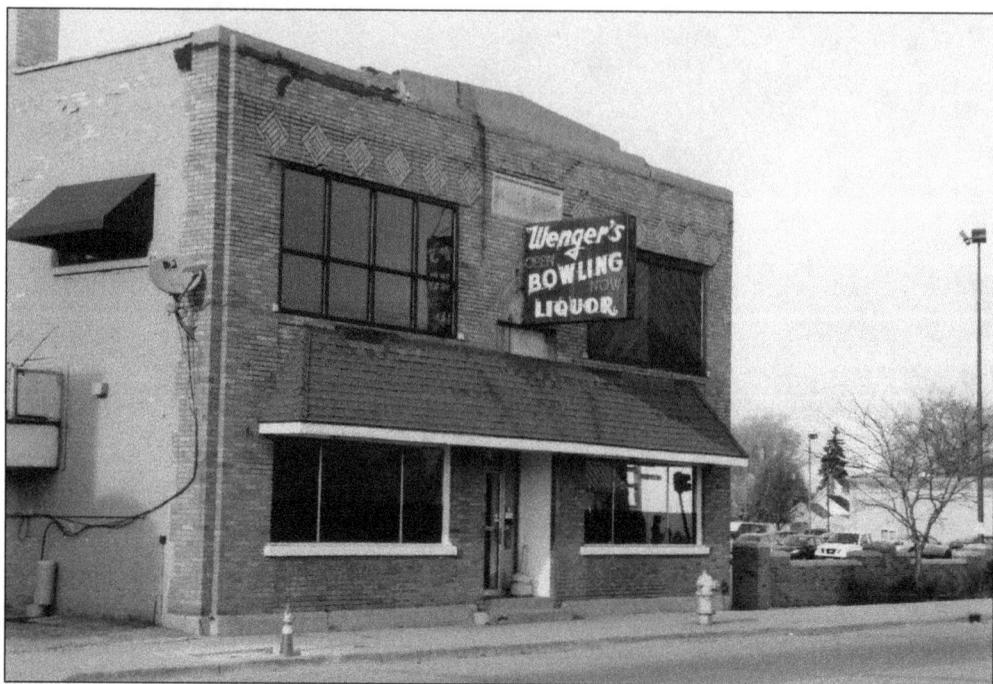

WENGER'S. Among the shops and boutiques in Grand Rapids' West Leonard District, Wenger's Bowling Alley is a rare glimpse at a "lost world." The vintage neon sign is the first clue. Inside, Wenger's features 16 hand-oiled alleys (eight on the main floor and eight upstairs) and has been in continual operation since 1920. Though it has upgraded over the years, adding automatic pinsetters, it remains one of the few alleys with aboveground ball returns.

WALKER STATION. East of Grand Rapids, Leonard Street splits from US 16 at the town of Walker, or Walker Station. First settled in 1836, it is home to the Meijer and Bissell Corporations. Only a few original buildings remain in Walker, as most were destroyed by a 1956 tornado that also devastated nearby Standale. The Walker interurban station, seen here, still stands. Although it is now repurposed as a clinic, its control tower still declares its original purpose to knowing passersby.

Eight

OTTAWA COUNTY

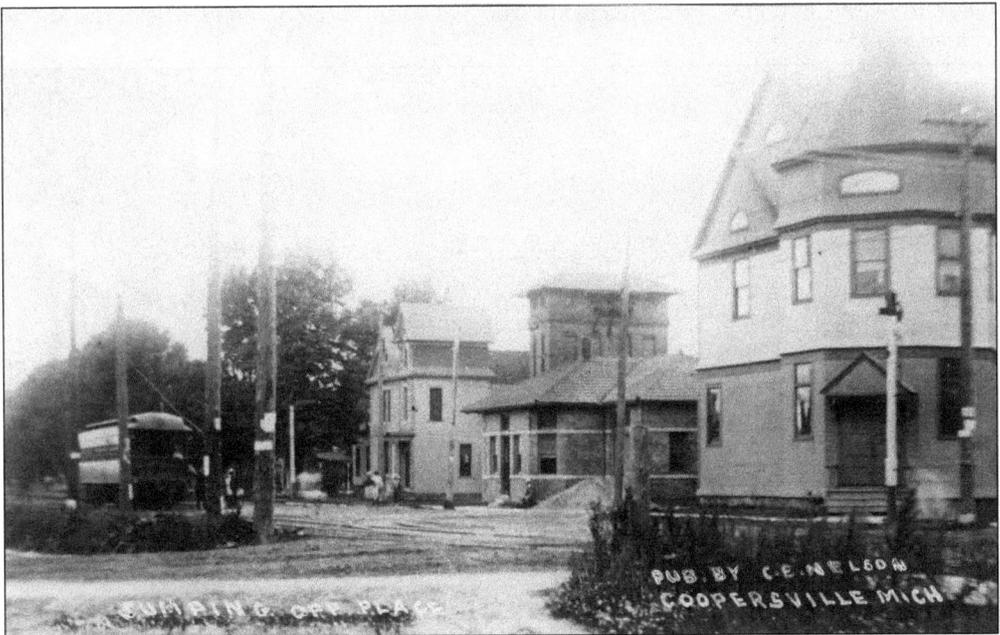

JUMPING-OFF PLACE. That is the title of this postcard print of Coopersville, Michigan, from 1910. At the time, Coopersville was a major stop along the Grand Rapids, Grand Haven & Muskegon Interurban Urban Railway, and a good point for travelers to "jump off" towards Spring Lake and Grand Haven, or up to Fruitport and Muskegon. The interurban station (center) still stands and is now the home of the Coopersville Historical Museum.

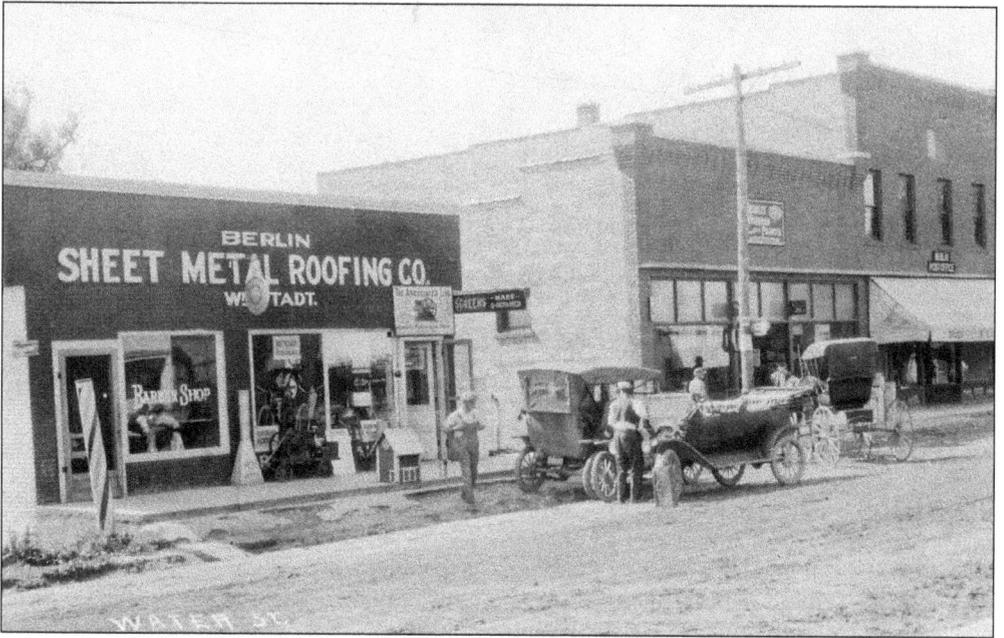

BERLIN/MARNE. In 1839, a group of German immigrants settled the village just west of Grand Rapids. To honor the capital of their homeland, they named the settlement Berlin (above). For the first 76 years, everyone seemed fine with the name, but when World War I came along, anti-German sentiment ran high, so the citizens of Berlin changed the name of their town from Berlin to Marne, in honor of the Americans who had fallen in the Second Battle of the Marne in France.

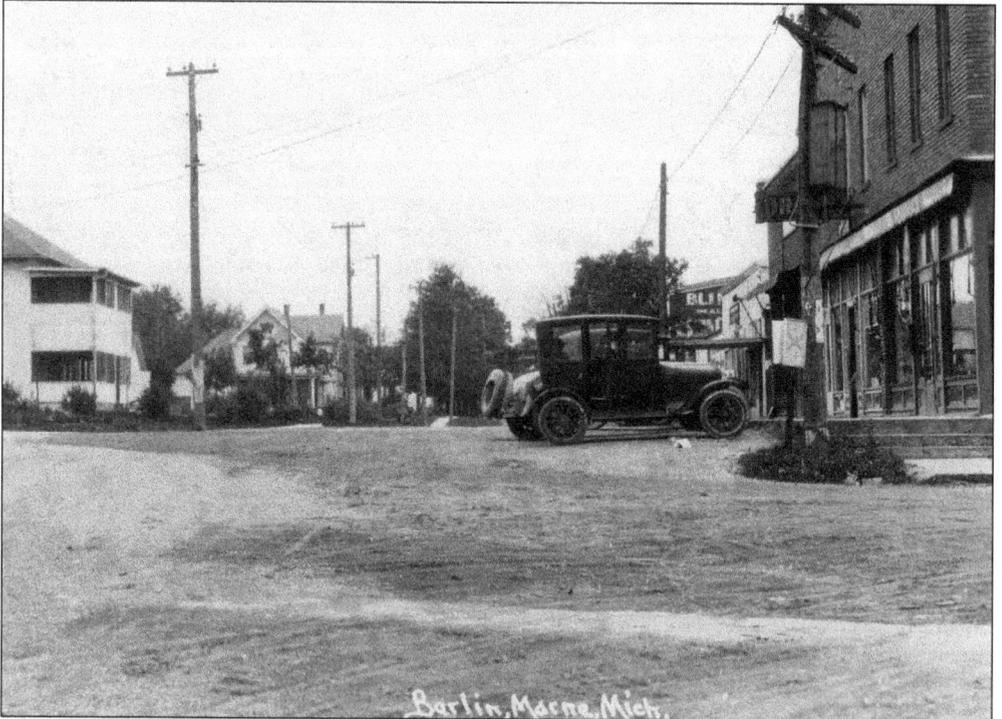

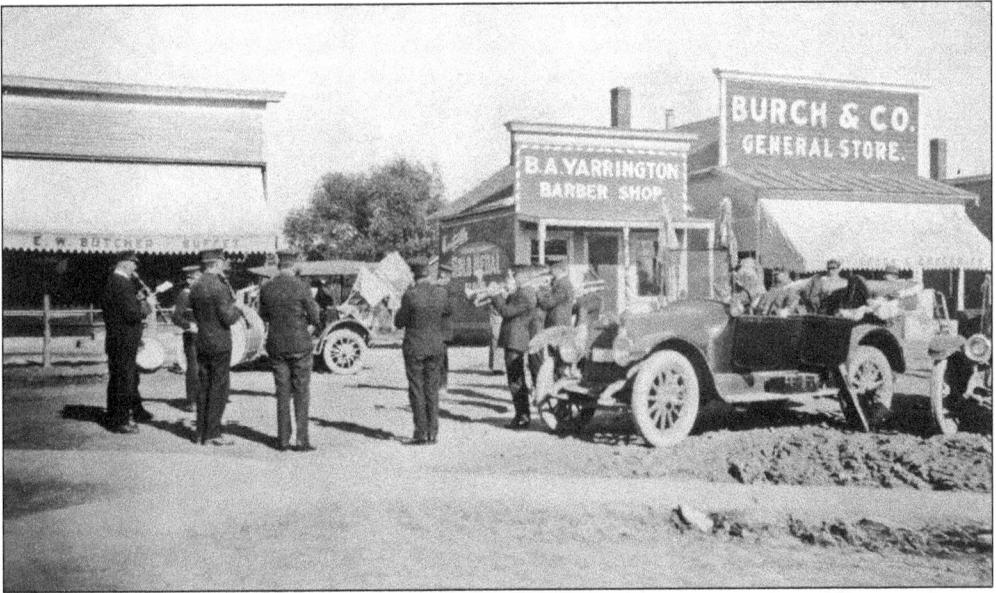

MARCHING BAND. The town marching band seems to be holding court in the center of the main thoroughfare in this image. In the background are Bert Yarrington's barbershop and George and Olive Burch's general store.

"HELLO CENTRAL, GIVE ME MARNE." Grand Rapids contributor Bill Burkhardt relates that his great aunt Fern Garter was Marne's Michigan Bell telephone agent during the 1930s, and her teenage son Eldred, seen here in 1935, often had the "honors" of covering the switchboard during the wee hours. Since the business was run out of their home, Eldred usually slept on the couch, briefly waking to handle calls when necessary. (Courtesy of Carol Park.)

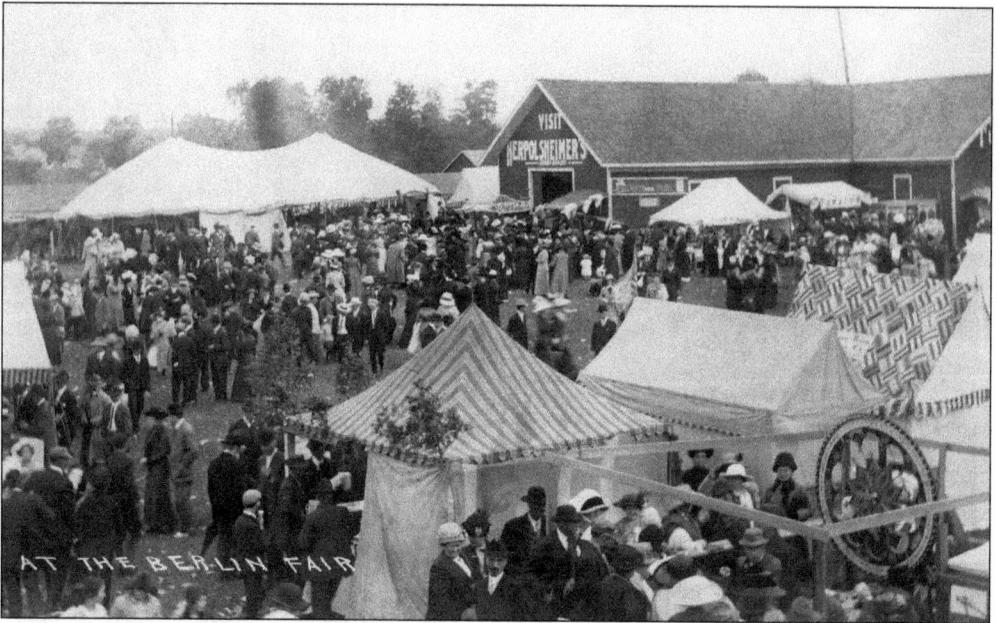

AT THE BERLIN FAIR

THE BERLIN FAIR. In 1919, while the Berlin/Marne town folk decided to adopt a new, non-German name, the people most responsible for organizing the annual fair—not to mention a particularly great American songwriter named Irving—decided to stick with Berlin. As a result, the town became Marne, but the fair and the songwriter remained the same. The Berlin Fair, shown above in 1913, was organized by the Ottawa Agricultural Society and has been a popular annual event for folks in Ottawa and Kent Counties since 1855, though it was not actually held in Berlin until 1870. Below, a scene in front of the grandstand seems to involve a race or an auto display of some sort. Marne picked up the pace a bit on that score, adding the high-speed, nationally known Berlin Raceway in 1950. Today, the track is a regular stop on the Automobile Racing Club of America (ARCA) and Champion Racing Association (CRA) racing tours.

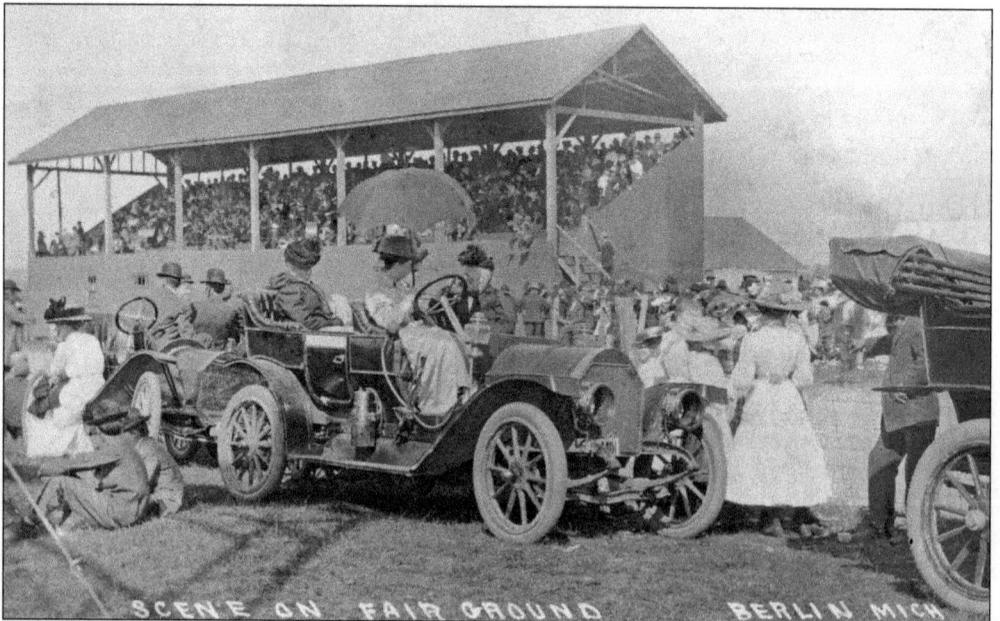

SCENE ON FAIR GROUND BERLIN MICH.

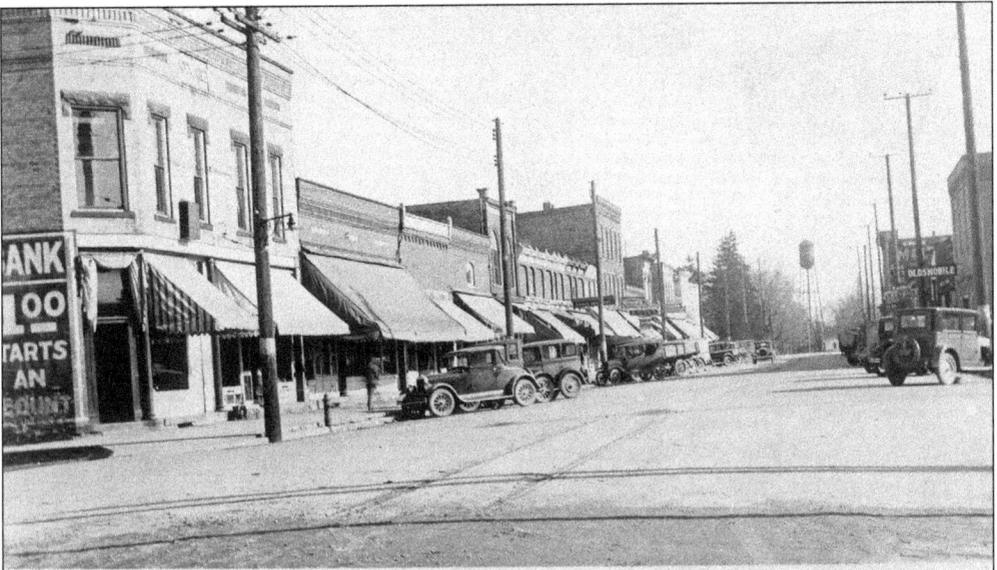

Main Street, Coopersville, Mich.

COOPERSVILLE. When a post office was established in Coopersville in 1846, township organizer Timothy Eastman named the town Polkton in honor of Pres. James Knox Polk. Most of the land, however, was owned by Benjamin Cooper, an original settler out of New York, and when the railroad came through in the late 1850s, he offered the railway as much land as it required, provided the station be named in his honor. The railroad complied, and the whole town eventually became known as Coopersville. Over the past 100 years, the town has changed very little, and, other then the mid-1920s automobiles in the photograph above, Main Street looks much the same. Today, it is still known as a railroad town, though mostly from a historical perspective. In the 1908 photograph below, a locomotive pulls into Coopersville.

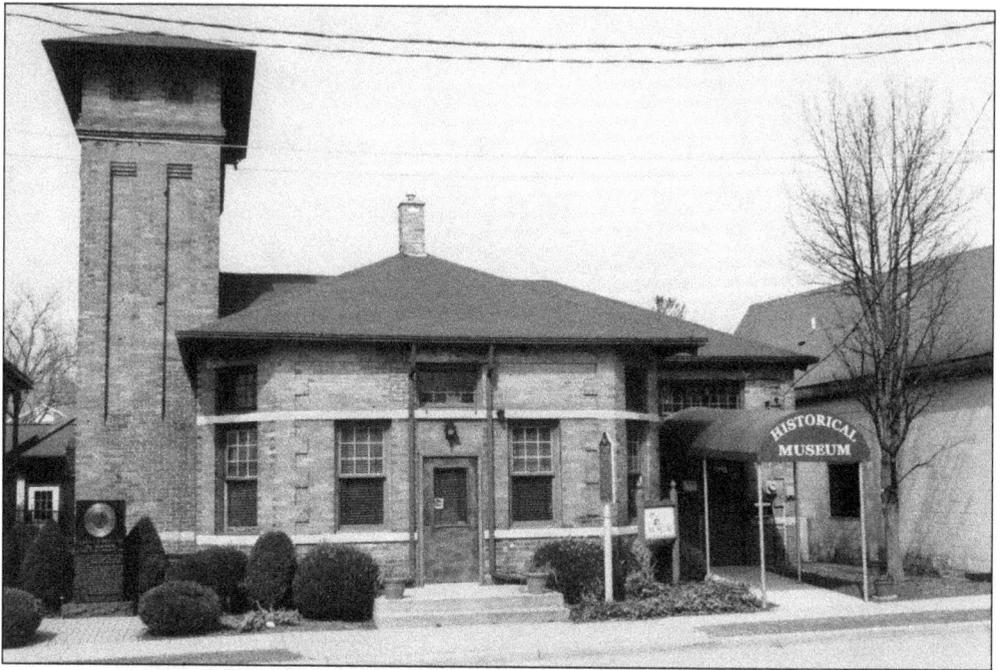

RAILROAD CROSSING. Coopersville is virtually a living museum of railroad history. The historical museum is actually housed in one of the only existing substations of the GRGH&M Railroad. Built in 1901, the interurban substation (above) still maintains its iconic tower. According to historian Jim Budzynski, 10,000 volts of AC power was regularly delivered to the substations via the tower, where it was converted to 600 volts of DC power in order to power and operate the trains. In addition to local railroad history, the museum features a wide variety of exhibits, artifacts, and information on Coopersville's unique past. While in town, visitors can also stop by the Coopersville Farm Museum and Event Center (below), located just across the parking lot from the museum.

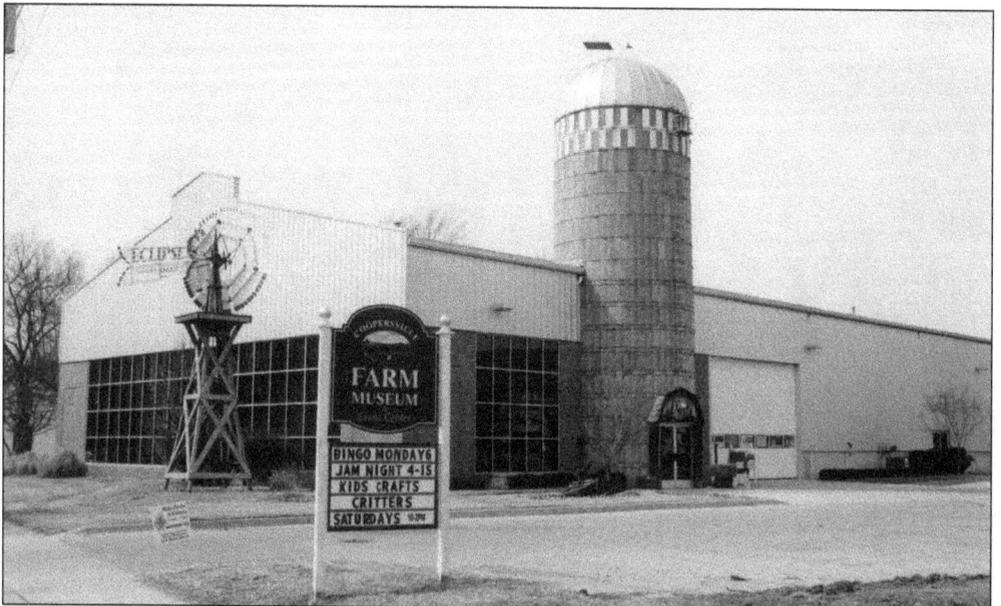

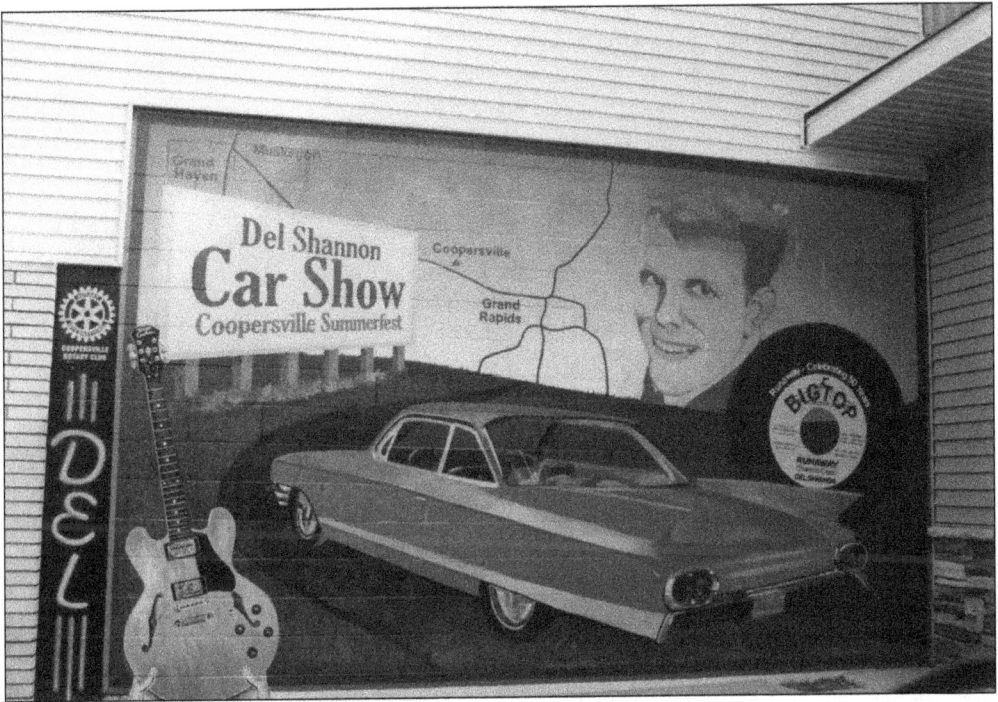

"RUNAWAY" COMES HOME. Coopersville devotes a mural and a memorial to its most famous son, Del Shannon. Born Charles Westover in 1934, he took the Del part of his name from his favorite car, the Cadillac Coupe de Ville, and the Shannon from a local wrestler. In the late 1950s, Shannon played the Hi-Lo, a local club. Signed to the Bigtop record label, he recorded his two biggest hits, "Runaway" and "Hats Off to Larry," in one day in New York City. "Runaway" ran to number one on the Billboard charts in 1961, and several hits followed. While Shannon's success dimmed in the United States, he remained popular in England, where he was the first American to record a cover of a Beatles song, "From Me to You." His career had many ups and downs, but his talent stayed true, and he was inducted posthumously into the Rock and Roll Hall of Fame in 1999.

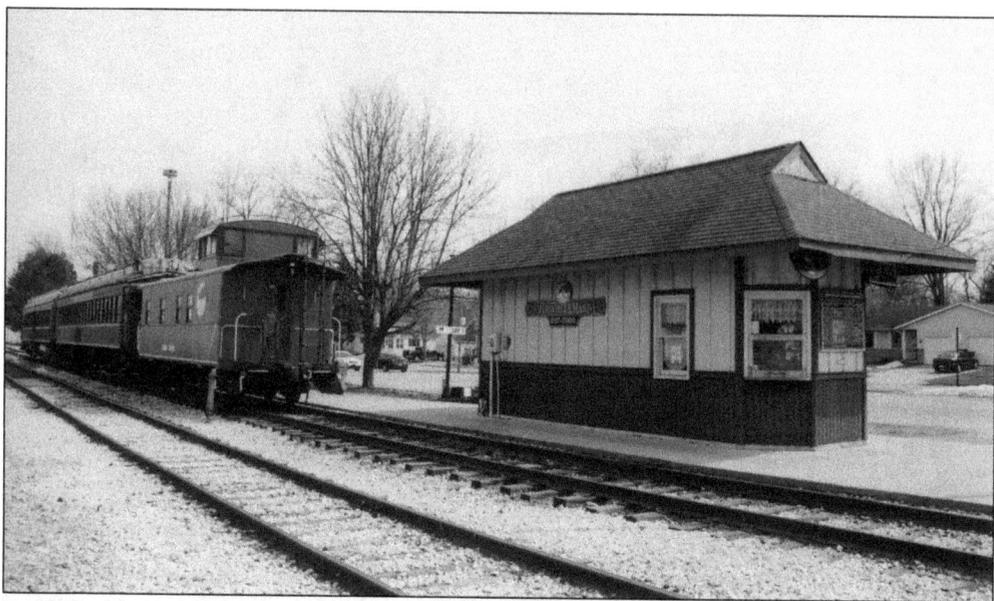

COOPERSVILLE & MARNE. A unique treat is the Coopersville & Marne Railway Company (above). Established in 1989, the volunteer railroad operates a round-trip excursion service from Coopersville to Marne over the track lines formerly used by the Grand Trunk Railway. With schedules running from March through December, trains depart from the ticket office in downtown Coopersville, stopping briefly in Marne before returning. Along with a regular schedule, there are special events and holiday excursions, including a "Great Train Robbery," a Halloween Pumpkin Train, and a Santa Train. More information and a list of events is available on the Coopersville & Marne Railroad website, www.coopersvilleandmarne.org. In the photograph below, a freight train runs by the Grand Trunk depot and through the rail yard around 1910, over tracks now utilized by the Coopersville & Marne Railway.

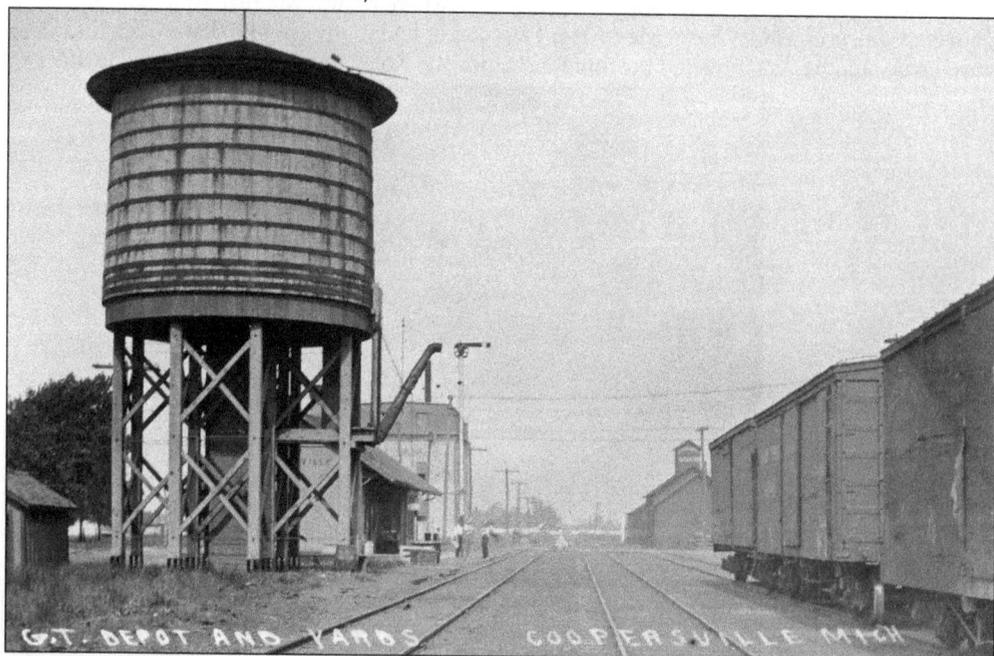

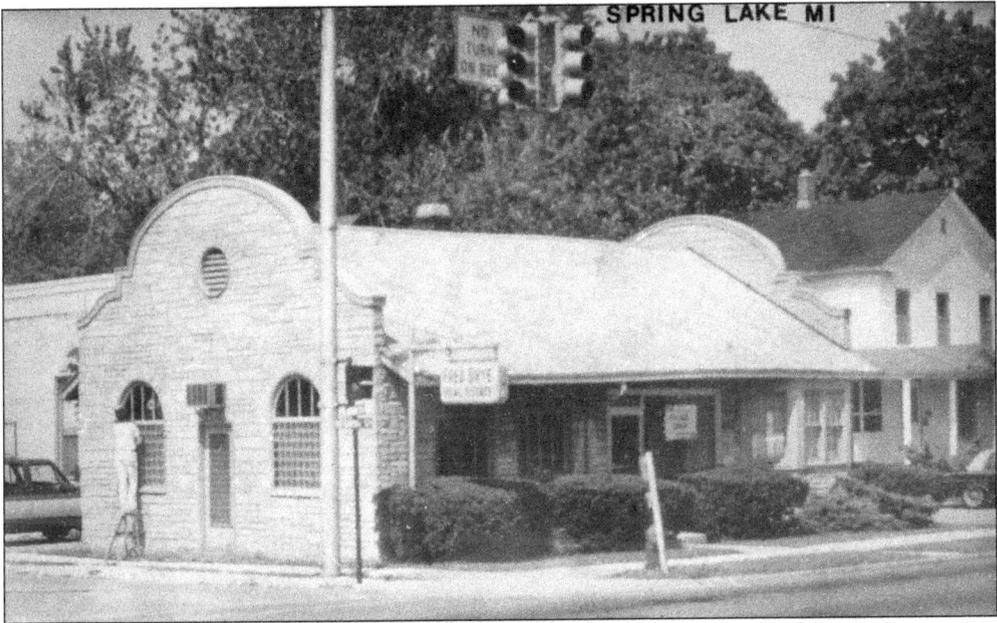

SPRUNG BACK TO LIFE. With an eye on local railroad history, the folks at the Coopersville & Marne Railway Company have made a point of preserving what they can of the region's past. For example, they came to the rescue of the Spring Lake interurban station. Built around 1913, the station stood on Savidge Street for many years after the Grand Rapids, Grand Haven & Muskegon Railway folded. Over time, it served several businesses, including the realty office pictured above. But, when a large bank purchased the property with a plan for new construction, the future of the landmark was clearly in peril. Thanks to the efforts of the popular tourist railway, along with some financial assistance from the bank purchasing the property, the station was moved to Coopersville, where it now continues to serve and enhance the historical railroad landscape (below).

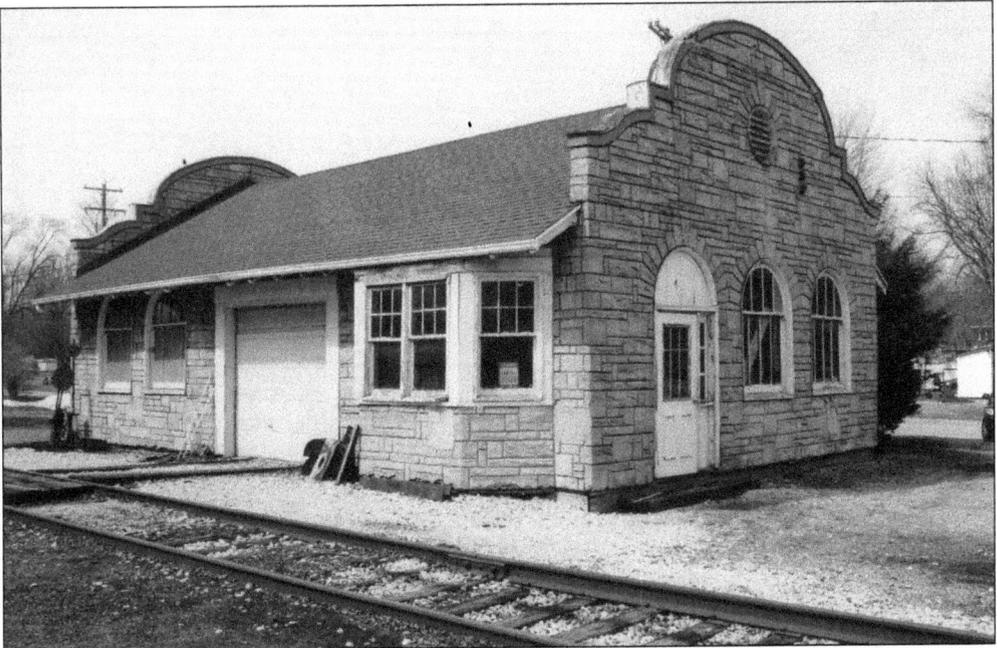

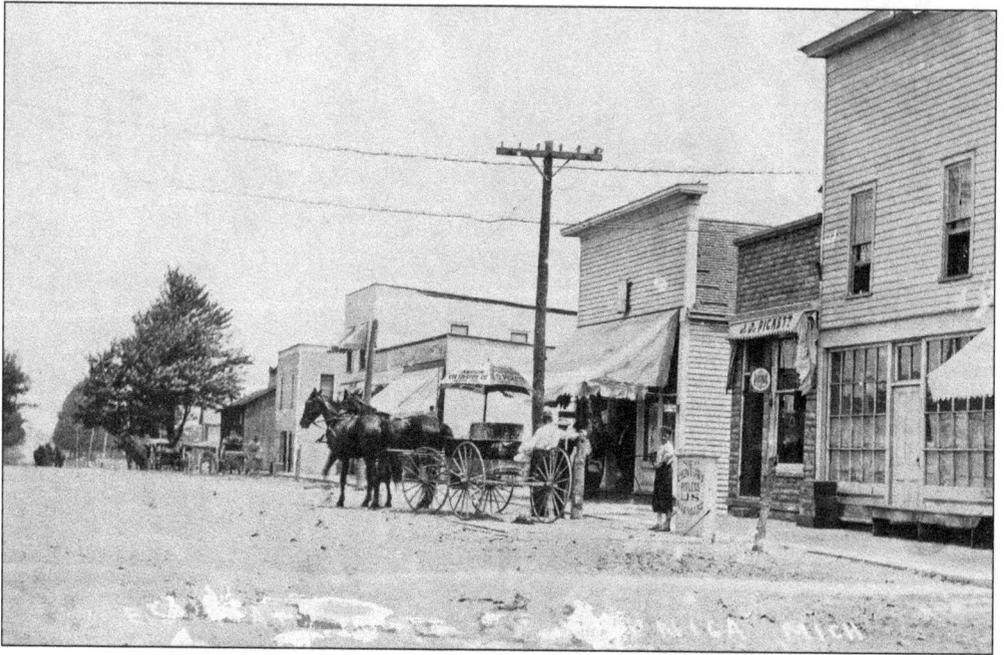

NUNICA. At first glance, Nunica seems like an unusual name, until one realizes that it is derived from the Ottawa (Algonquian) word *menonica*, meaning "clay earth," of which there is a great abundance in the region. For centuries, Native Americans used the regional clay for making pottery, and in 1836, European settlers began doing the same, though they initially referred to the settlement as Crockery Creek. The village officially became Nunica in 1859. What was once "downtown" Nunica, pictured above around 1910, is no longer extant. Most of the town was destroyed in the Great Nunica Fire of 1935, which was said to have started when the Grand Trunk depot, seen below, was struck by lightning.

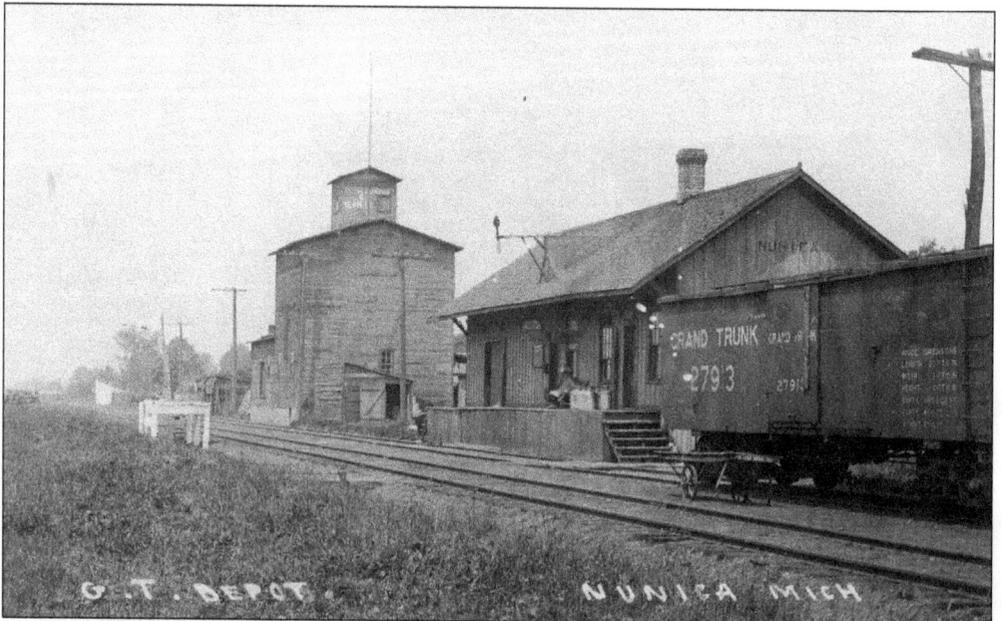

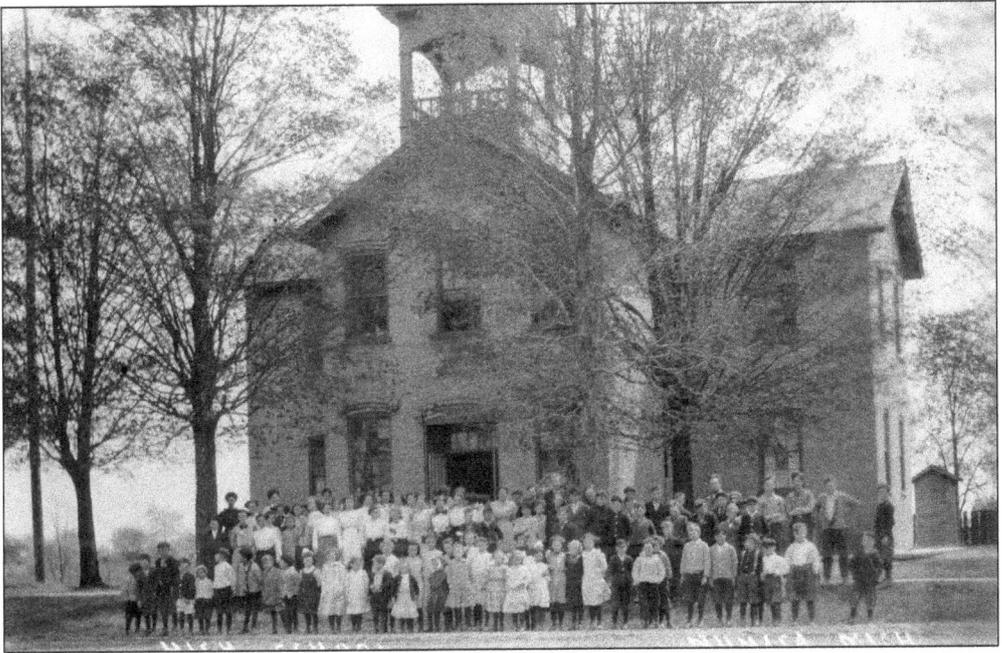

LAST TRAIN TO CROCKERY CREEK. The old Nunica High School is shown above with the entire student body assembled out front, in a photograph dated 1914. Despite a few minor modifications and the removal of the school bell cupola, the structure still stands, as shown below. Located directly across Main Street from the Crockery Township Fire Department, it is one of the few surviving original structures from a village that boasted a population of more than 8,000 residents in 1920. After the fire, however, the Grand Trunk depot and the rest of the ruined structures along the main street were never rebuilt. Today, Nunica is an unincorporated village of about 400.

REDISCOVERIES ALONG ROADSIDE AMERICA. The stretch of US 16 between Nunica and Coopersville seems to match a collectively shared vision of cruising through the countryside during the golden age of roadside America. The two-lane blacktop still winds along the hilly countryside, at times only a few hundred feet from modern-day Interstate 96, but it leads into—rather than bypassing—each small town and village along the way. There are still several examples of Michigan's iconic concrete camelback bridges (above) along this route, and the almost forgotten experience of discovering a unique eatery not too far down the road. For many motorists driving through Nunica along US 16, Turk's Restaurant has been that place for more than 80 years. Located around the corner from the old schoolhouse, Turk's Inn has been a regional favorite since 1933, and many travelers have been known to return for its famous burgers.

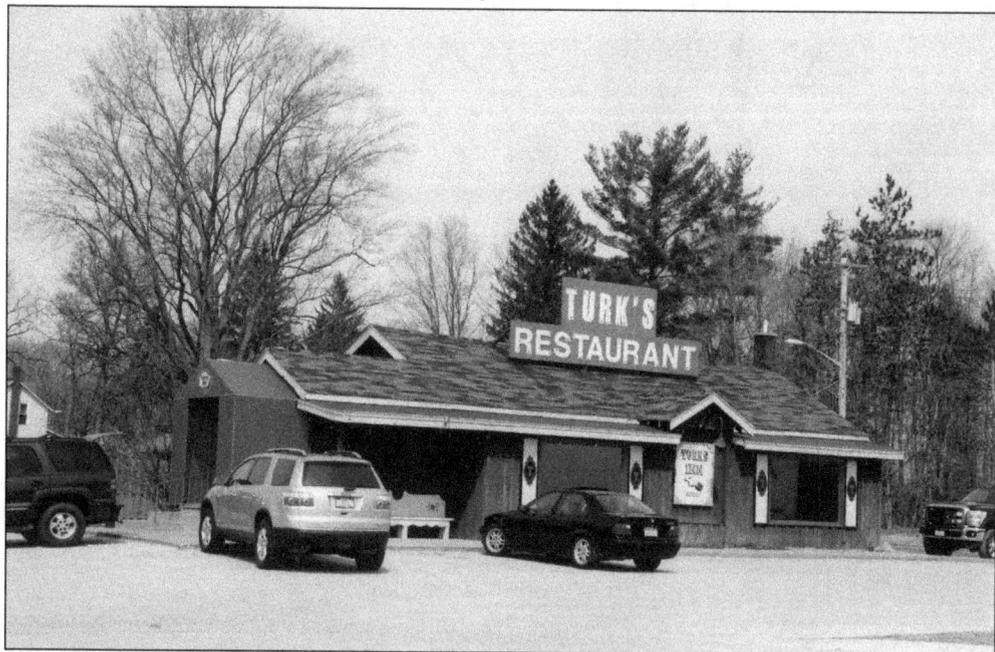

Nine

MUSKEGON COUNTY

TO THE LAKE. Since 1940, US 16 has led from Nunica into Muskegon and, ultimately, to the Lake Michigan shore. While the road goes by many names in this region, it is never again referred to as Grand River once it enters Kent County. The parasol-wielding bathing beauty in this photograph is identified on the reverse as Tessie, in a photograph taken by one of her girlfriends at the Muskegon shore in 1911.

A Major Producer. The village of Fruitport sits along US 16 at the far eastern shore of Spring Lake. It was founded in 1868 by Edward L. Craw, who decided to call it Crawville. However, since the village was a major fruit-producing area and also had access to Lake Michigan via Spring Lake, it was decided the name ought to be Fruitport. While the 1907 view of the main street in Fruitport above might seem a bit "disarming" (what with Venus de Milo standing over the entranceway of a structure on the far right), the village continues to be a busy commerce center today, with a current population of just over 1,000. In the 1909 image below, passengers have just disembarked from a Fruitport excursion boat on what looks to be a lovely spring day.

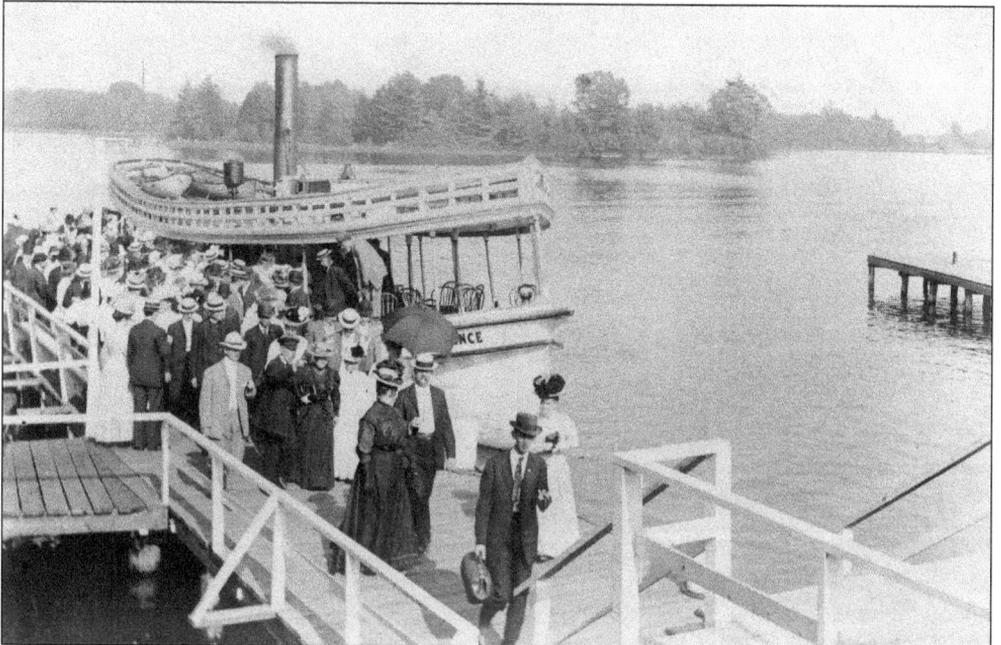

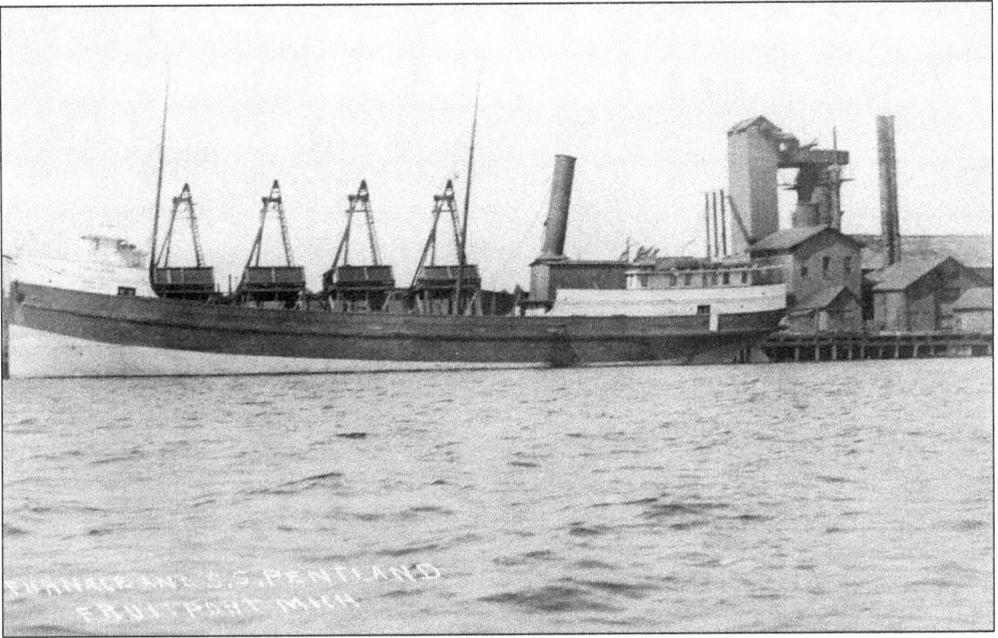

FRUITPORT IRON AND INDUSTRY. In addition to fruit, Fruitport was once an industrial center as well. The Spring Lake Iron Company (SLIC) was located in Fruitport from 1879 until 1912 and produced more than 950,000 tons of pig iron. Pictured above, the Spring Lake Iron Company's own ore carrier, the SS *Pentland*, awaits loading at the Fruitport dock. Considered one of the largest ore carriers of its time, the *Pentland* was seriously damaged in a collision in 1912 and ultimately scrapped. The Spring Lake Iron Company office and boathouse is seen below in a photograph from 1907. Today, only ruins remain of the once expansive facility.

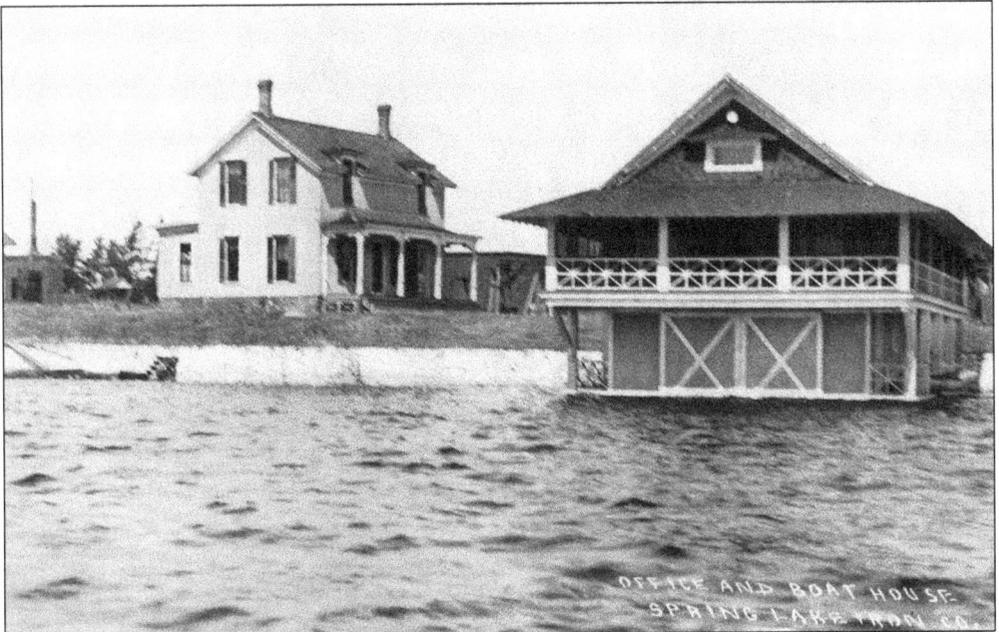

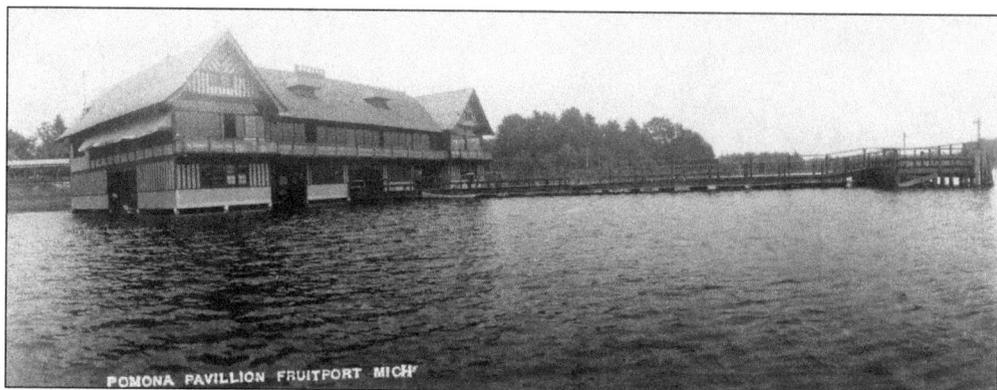

POMONA PAVILLION FRUITPORT MICH

SWEET MUSIC AND RED HOT JAZZ. The Pomona Pavilion, pictured above, was built in Fruitport in 1901. It was the crowning jewel of Pomona Park and stood just over the water's edge, allowing boaters to dock and participate in the many dances. Over the years, it was a venue that featured such notable national bands as Glenn Miller and His Orchestra and the Dorsey Brothers. One of the local house bands was that of Muskegon businessman and bandleader Frank Lockage, featured in the advertising postcard below; Lockage purchased the pavilion in 1926. In 1962, the pavilion was sold for the final time, but the sweet music and red hot jazz must have proved too hot to handle—the place burned to the ground and the waterline on a cold winter's night in January 1963.

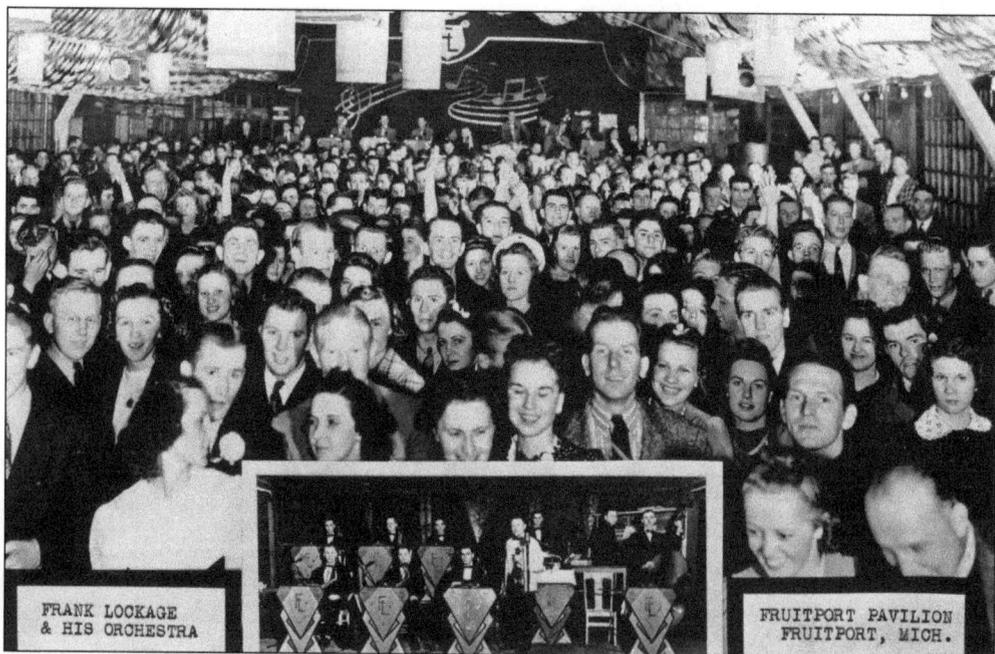

FRANK LOCKAGE & HIS ORCHESTRA

FRUITPORT PAVILION FRUITPORT, MICH.

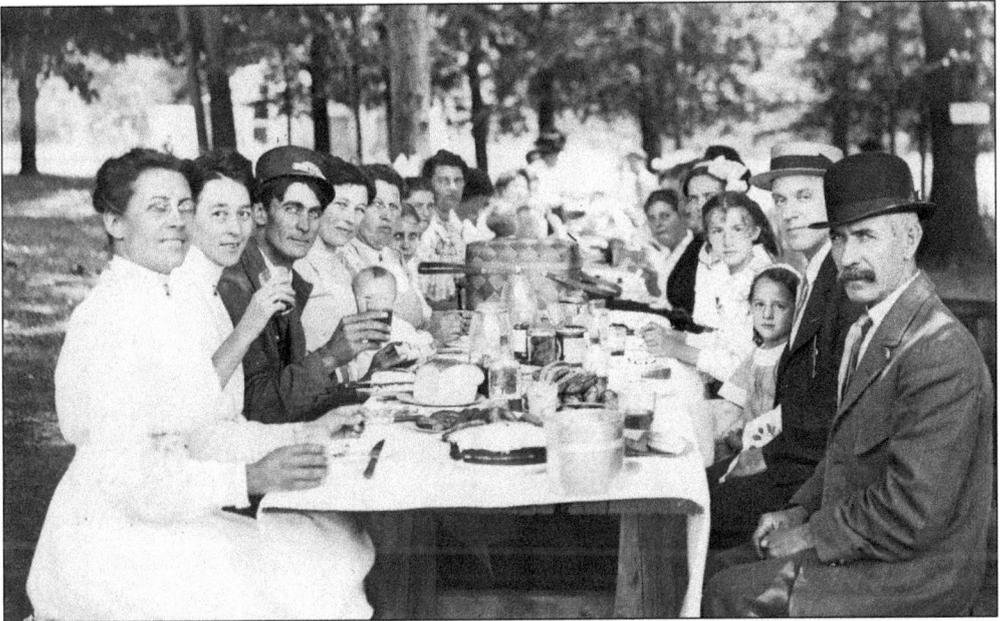

PICNIC IN POMONA PARK. "Dear Mother, we are all getting along . . . How do we all look to you, this morning?" writes daughter Ella on the reverse of this postcard from around 1910. The featured facial expressions seem to run the gamut from peacefully satisfied to downright grumpy. At any rate, with or without the pavilion, Pomona Park is still a popular place for picnics and parties along Spring Lake.

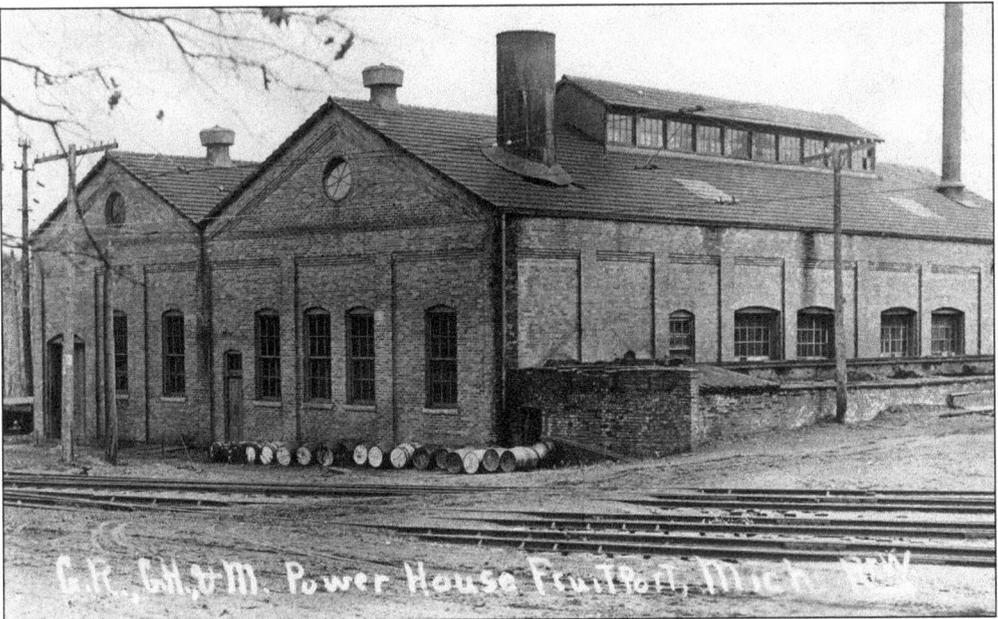

POWER TO THE PEOPLE AT POMONA. From 1902 to 1928, commuters and Pomona picnickers alike were afforded the great advantage of convenient transportation via the "Lake Line," formally known as the Grand River, Grand Haven & Muskegon Railway. The Fruitport powerhouse is seen in this postcard dated 1918. Sadly, by the late 1920s, the interurban system in America came to an untimely end, chiefly due to the popularity of automobiles.

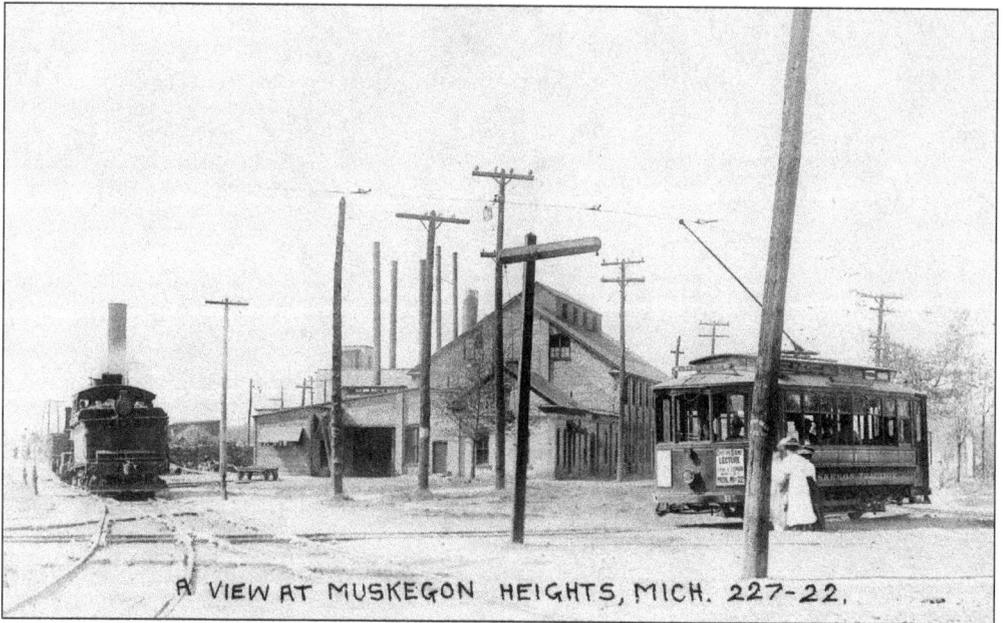

A VIEW AT MUSKEGON HEIGHTS, MICH. 227-22.

ALL ROADS LEAD TO MUSKEGON. While US 16 has only come directly into Muskegon since 1940, it has long been connected to it, via US 31. This photograph shows an GRGH&M interurban car coming close enough for a wink and a nod with a Pere Marquette engine as they pass through Muskegon Heights.

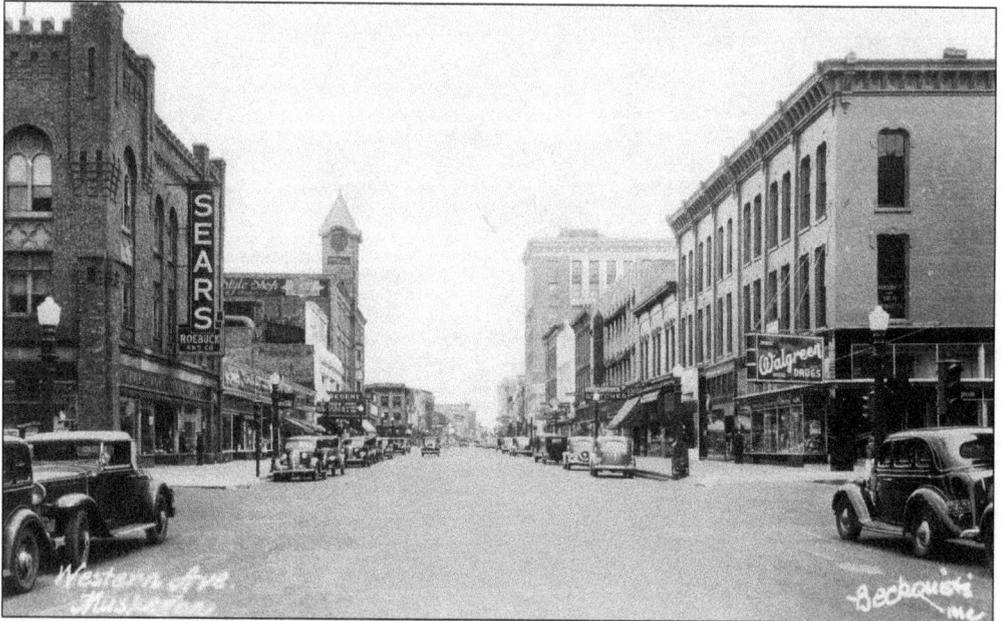

LUMBER, LABOR, AND INDUSTRIAL BOOM. Muskegon, seen here around 1938, was settled in 1834 and named for the Muskegon River, altered from the original French name, Masquignon. According to historian Walter Romig, the word is derived from the Ottawa (Algonquian) name for Marshy River. The river runs from north-central Michigan into Muskegon and the lake of the same name before joining the waters of Lake Michigan. The city of Muskegon thrived during Michigan's lumbering years and later became an important industrial center.

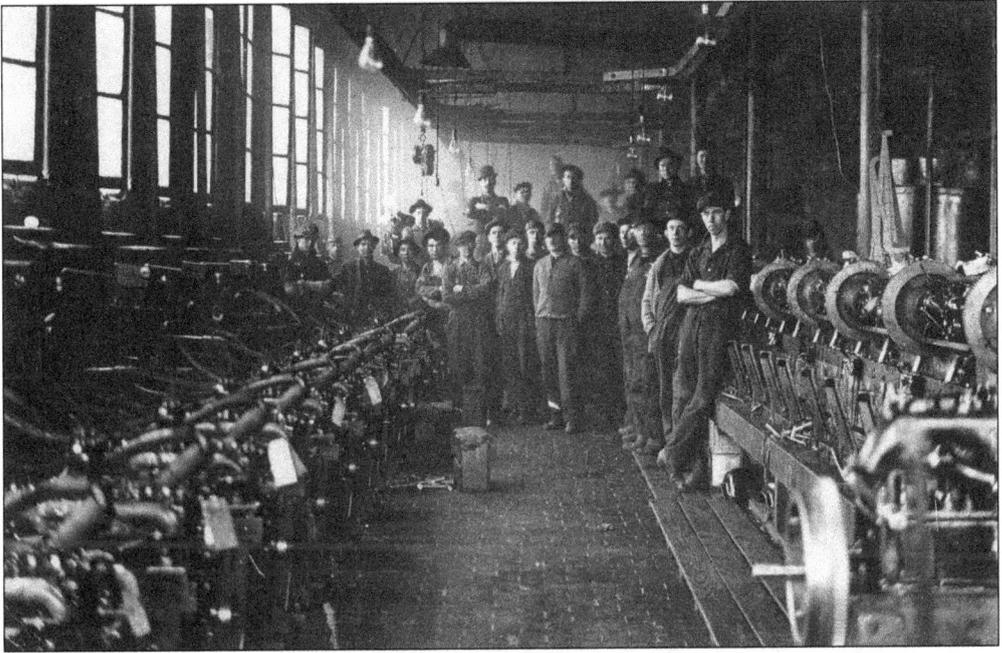

BOTH ENDS BURNING. Above, workers pose amid their dimly lit machinery in a factory along Muskegon's First Street in 1916. Positioned on opposite ends of Grand River, Muskegon and Detroit serve as industrial "bookends," commercially connected to the world by the waterways at their doorsteps. In Images of America: *Detroit 1900–1930*, Richard Bak notes that Erskine Caldwell referred to Detroit as the "eight-finger city," acknowledging the dangerous working conditions and often grisly injuries that became a daily concern for workers subjected to the greed-driven demands and negligence of unregulated industry. However, their plight did not go unnoticed; seen below around 1910, members of the Industrial Workers of the World (IWW), often referred to as "Wobblies," present a well-decorated float in one of Muskegon's annual parades, once a part of their ongoing efforts to organize workers, improve working conditions, and raise wages.

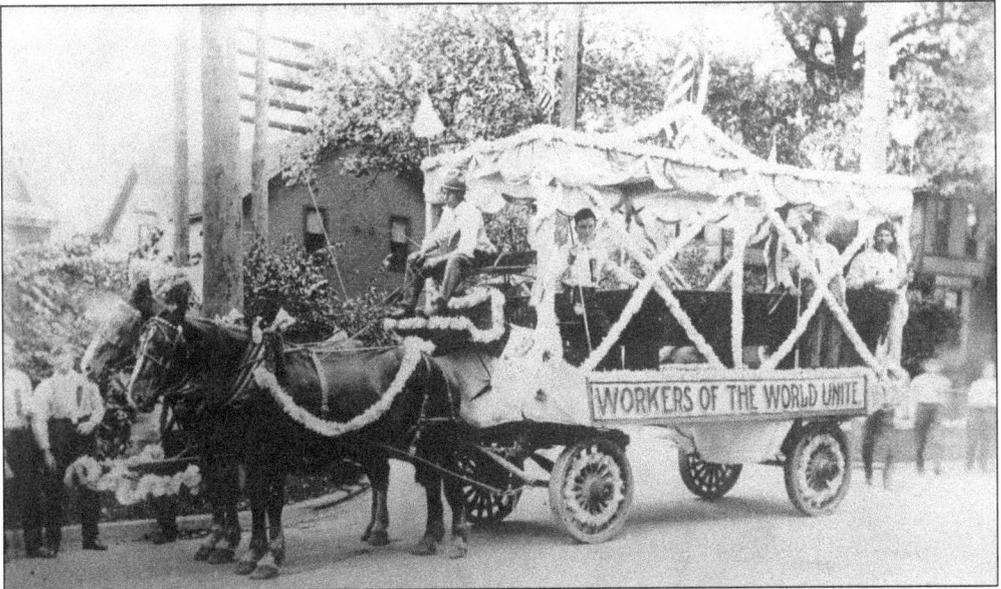

BUSTER KEATON. Film legend Buster Keaton (1895–1966) called Muskegon home, and the city is now home to a statue of him (left). Created by sculptor Emmanuil Snitovsky, Keaton's statue stands alongside Muskegon's Frauenthal Center for the Performing Arts. Keaton spent many summers in nearby Bluffton, where his father established an actor's colony in 1908. Keaton once reminisced, "The best summers of my life were spent in the cottage Pop built on Lake Muskegon." Today, Muskegon is home to the annual Buster Keaton Convention, hosted by the International Buster Keaton Society, known as "the Damfinos." The convention includes film screenings, with live musical accompaniment, presentations, walking tours, and more. More information on the Damfinos can be found at www.busterkeaton.com. Keaton is caricatured below on the cover of sheet music for a song from his 1930 film *Free and Easy*.

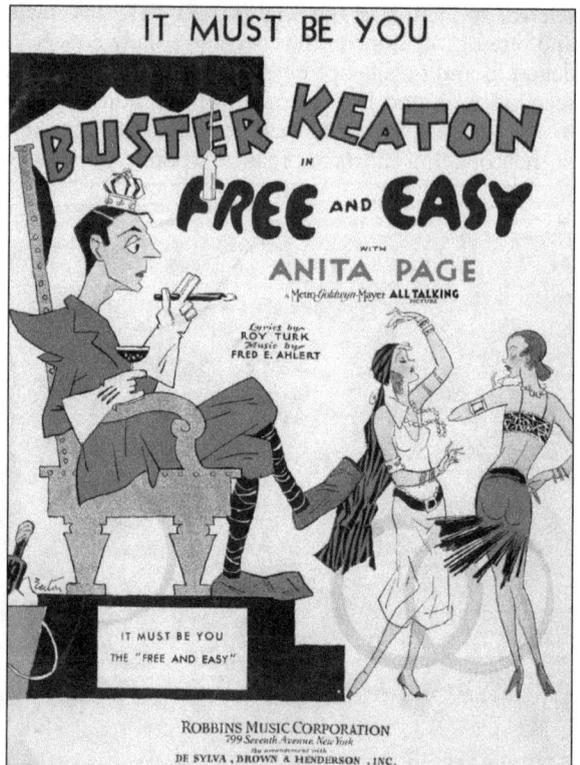

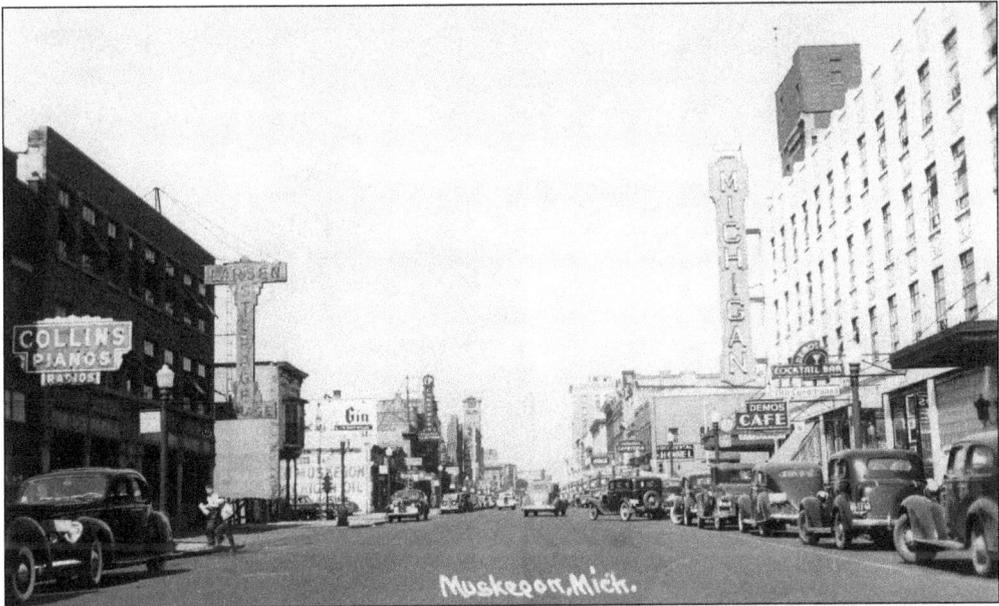

Muskegon, Mich.

THE FRAUENTHAL. Built in 1929, the Michigan Theatre (above) was a movie showplace, with seating for more than 1,700 and a sound system fully equipped for the new talkies. But, by the 1970s, the theater had fallen on hard times. Just before the wrecking ball came calling, local industrialist and theater lover A. Harold Frauenthal came to its rescue, saving the theater and the adjacent building it also occupied. As a result, the theater was renamed in his honor. In the early 1990s, the scope of the complex was expanded through the efforts of Muskegon's Community Foundation, which ultimately created the Frauenthal Center for the Performing Arts (left), and now includes the Beardsley Theatre, the Bettye Clark-Cannon Gallery, rehearsal halls, conference rooms, and more.

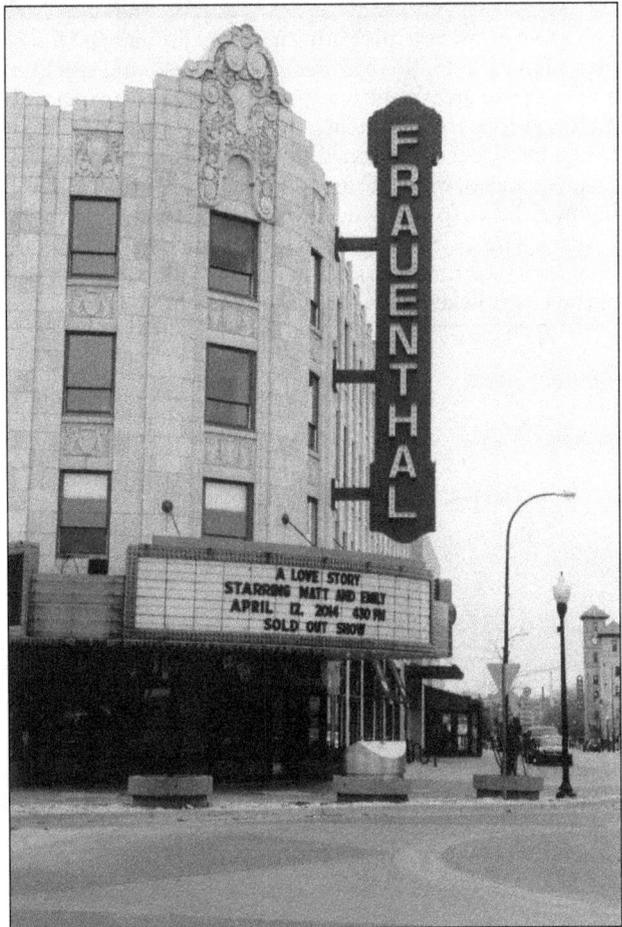

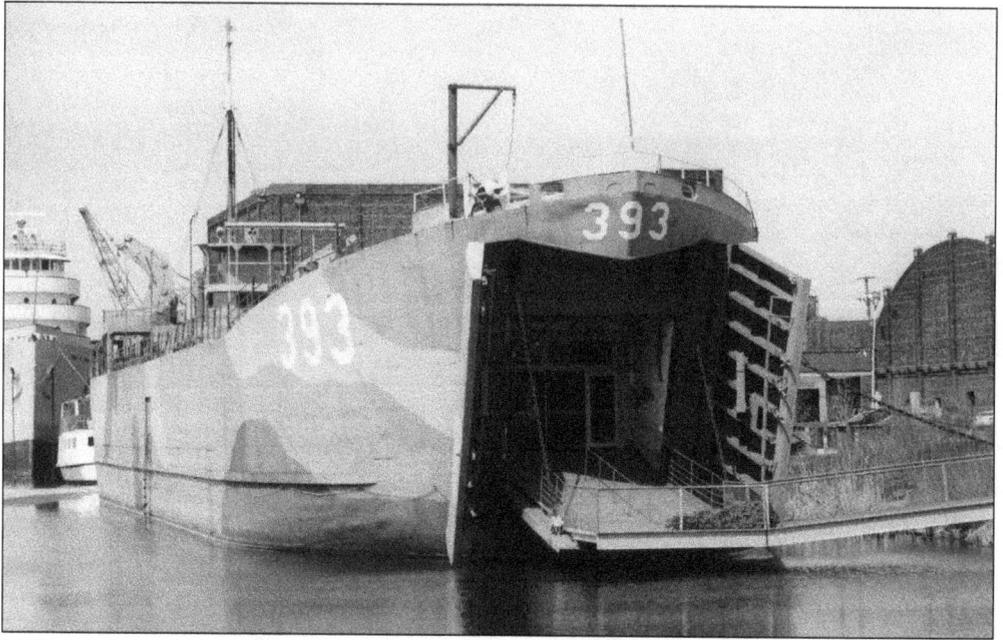

LSTs and Subs. Several floating museums are among Muskegon's most popular attractions. Landing Strip Tank (LST) No. 393 was built in 1942 and has quite a past. Capable of delivering tanks and troops to areas of heavy combat, it saw plenty of action in World War II, making more than 30 round-trips to the beaches at Normandy on D-day. It was also engaged at Sicily and Salerno before being decommisioned in 1946 and starting a whole new career transporting cars across Lake Michigan, where it earned its nickname "the US 16," as it was a waterborne extension of the highway. LST No. 393 is docked at Mart Street, next to the *Port City Princess*, of Lake Michigan Cruises. The USS *Silversides* is another decorated veteran of World War II, receiving 12 battle stars for its wartime service. Launched in 1941, the *Silversides* is now a submarine museum, part of the Great Lakes Naval Memorial Museum.

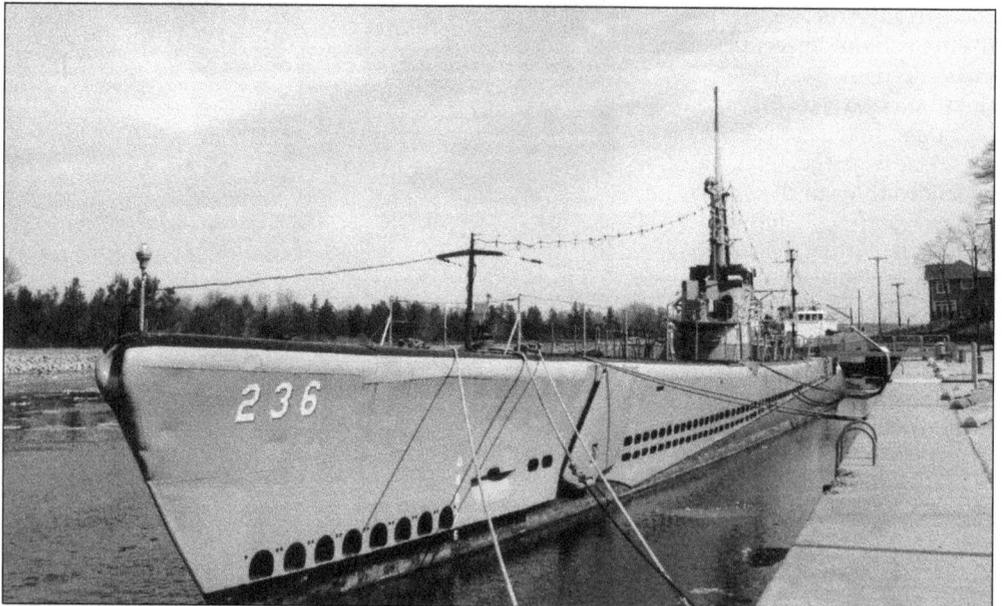

TRAIL'S END. As the Old Grand River Route reaches the water's edge, it seems almost poetic to find a final resting place for the native people who created it. Muskegon's Old Indian Cemetery dates from about 1750. Used primarily by the Ottawa people, it was shared with settlers from 1806 to 1854. In 1926, Martin A. Ryerson deeded the cemetery to the city with the stipulation that it be protected and maintained forever.

5080. Hackley Library. Muskegon, Mich.

CHARLES HACKLEY. Born in 1837, Charles Hackley came to Muskegon in 1856 and made a fortune in road construction and lumber. A true man of the people, he once remarked, "A rich man to a great extent owes his fortune to the public. He makes money largely through the labor of his employees." By 1905, when he died, he had given Muskegon its library, seen here, as well an art gallery, a hospital, several schools, and more. His home and that of his business partner Thomas Hume are now historic sites.

111

The Milwaukee Clipper and the Lake Express. The SS *Milwaukee Clipper* began life in 1904 as the *Juniata*. Built by the Pennsylvania Railroad, the massive, 350-foot ship originally hauled passengers and freight from Duluth to Buffalo. Later, it was used primarily to transport passengers. In 1940, it was completely rebuilt, equipped with many new, passenger-focused amenities, and altered to accommodate up to 120 automobiles. Renamed the SS *Milwaukee Clipper*, it transported passengers and automobiles between Muskegon and Milwaukee for many years. Today, the SS *Milwaukee Clipper* is a National Historic Landmark and a public museum. More information is available at www.milwaukeeclipper.com. Today, cross-lake transportation for passengers and automobiles traveling between Muskegon and Milwaukee is provided by the *Lake Express*, a high-speed ferry service located just down the shore from the SS *Milwaukee Clipper*.

Ten

THE RIVER ROUTE

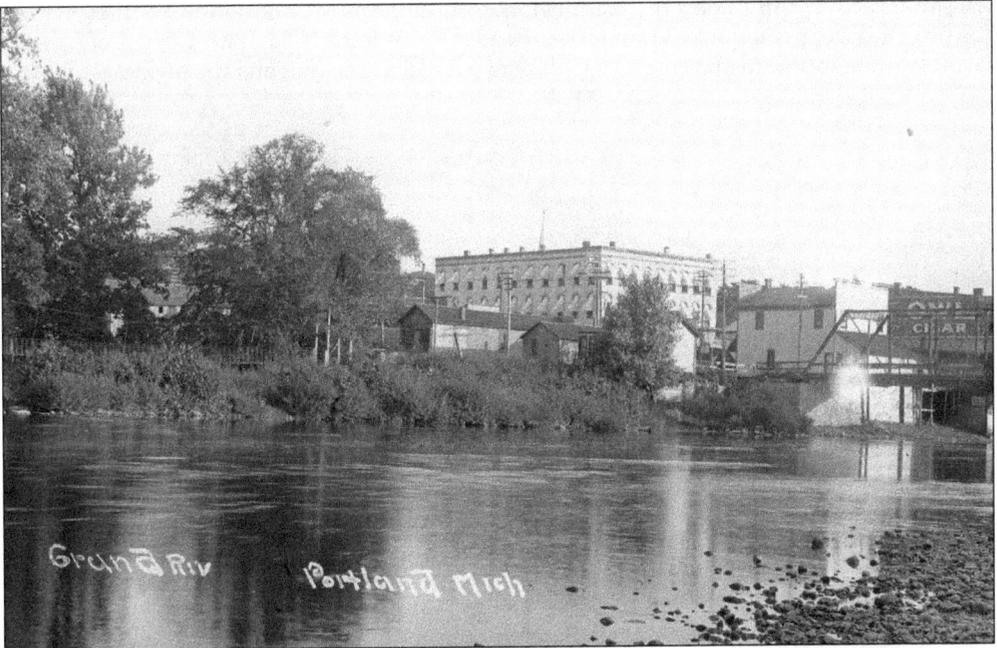

WINDING ITS OWN WAY. The Grand River makes its way past Portland, seen here, just beyond its junction with the Looking Glass River, one of its major tributaries. As the river approaches the bridge at US 16, the Hotel Divine, a longtime local landmark, is clearly visible at center.

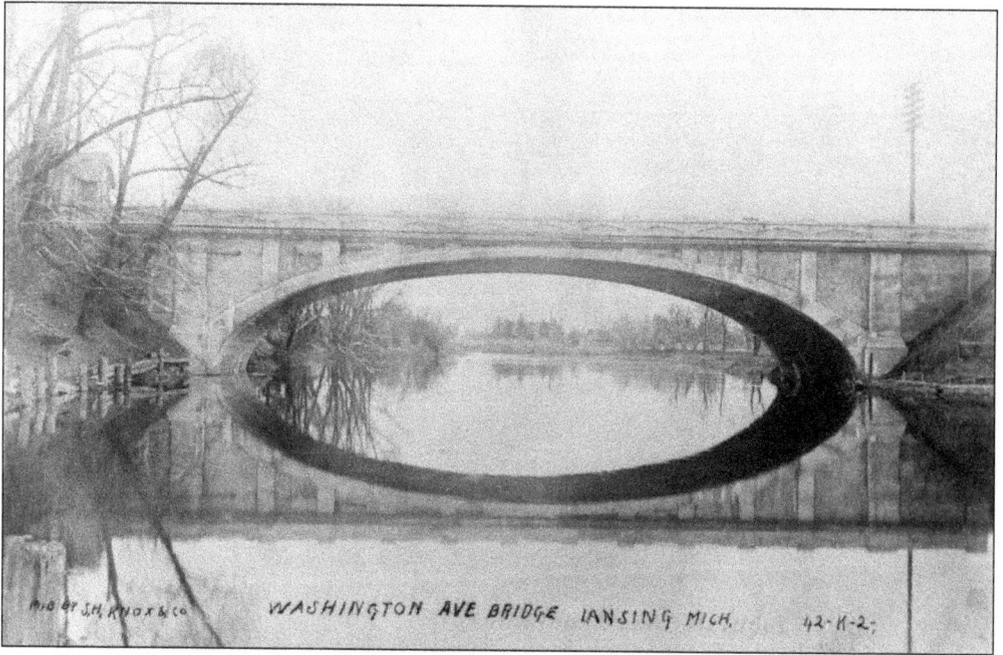

WASHINGTON AVE BRIDGE LANSING MICH. 42-K-2

THE RIVER'S ROUTE. While the trail and the highway rarely veer too far apart, the river first makes an appearance in their general vicinities at Lansing, roughly halfway between Detroit and Grand Haven. Historical records indicate that the Native American name for the Grand River is O-wash-ta-nong, which roughly translates to "faraway water"—not much of an exaggeration if one happens to be standing somewhere along the trail near Detroit. The Grand River meanders into Lansing (above), crossing under the Washington Avenue Bridge. Moving northward through town (below), the river passes under Grand River Road (US 16) in the Old Town District of Lansing before turning westward and cutting a path semi-parallel to the trail and the highway.

1849. SCENE ON THE RIVER.

GRAND LEDGE. From Lansing, the river rolls through the city of Grand Ledge, seen here, which is named for the 300-million-year-old sandstone and quartzite rock ledges that rise as much as 60 feet over the banks of the Grand River in places. Native Americans once pitched seasonal camps in this region, finding abundant fishing, hunting, and clam digging along the riverbanks.

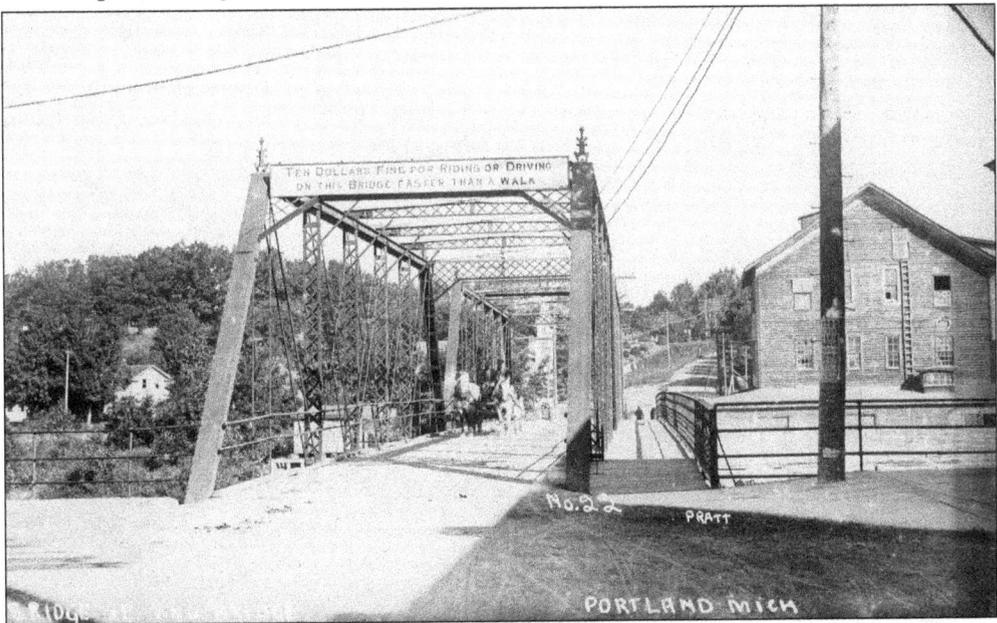

EAGLE AND PORTLAND. Beyond Grand Ledge, the river flows north past Eagle and through Portland (pictured), where it is joined by a tributary known as the Looking Glass River. Here, riders on horseback cross the Grand River on the Bridge Street Bridge. While the sign overhead reads "Ten Dollars Fine for Riding or Driving on this Bridge Faster than a Walk," it is unclear how that rate of speed was determined and who ultimately made the judgment.

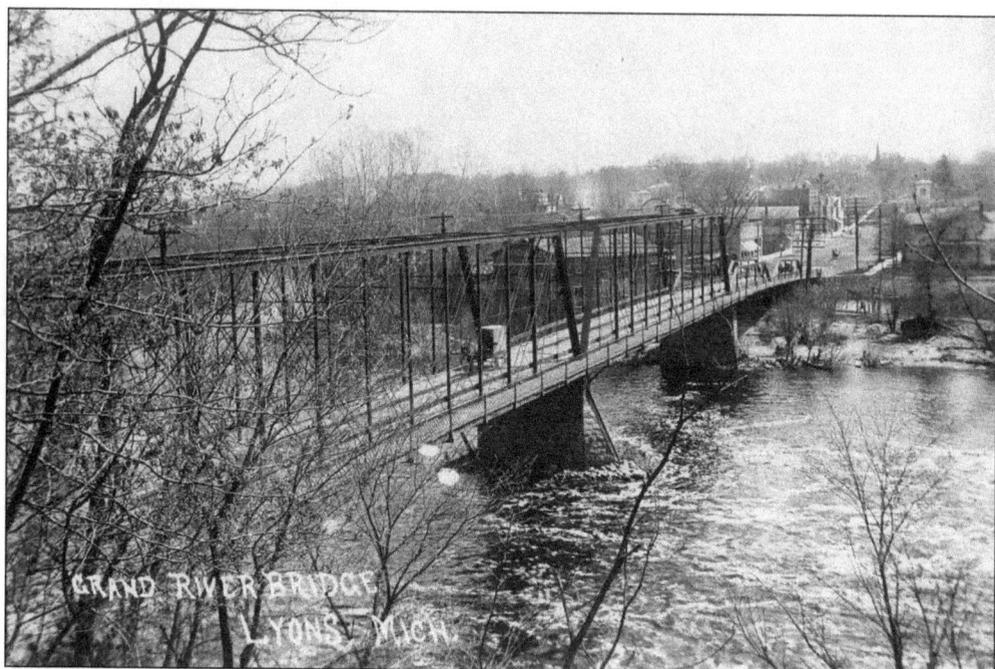

GRAND RIVER BRIDGE
LYONS MICH.

UP THE RIVER TO IONIA AND BEYOND. As the Grand River continues its northwesterly, albeit circuitous, trek towards Muir and Ionia, it passes through the little-known and seldom mentioned village of Lyons (above), once the site of a Native American village known as Chigaumishkene. According to historian Walter Romig, the first white settlers arrived from New York in 1833, and, in 1836, a rather ambitious fellow named Lucius Lyon wrote a relative: "The place is called Arthursburg . . . but we will change the name . . . I own the whole town site . . . it will become one of the most important towns in Michigan." In the 2010 census, the population of Lyons was 789. Beyond Ionia, the Grand River runs through the little village of Saranac (below), settled in 1836 and named for the resort town of the same name in New York.

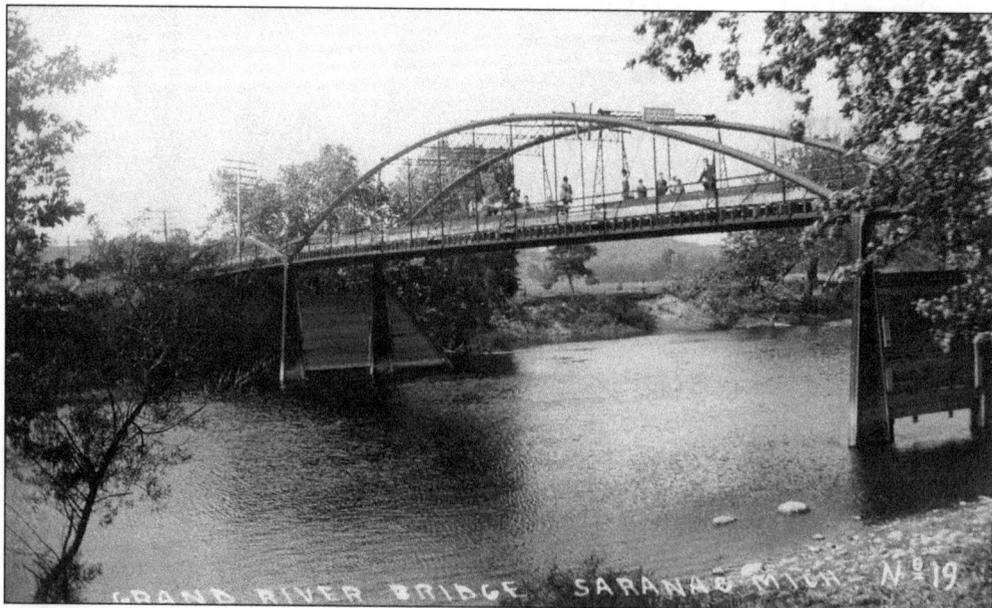

GRAND RIVER BRIDGE SARANAC MICH. Nº 19.

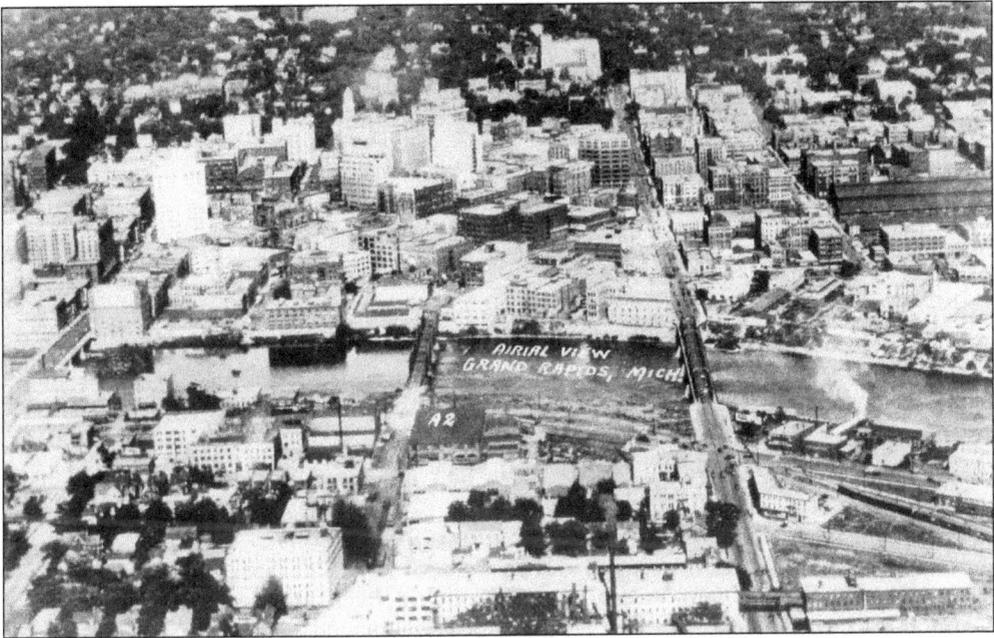

AIRIAL VIEW
GRAND RAPIDS, MICH.

GRAND RAPIDS AND GRANDVILLE. As the river continues a somewhat parallel course with the old trail and highway, it runs through Lowell and into the city of Grand Rapids. In the scene above, from a mid-20th-century aerial photograph, the Grand River cuts directly through the center of Grand Rapids. Several of the city's major thoroughfares bridge the river, including US 16, which shares the road with Fulton, Monroe, and Leonard Streets, as it runs through town and crosses the river on its way to Walker Station. First settled in 1820, the city was named for the rapids once found in the Grand River at this point. Recently, the city is planning to restore these landmark rapids. Just outside of Grand Rapids, the river winds through the nearby town of Grandville, settled around 1832 by Luther Lincoln and named for its position along the river.

Grandville from the Viaduct, Grandville, Mich.

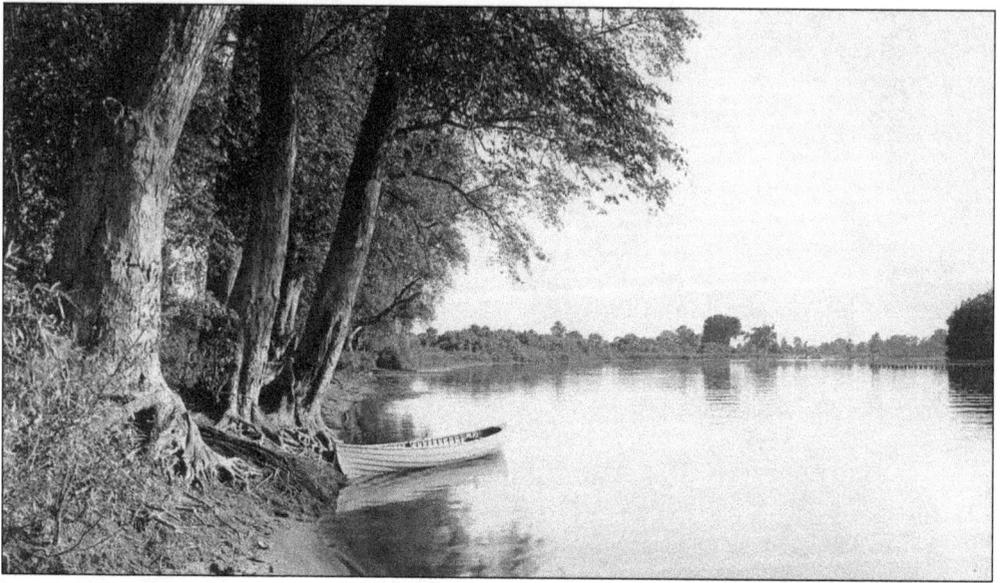

BURIAL MOUNDS ALONG THE GRAND BANKS. Along the riverbanks between Grandville and Grand Rapids, the ancient Hopewell people built burial mounds more than 2,000 years ago. Known as the Norton Mounds, this prehistoric cemetery can be viewed at Hopewell Indian Mounds Park, located within Millennium Park. There is a dramatic bend in the river as it passes near Grandville, pictured above. During the lumbering boom, work teams were stationed along this stretch to break up any logjams that might occur as the lumber floated through en route to Grand Haven. From here, the river heads in a northwesterly path through the tiny village of Lamont, originally established in 1851 as Steele's Landing. The name was changed in 1855 when a man named Lamont Chubb offered to give the townspeople a road scraper in exchange for naming the village after him. In the 1913 photograph below, the side-wheeler *May Graham* is seen plying the Grand River at Lamont.

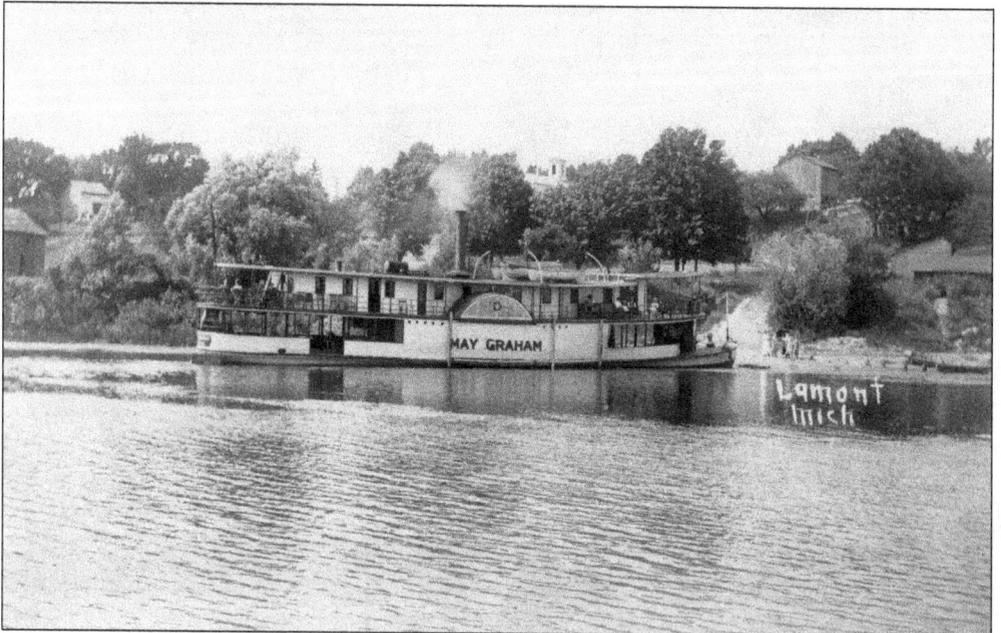

Boat Landing, Arbutus Banks, Spring Lake, Mich.

SPRING LAKE. Beyond Lamont and Eastmanville, the Grand River joins with the waters of Spring Lake as it passes the resort town of the same name. In the 1916 photograph above, a pleasure cruise sits alongside the boat landing at Spring Lake's Arbutus Banks. Originally established as Hopkins Mill in 1837, the town became a popular summer destination for people escaping the city heat in Chicago, Detroit, Gary, Grand Rapids, and everywhere in between. It is connected to Grand River Highway (US 16) by way of a business route that runs from Nunica through Spring Lake to Grand Haven. At the turn of the 20th century, Spring Lake and Grand Haven were also connected to points along the highway by the Grand Rapids, Grand Haven, and Muskegon (GRGH&M) interurban railway. The interurban train servicing Spring Lake is seen below at the Nunica station.

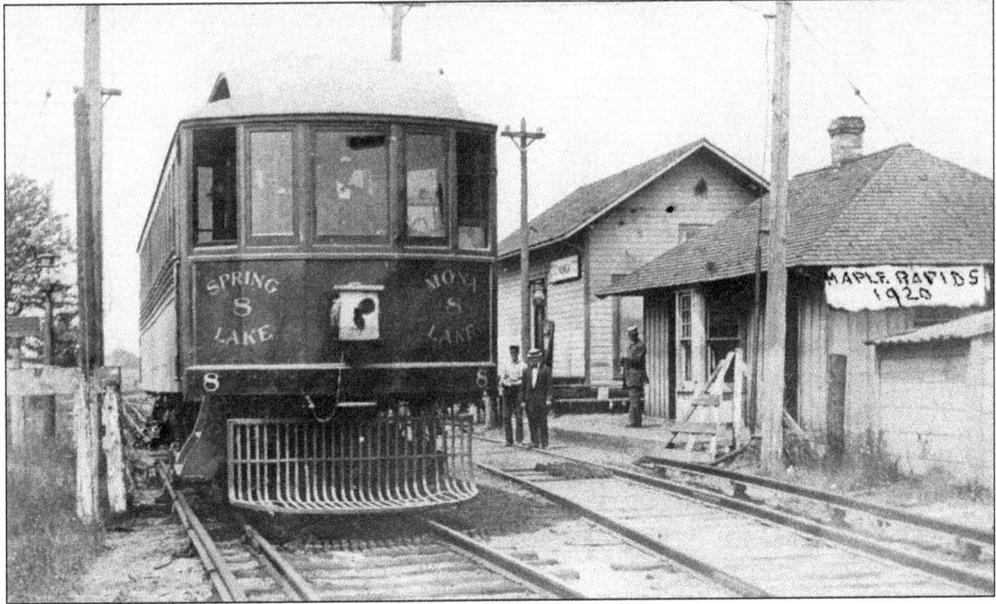

119

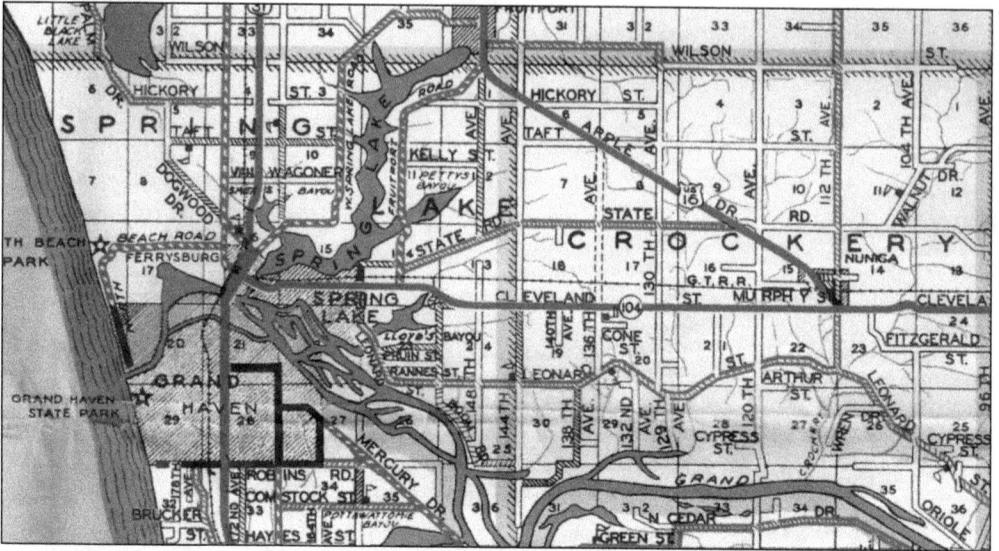

WHEN US 16 WENT TO SPRING LAKE. Before 1940, US 16 ran from Nunica westward into Spring Lake on the stretch of highway now designated M-104 (see map). Both roads still come together in Nunica, where they are collectively referred to as Cleveland Road. But, since 1940, US 16 has been rerouted at Nunica, running northwest along Apple Drive into Fruitport.

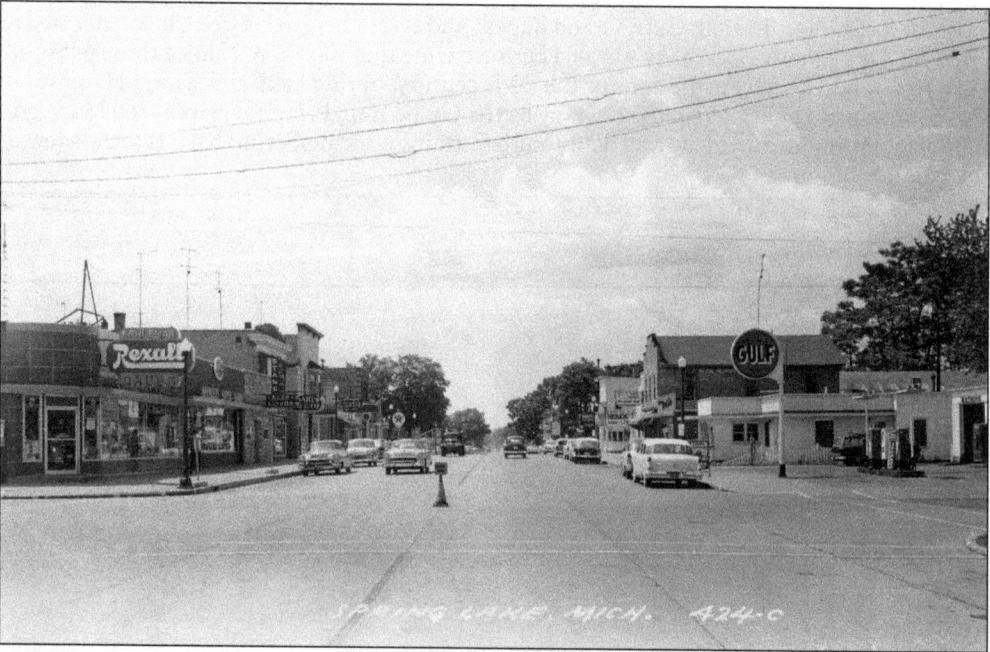

M-104 IN SPRING LAKE. No longer US 16, M-104 is known as Savidge Street in downtown Spring Lake. In this photograph from the mid-1950s, the view looks west from the corner of Jackson Street down Savidge Street. Many of the buildings shown in this section of Spring Lake's business district are still standing, but few of the businesses remain. One exception is Stan's Bar, just down past Eshleman's Rexall and the grocery store on the left.

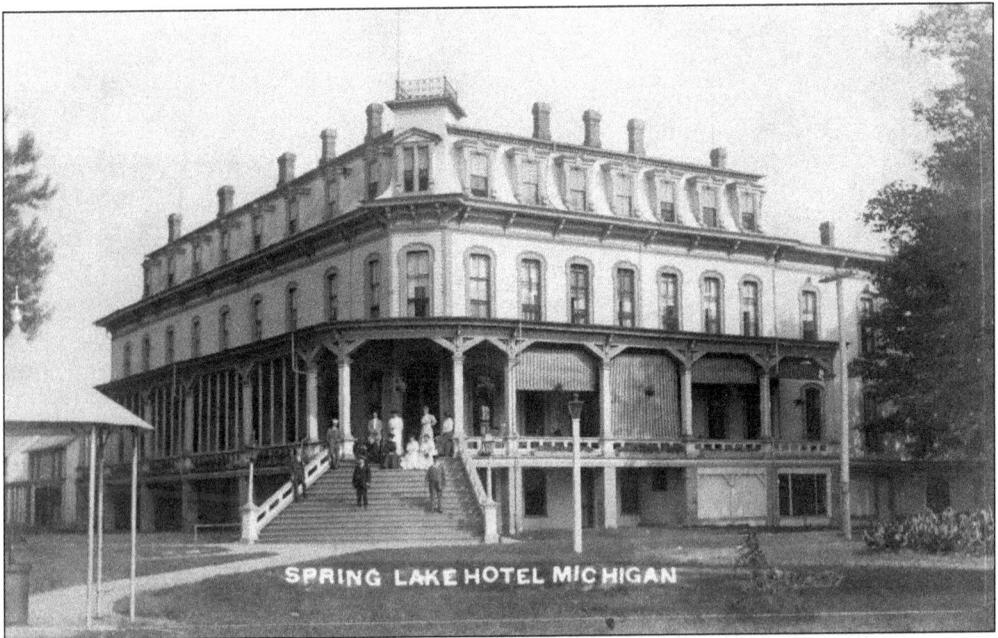

SPRING LAKE HOTEL MICHIGAN

SPRING LAKE IN THE GILDED AGE. In the 19th century, the Spring Lake region was a center of recreation and industrial ingenuity. It thrived on the lumber industry, with a wide variety of lumber-related business, but it was also famous for boat manufacturing, mineral springs, boating, swimming, and as a summer getaway. The Spring Lake Hotel, shown above in 1913, had 150 rooms and was originally known as the Spring Lake House, built around 1871. Like many of the grand old structures of Spring Lake that shared in the splendor of the Gilded Age, it was eventually destroyed in a fire. "Our Friend Teddy" is scrawled across the photograph below, showing Pres. Theodore "Teddy" Roosevelt speaking briefly to the gathered crowd at Spring Lake during a whistle-stop tour. There was great wealth in and around Spring Lake, and the wise politician knew it was always a good idea to generate the support of folks with deep pockets.

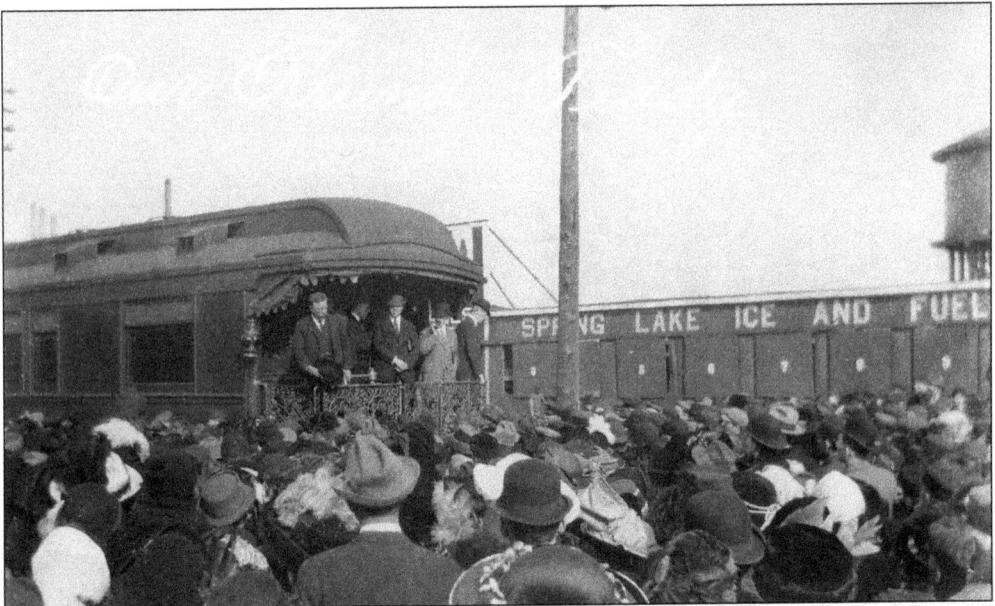

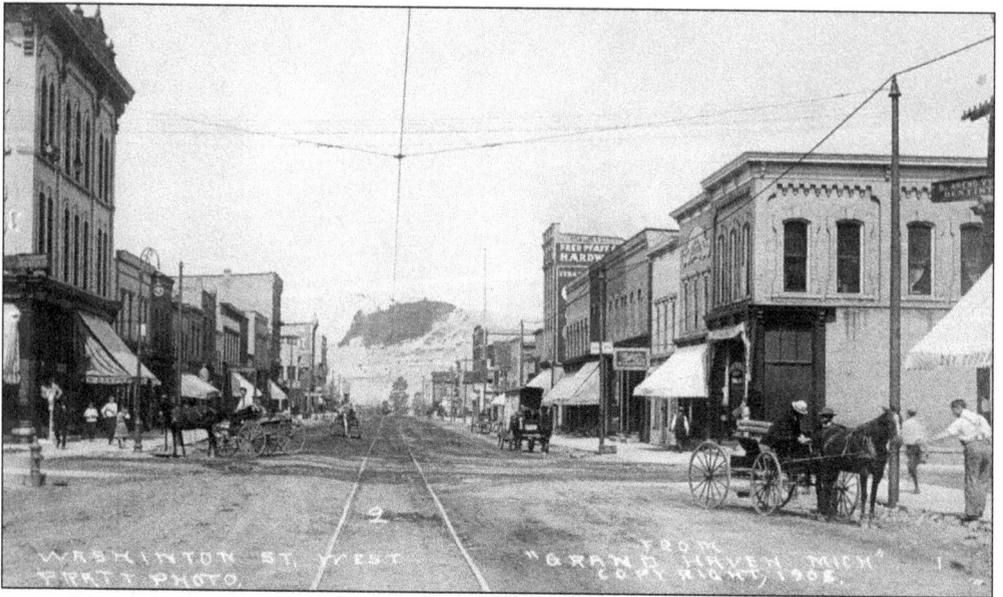

GRAND HAVEN. Downtown Grand Haven still looks much as it does in this scene from 1908 (above), though some structures have been altered or replaced. Of course, the road has been paved since then, and the horses and buggies are just a memory, but Washington Street is still a popular place with residents and visitors, strolling the boutiques and specialty shops and sampling some of Grand Haven's unique eateries. Visible at center, just across the Grand River, is Dewey Hill, a grass-covered natural landmark that began life as a moving sand dune. At its foot stands Grand Haven's Musical Fountain. Created in 1963, it is the world's largest illuminated musical fountain, and features shows from May through September. Grand Haven State Park (below) continues to be a popular destination for summer visitors who still head down old US 16 (now M-104) to the great Lake Michigan shore.

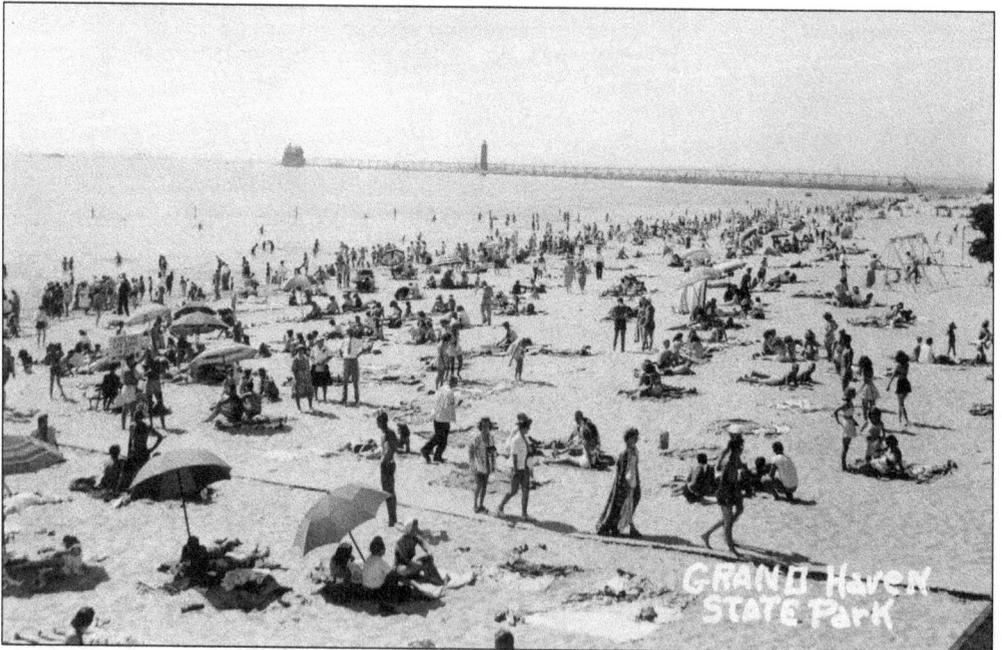

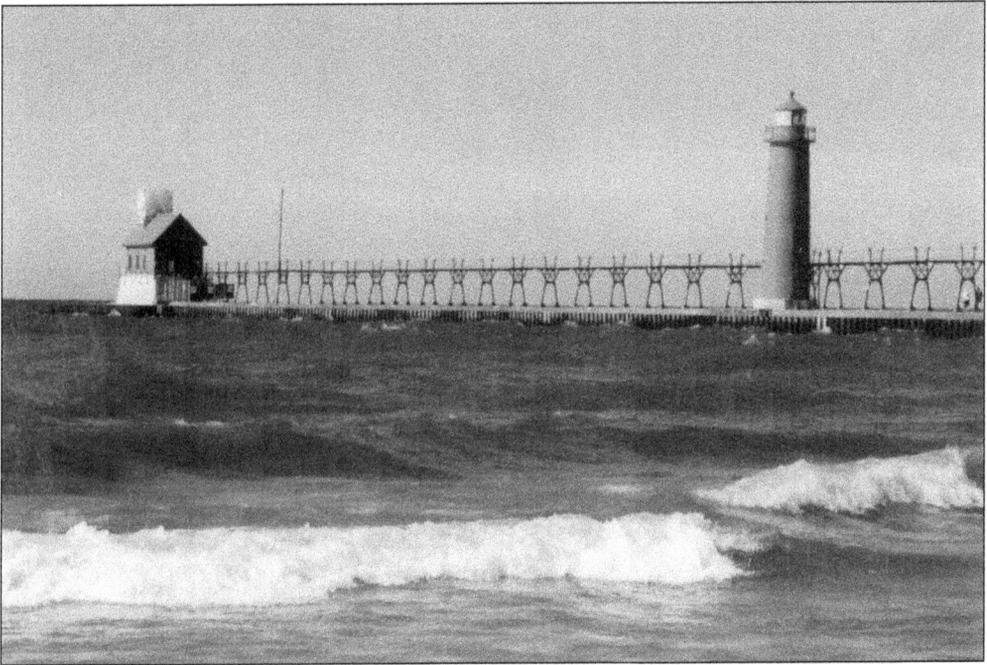

FROM GRAND HAVEN TO MUSKEGON. There has been a lighthouse at Grand Haven since 1839. The dual lights in use today (above) date from 1875 (left) and 1905, respectively, and are currently undergoing a major restoration. From Grand Haven, travelers can reach Muskegon via northbound US 31, a pleasant drive just inland from P.J. Hoffmaster State Park. Just north of here, US 31 meets up with US 16 at a junction near Muskegon Heights. In the stretch from Fruitport to Muskegon, the northwesterly, redirected US 16 (Grand River) is known as Airport Highway. The Edgewater Cabins are shown around 1950 (below), and it is believed they were located in the area where US 31 becomes Seaway Drive.

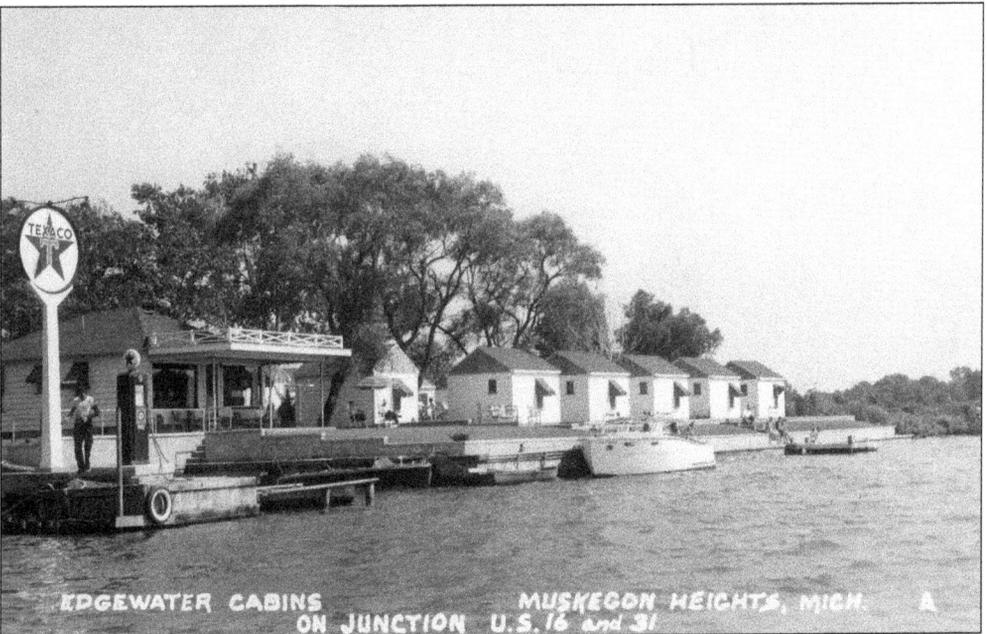

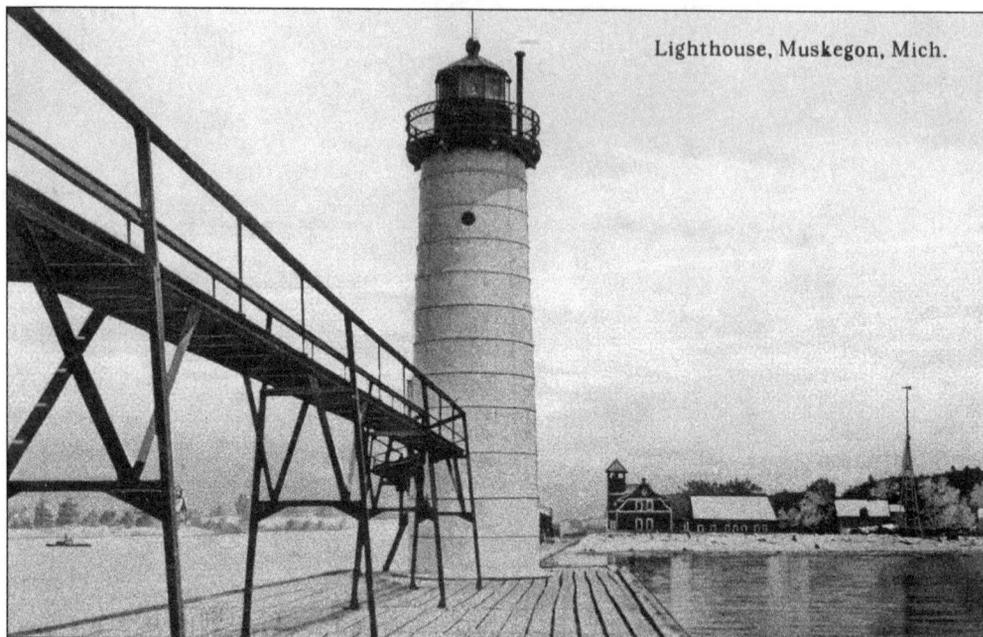

LIGHT AT THE END OF THE TRAIL. US 16 (Grand River) ends in Muskegon, where it enters town from the southeast and unceremoniously merges with Peck Street. But the statewide journey officially ends just east of Muskegon's South Pierhead Lighthouse, seen here. The current light dates from 1903 and is an active light, not open to the public. But its old red tower still presents picturesque profiles for some of Michigan's greatest sunsets.

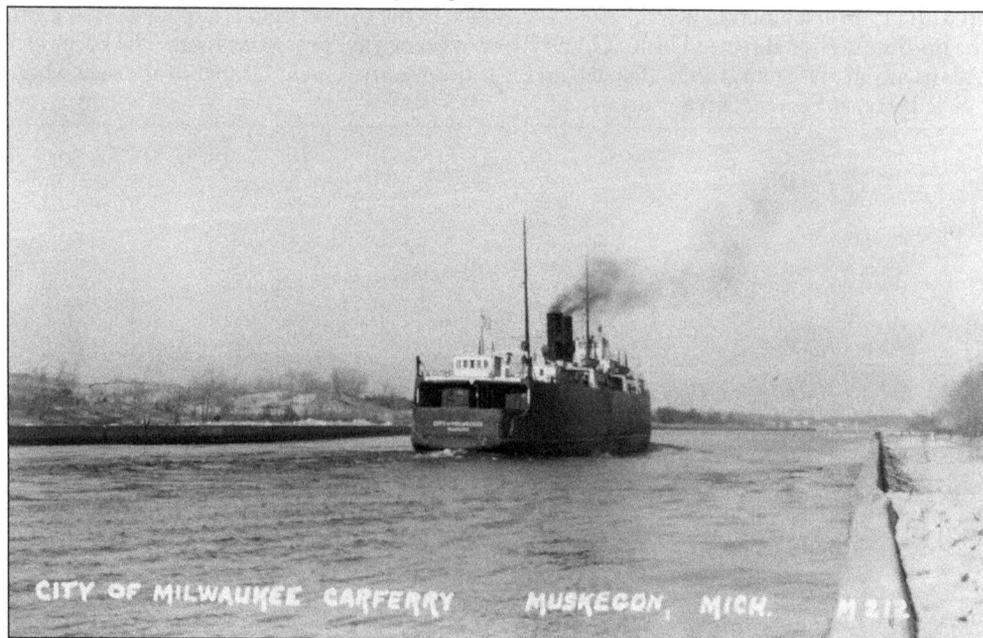

ON TO MILWAUKEE. In this 1950 photograph, the car ferry *City of Milwaukee* leaves Muskegon destined for Milwaukee, 87 miles away. Built in 1931 to haul railroad cars across the lake for the Grand Trunk and, later, the Ann Arbor Railroad, the *City of Milwaukee* was retired in 1982 and is now maintained as a National Historic Landmark and museum in Manistee, Michigan.

ACROSS THE CONTINENT ON US 16. While Michigan's stretch of US 16, generally known as Grand River, ends in Muskegon, US 16 continues along an imaginary line (center of map below) traveled by the many ships that have transported passengers and vehicles across Lake Michigan for more than a century. At Milwaukee, US 16 once again becomes a solid road, and ultimately runs across the Great Plains to Yellowstone National Park. The map below, from a 1940s promotional travel brochure, at right, was printed and distributed by the U.S. 16 Highway Association of Mitchell, South Dakota. And it only goes to show the reader that, while this journey along the Grand River Trail ends here, explorers who do not know when to quit may elect to climb aboard and keep going.

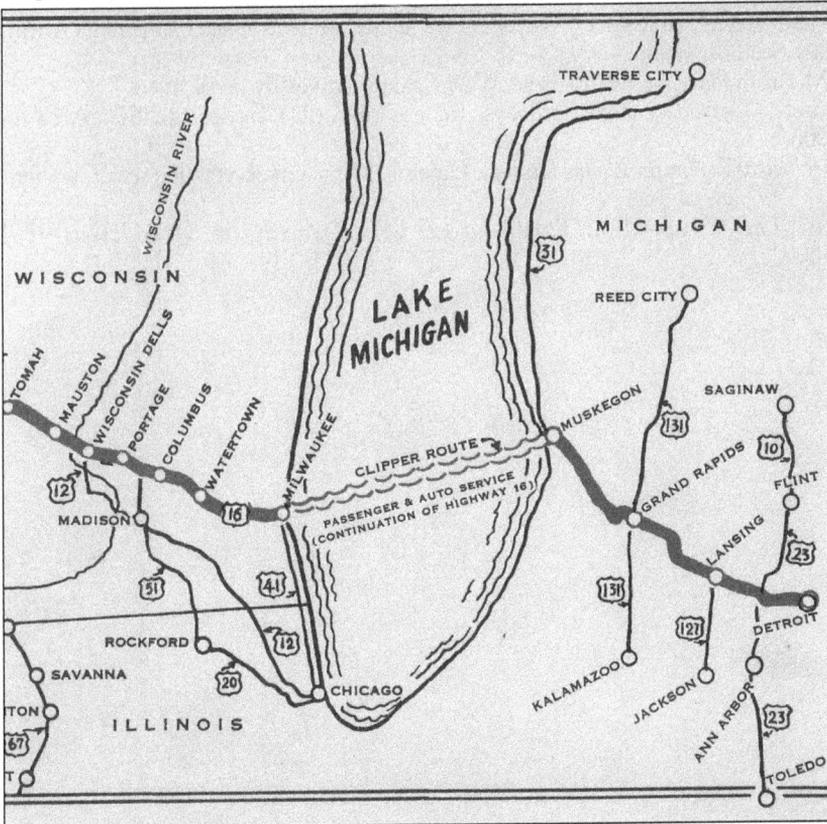

BIBLIOGRAPHY

Boyle, Kevin. *Arc of Justice: A Saga of Race, Civil Rights, and Murder in the Jazz Age*. New York: Henry Holt & Co., 2004.

DesAutels, Fred. *Redford Township: Its Heritage and History*. Redford, MI: Redford Historical Commission, 1975.

Ewing, Wallace K., PhD, and Elizabeth Dobbie for the Tri-Cities Historical Museum. *Grand Haven. Then & Now*. Charleston, SC: Arcadia Publishing, 2009.

Farmer, Silas. *History of Detroit and Michigan or The Metropolis Illustrated*. Detroit: Silas Farmer Co., 1884.

Finney, McIntosh Jr. *Howell*. Images of America. Charleston, SC: Arcadia Publishing, 2013.

Fox, Jean. *More Than a Tavern: 150 Years of Botsford Inn*. Farmington, MI: Botsford Inn, 1986.

Golden, Brian M. *Farmington Junction: A Trolley History*. Farmington, MI: self-published, 1999.

Oleszewski, Wes and Wayne Sapulski. *Great Lakes Lighthouses: American and Canadian*. Gwinn, MI: Avery Color Studios, 1998.

Romig, Walter. *Michigan Place Names*. Detroit: Wayne State University Press, 1986.

Schramm, Kenneth. *Detroit's Street Railways*. Images of Rail. Charleston, SC: Arcadia Publishing, 2006.

Sherzer, W.H. *Geological Report on Wayne County*. Lansing, MI: Wynkoop Hallenbeck Crawford Co., 1913.

Willyard, John. *The Wixom Inn*. Farmington, MI: Farmington Hills Historical Commission, 2002.

INDEX

Visit us at
arcadiapublishing.com